The art of
DRAWING

The art of DRAWING

Create stunning artworks step by step

Vivienne Coleman

ARCTURUS

Dedication

To my wonderful brother John; long-lost
(and found).

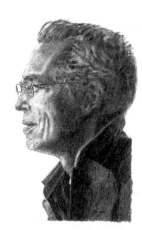

Acknowledgements

My grateful thanks to Arcturus Publishing, Ella Fern and Diana Vowles.

A huge thank you to my lovely husband Chris for his support, and to my sister Jen and her husband
Steve. Special thanks to dear friends Rachel Billings and Bernice Young for their unbounding positivity,
and Hesham El Essawy for giving me back my life. Thank you Annette Gibbons, for running that
organic gardening evening class (it's all your fault!), Sharon Warwick (great party!), and the late Diana
Carroll for those wonderful Saturday mornings. Also, artists Clive Wylie and Ron Ablewhite, and
fantastic teacher Fiona Dixon who all encouraged me to draw and teach. My thanks to wonderful
friends, brilliant coaches Mo Colohan and Tanya Moxon, patient 'guinea pigs' Karen Carter, Bernie, and
Jennifer Tuck, my students and amazing clients – who all inspire me to keep drawing. Thanks to the
unwitting models (Jon, Ailsa, Harry, Ben, Dulcie, Ken) and the owners of props (Phil, Helena and Harry
Moffat – Land Rover; Lesley Hedges – Lower Sticker farm camping). Thanks also to the 'borrowed'
animals and their owners: Andrea Hayes and Peter Sayer (Ellie May), Elisabeth Atkinson (Red), Janet
and Jem Caunce (Tara), Louise Walker (Fin), Amanda Owen (Swaledale ewe and lambs), David Weir
(Herdwick sheep), Richard Steel wildlife photographer (hare), Annabell and Rodney Armstrong
(Ayrshire cows), and Tigger, Heather, Bo, Rufus, Millie and Aurigney. And how can I forget Dad's words
when he said 'Pick up your pencils', or artist Ian Watson who said that if I practised I might be quite
good one day – thanks.

ARCTURUS

This edition published in 2018 by Arcturus Publishing Limited
26/27 Bickels Yard, 151–153 Bermondsey Street,
London SE1 3HA

Artworks and text copyright © Vivienne Coleman
Design copyright © Arcturus Holdings Limited

ISBN: 978-1-78599-315-2
AD004802UK

Printed in China

Contents

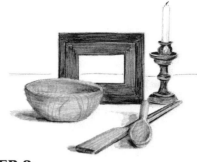

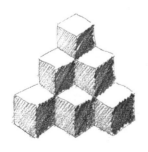

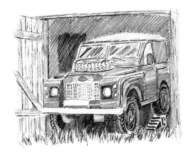

CONTENTS

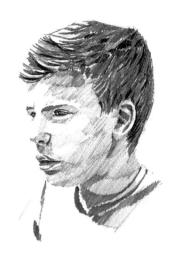

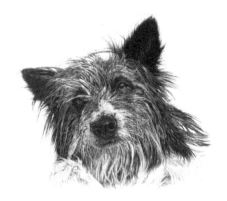

Introduction

If you are a novice artist, you may be wondering whether you will ever possess the skill to match the standard of the drawings you have seen in books, magazines and framed pictures. But drawing is not just about creating fine works of art, it's something you do in everyday life, for example, when you doodle, sketch out directions to a location, draw flow charts or diagrams, plan a new kitchen or design a garden, make simple drawings for a child's amusement – the list is endless. You've probably been drawing for a long time without even realizing it. Yet suddenly, when you consciously try to make a lifelike drawing on paper, the process begins to seem much harder.

Making successful drawings that can be considered as art (rather than sketches with a purely practical purpose) is simply a case of learning to see things differently and looking at what's really there, not just what you *think* is there. You can practise this at any time. Try looking around and momentarily turning off the autopilot in your head – that mind's eye which immediately identifies what you are seeing, based on your memory of having encountered it before.

Next time you look at a building, don't just register a rough shape of walls and a roof – study it more carefully, as if you had to record some of the details. Is the roof flat or sloping? Is it made of slate, tile, stone, or straw? Is there a brick, stone, or concrete chimney and is it plain or decorated? Are the gutters made of metal or plastic? Are they dull or shiny? Are they fixed to the building with ornate metalwork or simple clamps?

You can look at everyday objects in your home in the same way. Windows and doorways are easy to begin with because they tend to be regular square or rectangular shapes. If the frames are painted the same colour, do some parts appear slightly lighter or darker than others depending on whether they are in light or shadow? What about your drinking mugs or cups? Do they have straight or curved sides, plain or ornate handles? Are they shiny or dull? Can you see anything reflected in them?

Once you start to look at objects in this way, you'll see all sorts of features, perhaps for the first time. Obviously, you can't do this all the time or you'd be exhausted! But when you need to draw something, focusing more closely to work out what it really looks like is very helpful.

Of course the next step is to translate what you see on to paper! In the following pages, you'll find plenty of advice and examples of how to make marks with a range of media. You'll discover how to show texture and three-dimensionality in a way that turns your drawings into fully realized, convincing portrayals of the world around you.

We all come to drawing via different paths and at different times and whatever your reason for drawing, I hope you will be inspired. As for me, I am self-taught. I worked and studied in other fields for many years before I started drawing, by accident. I'd moved to a new area, made new friends at an evening class and, following a chance conversation at the end-of-term party, was invited to an occasional informal Saturday morning art group. I discovered I loved drawing and so began a very enjoyable new career!

Vivienne Coleman

Teaching people to draw is teaching people to look.'
David Hockney

Chapter 1
Getting started

In this chapter, we look at the drawing basics, including the materials you need, and at how to make those essential marks on paper. You will learn how to create the strokes, shapes and shades that form the basis of all drawings and see how to combine these elements into simple pictures. The great advantage of this approach is that by practising these strokes, shapes and shades in various combinations you will eventually be able to draw anything you like.

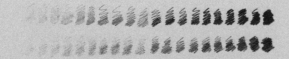

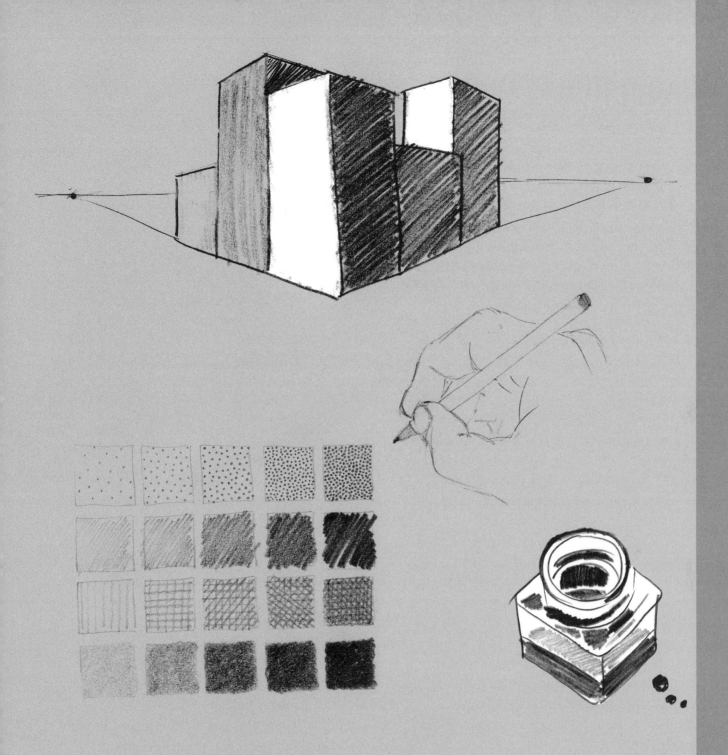

We look at some key drawing techniques, including how to scale your drawing and position it on the page, and how to create the illusion of perspective. If you have drawn before, you may be tempted to speed through the simplest exercises, but remember that practice is never wasted and these building blocks of drawing will always come in useful.

We also consider some advanced shading techniques, such as blending and creating 'white bits' in your drawings. You'll see that most exercises can be completed with a variety of different drawing materials. And you'll be encouraged to experiment to discover your favourite drawing materials as well as your own particular style of working.

Making marks on paper

Drawing is all about making marks on paper, and getting started is straightforward. All you need is an ordinary pencil and a piece of paper and you can begin to make marks straight away – it's as easy as that! You just need to know where to start and stop, how hard to press, and the angle to hold your pencil. You can also make different marks using other drawing materials such as charcoal, solid graphite pencils without a wooden casing and graphite sticks.

The marks you make may be doodles; they may represent objects, scenes or photographs, or even images from your memory or imagination that you'd like to capture on paper. Whatever it is you want to draw, there is no right or wrong way to do it! We are all different, we see the world differently, and so it follows that we'll all draw differently, just as we all have our own unique style of handwriting.

Drawing is the basis of other artistic disciplines, too, such as painting. So, by mastering the pencil essentials, you'll begin to build your other skills.

The following pages look at various drawing materials, and then I'll guide you through some confidence-building techniques for making marks that form the basis of all drawings. We'll also look at different styles of drawing so you'll be inspired to experiment, explore, and develop your own style as you find out what works best for you. Throughout the book, the examples begin with easy, small-scale subjects and progress to more challenging larger-scale subjects, scenes and compositions.

Drawing materials and equipment

You don't need to spend a great deal of money to get started; it's best to begin with a few items then add to your collection as you grow in confidence. Most of the materials I've listed are relatively inexpensive and easy to obtain. They are also very portable.

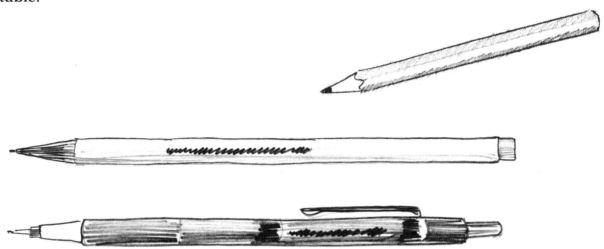

The basic drawing materials are a pencil and paper, a craft knife and/or pencil sharpener, an eraser and something to rest on, such as a drawing board or smooth, stiff card.

Top to bottom: *Graphite pencil, propelling or mechanical pencil and clutch pencil.*

PENCILS

Graphite pencils are the most popular. They are graded from very soft (9B) to very hard leads (9H), with HB in the middle of the range. Harder pencils have more clay content in them. 'H' describes the hardness of the pencil lead, 'B' is for blackness, and 'F' means fine point, originally designed for the precise marks of shorthand. 'HB' means 'hard and black'.

The marks these pencils make appear shiny on the page. Soft-leaded pencils make darker, less well-defined marks and they tend to be more crumbly and wear down more quickly, whereas harder leads produce sharper, finer, paler marks and feel quite scratchy on the paper.

The lead in a propelling or mechanical pencil is not bonded to the outer casing as it is in a graphite pencil and it can be mechanically extended as the point is worn away. These pencils often have refillable leads. The lead in a clutch pencil, also refillable, is operated when the cap is pressed and the jaws open at the tip to allow the lead to extend or retract. Wood-encased graphite pencils will need to be continually sharpened and replaced.

Pencils are so versatile that you can create almost anything with them, using a wide range of pale and dark marks. In the two graded strips shown below, the top one was created with different grades of pencil and the bottom one with a single HB pencil using different pressures on the paper.

Top: *Marks made with graded pencils from 9H to 9B.*

Bottom: *A range of pale and dark marks made with an HB pencil.*

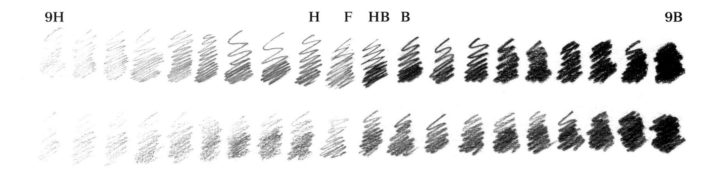

There are many brands of pencil and you'll find that the darkness and lightness of the grades varies slightly between manufacturers. There are even variations within single brands. This could be important if you're working on a large drawing and need to make consistent marks across it.

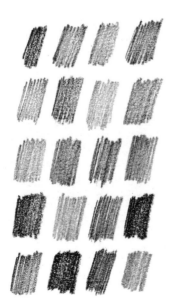

Different HB pencils, applied with the same pressure.

GRAPHITE STICKS

Solid graphite sticks without a casing also come in different grades. They appear duller on the page than pencils and with their wider strokes will cover areas more quickly.

If you're a beginner, a useful range of pencils includes 6B, 4B, 2B, B, HB and 2H grades.

Graphite scribble and stick.

CHARCOAL

Charcoal is much softer (and messier!) than graphite and smudges very easily. It comes in sticks and pencils and makes very dark marks which are ideal for working on large drawings. Charcoal pencils are best sharpened with a craft knife.

Left to right: *Charcoal sticks, charcoal stick scribble, medium and hard charcoal pencil scribbles.*

PEN AND INK

Ink pens include technical drawing pens, biros and calligraphy fountain pens. They are great for sketches and line drawings as they produce clean, crisp sketches. Technical drawing pens with ink cartridges are easier to use than traditional dip pens and you can buy a range of nib sizes to create different line widths.

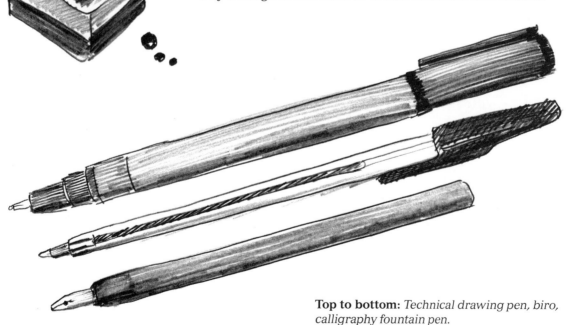

Top to bottom: *Technical drawing pen, biro, calligraphy fountain pen.*

Most of the exercises in this book can be produced using all these different materials so I encourage you to happily experiment!

ERASERS

You'll need an eraser to remove unwanted marks, of course. The most common are plastic and putty erasers. Plastic erasers are versatile and can be cut into slivers for precision work, but they do leave little crumbs of eraser on your paper. Putty erasers leave no detritus and can be moulded to a point, which is great for lifting out areas of pencil.

Clockwise from top: *Sanding block, pencil sharpener and craft knife.*

SHARPENERS

Many artists recommend using a craft knife to create a long, sharp pencil point, but I find a good metal pencil sharpener is perfectly acceptable. A sanding block, or sheet of fine sandpaper, is invaluable for keeping a point on your pencils, which will last much longer if you only sharpen them when the lead has worn right down. To make a block, simply glue or staple a strip of fine-grade sandpaper to a small piece of wood.

RULER

It's great if you can measure and draw straight lines freehand but if, like me, you struggle with this then a clear plastic ruler is ideal, especially one with a finger grip to lift the ruler easily off the paper. A ruler can also help you to size an initial layout, scale a drawing, create lines of perspective and make other accessories such as viewfinders and grids.

BLENDERS

The purpose of blenders is to soften and blur areas of pencil or charcoal to make a smooth transition between adjacent dark and light areas, or to create areas of even shading. Blending stumps are soft, colourless, solid cylinders of tightly rolled paper or felt paper, tapered at one or both ends.

A tortillon (the French name for a blending stump) is hollow, shorter than a blending stump and usually made of rolled paper. You can make your own by tightly rolling a sheet of paper across its diagonal (I start by rolling the paper around a very thin knitting needle or large paper clip), taping the paper to stop it unrolling, then trimming the end(s) to suit.

A burnisher is similar to a blending stump but is made of a harder, colourless material. You create a more polished finish when you rub it over your work.

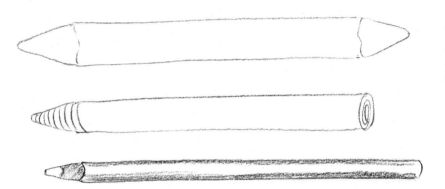

Top to bottom:
Blending stump, tortillon, burnisher.

You can use plenty of other materials to blend your work, such as chamois leather, cotton buds and paper handkerchiefs. Of course, you can always use your finger, but grease from your finger is transferred to the paper, adversely affecting its surface. Blending can look very effective, but it has the disadvantage that it's more difficult to draw on top of a blended surface.

> **TIP**
> It's best to leave any blending until you've almost finished your work, because it's difficult to undo what you've done.

PAPER

Paper comes in various weights (thicknesses), measured in grams per square metre (gsm), or pounds (lb) per ream (500 sheets). Papers range from lightweight, low quality (80gsm/50lb) to heavyweight, good quality (200gsm/120lb). Boards are classified according to their thickness in microns (1,000ths of a millimetre) and the higher the value, the thicker the board.

Heavier, more expensive papers withstand more erasing and working, but I advise starting out with cheaper lightweight papers (for example 110gsm/70lb) which can also be used for sketching and rough work, and saving the more expensive paper for your best work. Cartridge paper is fine for most drawing work.

The texture, or 'tooth', of the paper varies from smooth (for example, Bristol board) to rough (for example, rough watercolour paper) and affects how your marks appear on the page. Your pencil will glide easily over very smooth paper to give even, fine and sharply defined marks, whereas coverage is more uneven on rough-textured paper, which can produce interesting effects.

Paper is available as loose sheets, sketchpads, spiral-bound books and large rolls. You may consider buying a small sketchpad to carry around with you for quick sketches and keeping a larger pad at home for bigger and more detailed works.

Most artists prefer to use acid-free paper because this resists discoloration and disintegration over time, thus conserving the quality of your artwork. However, it's always a good idea to have scrap paper for trying out ideas, for resting greasy or smudged hands on, and for covering parts of larger work as you draw to prevent your drawings getting smudged.

This list of materials is by no means comprehensive, and I would urge you to try as many different materials as you can to discover

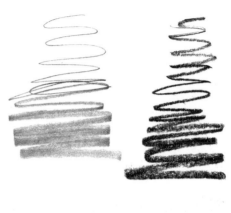

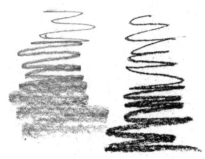

Smooth Bristol board (top) and rough watercolour paper (above).

your personal favourites. You could swap ideas with your friends, join an art group or class, search online, and explore each art shop you go into – the staff are usually very friendly and eager to offer advice. At the end of your experimentation you may find you have only a small set of materials that you are convinced suit you best. When I draw, I prefer a single HB pencil, smooth heavyweight cartridge paper, a plastic eraser, a sanding block, a metal sharpener, and a 30cm (12in) plastic ruler with grip if I need to measure anything. That's it!

> **TIP**
> Before buying expensive paper, remember that most reputable art stores will be happy to supply paper samples, either in the shop or online.

Other accessories

In addition to essentials such as pencils and paper, there are some other straightforward items you might find useful.

FIXATIVE

Charcoal smudges very easily, so when you have finished a drawing you will need to spray it with fixative, available from any art supplies shop. Hairspray will perform the same function, but may discolour your work over time, so for drawings you want to keep long-term it's best to use the correct product.

WET WIPES

Finally, after all your drawing, blending, and sharpening, you'll need something to clean your hands of all that graphite and charcoal dust so that you don't inadvertently spoil your work. Wet wipes are a quick and simple solution and a small lightweight pack is easy to carry around when you are sketching on location. Otherwise, at home, plain soap and water will do.

VIEWFINDER

A viewfinder is useful to help you select what to draw, particularly if you have a vast landscape or complicated subject in front of you. Simply look through the viewfinder aperture and move it around until you find a pleasing aspect. To make one, all you have to do is cut a rectangular-shaped hole in a piece of card or board.

A viewfinder helps you to focus on an area of interest. It can also simplify a complicated subject.

Holding the pencil

Just as there is no right or wrong way to draw, so there is no right or wrong way to hold a pencil; we are all made differently, and have individual levels of ability and joint flexibility. However, there are a few guidelines to help you.

Upright fine point (left); angled blunt point (centre); wide, flat edge of pencil lead (right).

PENCIL POINT AND ANGLE

The way you hold your pencil will affect the marks you make on the page, so you can create different marks simply by altering the angle of your pencil.

Generally, you create very fine marks with a fine pencil point when you hold the pencil upright. It's easier to make fine lines with harder pencils such as 2H and 4H because they retain a sharper point more easily than a softer, crumblier 4B or 6B.

To make wider marks on your page, use a blunter pencil point and hold the pencil at a less upright angle. This way, it's also easier to create increasingly dark marks by applying more pressure on the paper.

If you hold the pencil lead on its side, flat against the page, you can create very wide marks. However, at this angle you cannot use as much pressure because the pencil lead will break more easily.

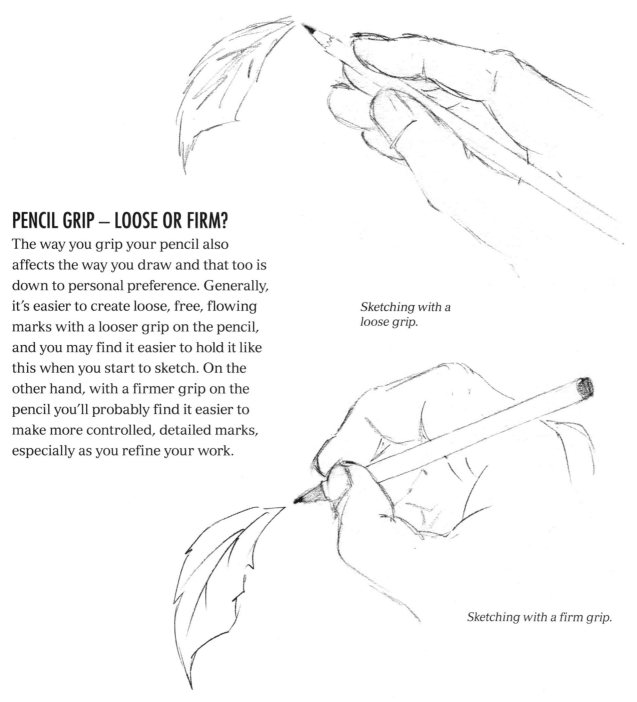

PENCIL GRIP – LOOSE OR FIRM?

The way you grip your pencil also affects the way you draw and that too is down to personal preference. Generally, it's easier to create loose, free, flowing marks with a looser grip on the pencil, and you may find it easier to hold it like this when you start to sketch. On the other hand, with a firmer grip on the pencil you'll probably find it easier to make more controlled, detailed marks, especially as you refine your work.

Sketching with a loose grip.

Sketching with a firm grip.

SIT OR STAND?

Again, it's personal preference as to which you feel is more comfortable, but you may find it easier to produce looser, sketchier works standing at an easel and more controlled, detailed work sitting at a desk or desktop drawing board; your posture will affect how you move your arm and hand and hold your pencil. As for me, I do all my drawing sitting at a desk with my drawing board either flat on the desk or slightly raised at the back with a 7.5cm (3in) thick book.

If you are sketching outside, you may need a lightweight folding stool to sit on, a board or folding easel to work at (or use a sketch pad with a thick backing board), and some clips to secure your paper to stop it blowing away.

Making your mark

Now that you've assembled your drawing materials, we'll make more marks on paper! One of the keys to successful drawing is learning where to make your mark – where to start and stop, that is, the length and direction of your mark. You also need to focus your attention in that moment so your hand and eye are co-ordinated and you can produce exactly the marks you want. This comes with practising the basic drawing elements of **strokes**, **shapes** and **shades**. These elements are the foundations from which we create drawings. As with buildings, the better your foundations, the better your drawings will be.

You'll practise all the basic elements of drawing in the following exercises, so have fun and, above all, relax and enjoy yourself as you draw! There is no need to rush.

· | – \ / l ᒿ J c ɔ ∩ ∪ ෧ *You can see how you already draw these strokes when you write.*

· | ᴛ v l ᒿ j d b n u s e

STROKES

Strokes, or lines, can be long or short, straight or curved, thick or thin. You already know how to make most of these marks because you use them when you write. Here we're simply looking at them in a different way.

The first step is to practise some simple vertical, horizontal, diagonal and curved strokes. Start by making these marks on your paper, using different drawing materials if you wish. Don't worry if they're not perfect – we all make shaky or wobbly marks at first – but persevere and you'll be surprised at how much you'll improve.

Now try drawing these examples, which build on variations of simple strokes. You can even invent some of your own! The idea is to start controlling the length and direction of your marks on the page. Notice how some combinations of strokes unintentionally begin to look like textures.

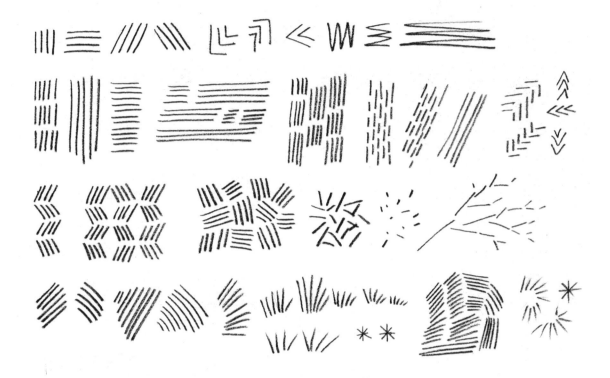

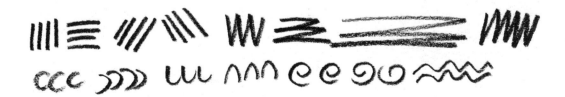

Shapes from strokes

Next, try making some recognizable simple shapes using the strokes you have practised. You'll be surprised at what you can create with just a few strokes!

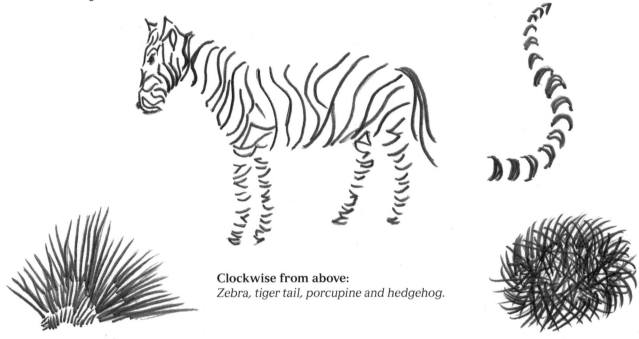

Clockwise from above:
Zebra, tiger tail, porcupine and hedgehog.

You can also create geometric shapes with simple strokes. Try drawing these, adding outlines to two or three of them.

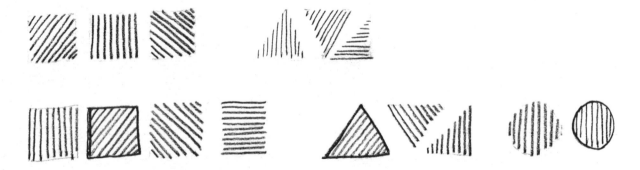

KEY POINT

Notice the difference between shapes with a distinct border around them and those without. In reality, if you look around you, few objects are distinctly outlined. Once you realize this, you'll see that most objects are defined by their contrast with their surroundings.

TIP: If you need an outline as a guide to 'filling-in' shapes, first draw a very faint, almost invisible, line so it won't show in the finished work. Another way is to draw a line then gently erase most of it (see right).

Erase the outline gently.

OUTLINE SHAPES

We make shapes from strokes, including outline shapes such as the triangle, square, circle, and blob – the word I use to describe any irregular shape.

Simple outline shapes: triangle, square, circle, and blob.

Using the same shapes, now have a go at creating all these! Again, the idea is to try to draw consistent shapes and to practise these exercises as often as you can.

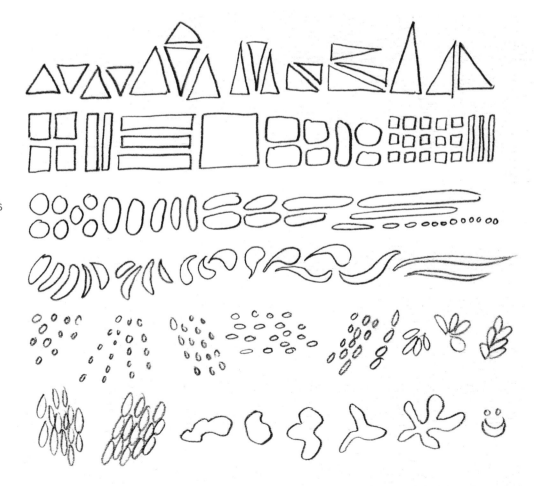

ROUNDED SHAPES

Rounded shapes such as circles and ellipses – flattened circles – can be tricky at first. Ellipses are made of curved strokes and are symmetrical, as each side is mirrored along a central axis.

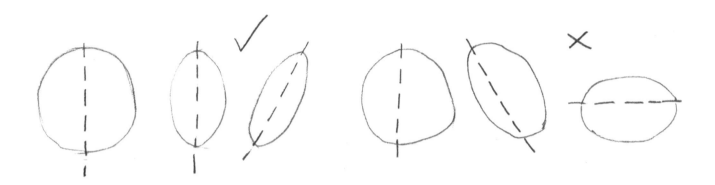

You can draw circular shapes either in a single stroke or as two 'mirrored' halves. Sometimes, a grid can be helpful when drawing circles and ellipses.

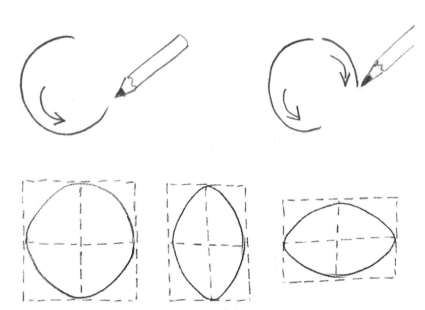

Shapes into pictures

Now that you have practised some simple outline shapes, you can have fun creating pictures from them as well as finding these shapes in your everyday world. This way, you'll start to 'see' things differently, which will help you when you draw.

Try drawing these daisy and cityscape pictures using simple rounded and regular outline shapes.

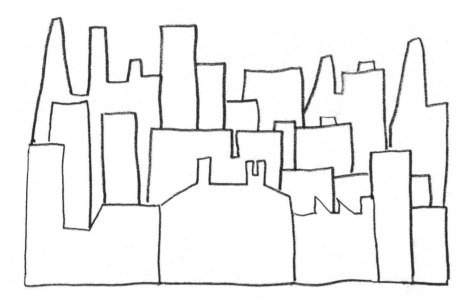

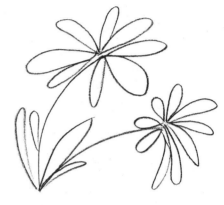

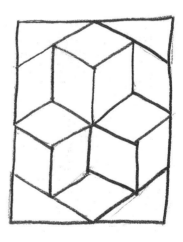

Pictures created from simple outline shapes: Daisies (ellipses), a cityscape (mostly regular rectangular shapes), fish tessellation (irregular curved shapes) and diamonds and triangle tessellation (regular geometric shapes).

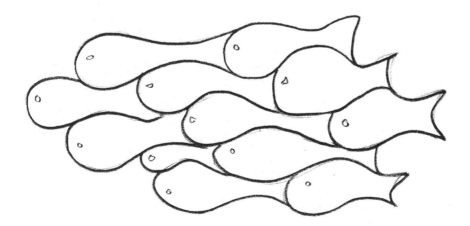

The fish and geometric diamond tessellations are a little more difficult to draw. The Dutch artist M. C. Escher (1898–1972) was a master of creating tessellated images; if you have access to the internet you might like to study some of his work for inspiration.

Composite and enclosed shapes

More shapes to consider are **composite** shapes, made from two or more objects, and **enclosed, trapped** or **negative** shapes, which are the spaces between objects rather than the objects themselves.

Have a go at drawing the following composite and enclosed shapes.

A composite shape: a plant in a pot.

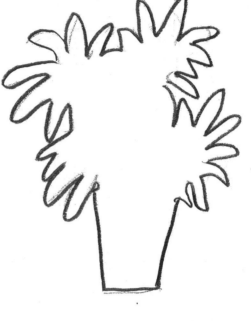

Next, draw these enclosed shapes in a mug handle and a bunch of grapes – the enclosed shapes are illustrated on the right. Can you find more examples in objects around you?

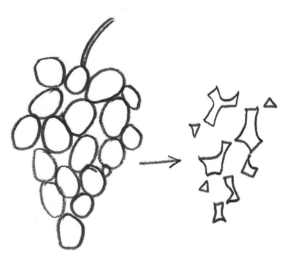

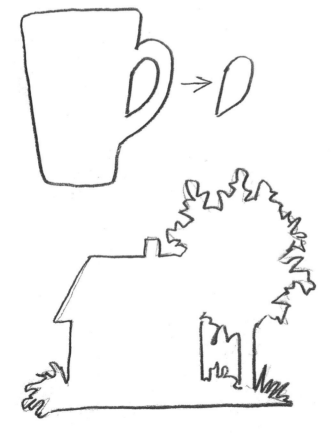

This next example of a house, tree and vegetation has both composite and enclosed shapes and is more difficult to draw.

Shading

The final building block of making marks is shading. Shades, also known as tones or values, simply refer to the relative lightness and darkness of objects as they appear to you.

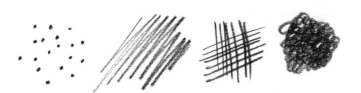

From left to right:
Dots (stippling), sketchy strokes, cross-hatching and small random circular strokes (swirls).

Shades range from very bright to very dark (that is, from white to black). These represent the brightest highlights and darkest shadows you see in any object or scene, and there is a wide range of shades in between. When you are working in graphite pencil, the shades represent lighter and darker colours, too.

There are different ways to draw light and dark shades, including dots (stippling), sketchy strokes, cross-hatching and small random circular strokes (swirls).

GRADUATED AND CONTINUOUS SHADING

The best way to master shading is to practise drawing graduated individual blocks of tone and continuous strips – very simple tonal scales that reduce the multiple shades we see in real life to just a few values. The idea of the exercises is to try different ways of creating tones and to control your pencil to produce the exact depth of tone you want. Later, we'll look in more detail at how you can recognize tones in the subjects you observe and then reproduce these in your drawings.

In this exercise, begin with blocks of 2cm (3/4in) squares and shade a range of

Blocks of five graded tones in individual 2cm (3/4in) squares, shaded from light to dark using different techniques: dots, sketchy strokes, cross-hatching and swirls.

five uniform tones from light to dark. Use either a single HB with variable pressure, or several different grades (for example 2H to 6B). Shade the lightest and darkest tones first, then the remainder in even steps. If need be, use an eraser to help create the lightest tones.

GRADUATING TONES

Dots Create darker shades by increasing the dot density or dot size. This technique takes time but it is ideal for pen and ink or marker pen.

Sketchy strokes A quick and easy method using rapid back-and-forth strokes – a great technique for shading both small or large areas

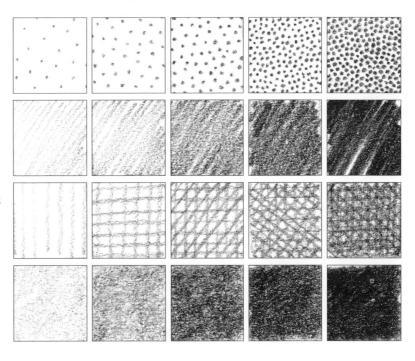

with pencil, graphite or charcoal. Apply more pressure for darker shades. In these exercises, the trick is to shade within the outline!

Cross-hatching Darker tones are created from successive layers of different directional strokes, and/or increasing the density of the strokes themselves. It's a technique you can use with

most drawing media, but it's especially good for pen and ink and marker pen.

Swirls Aim to produce a uniform tone with no distinct pencil strokes or patterns (my examples are not perfect by any means!) For darker tones, use increased pressure or softer-grade pencils.

To create more uniform areas of tone with swirls (left), avoid shading in rows (right), unless this ribbed effect is what you want to create.

For a challenge, draw this block of seven tones with an HB pencil. If you struggle to get a good range of tones, try using more textured paper so your pencil grips the paper tooth more. For in-between tones, experiment with a combination of pencils, for example a harder grade pencil overlaid with a softer grade.

Next, draw some continuous tonal strips. I drew faint outlines of the blocks before filling in with HB pencil. Reward yourself if you complete the graded tones with swirls – it's not easy!

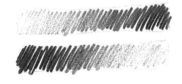 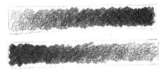

Continuous tonal strips created with sketchy strokes (left) and swirls (right).

A graduated block of seven tones.

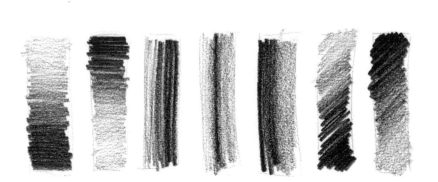 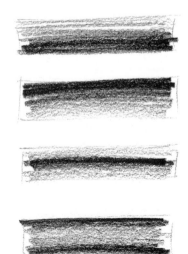

Vertical and horizontal strips of continuous shades.

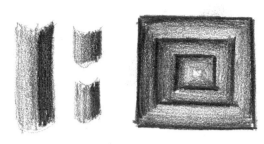

Now have fun with some more shading exercises. You can rotate your page to fill in the blocks at different angles. If you like, make things a bit harder and use no guidelines.

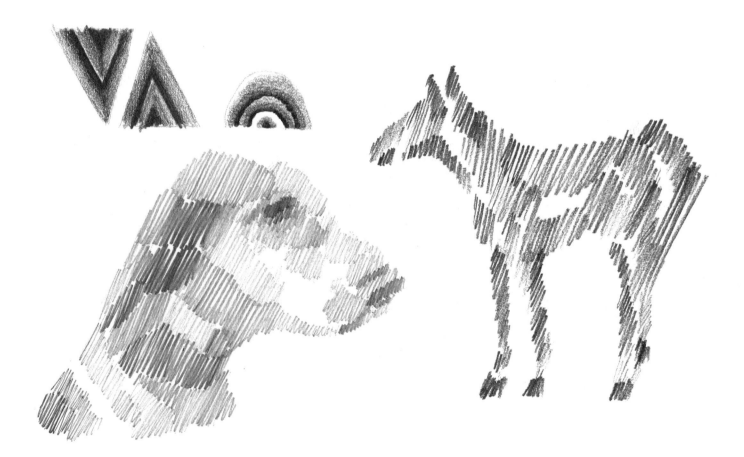

MORE COMPLEX SHAPES AND SHADING

As a beginner, I wasn't aware that I needed to use a greater range of tones in my drawings. Some drawings didn't look quite right but I didn't know why and, looking back, I realize I hadn't used very dark tones. This can make a big difference, and some of my drawings looked a bit pale and flat without them. So, don't be afraid to use a blunter pencil point and press really hard on the page to create those dark, velvety shades!

If you're feeling adventurous, you can even sketch with tones rather than outlines, like I have done with this dog and foal.

I cannot emphasize enough how important it is to practise all these techniques to develop your drawing skills so you will confidently and accurately make the marks you want. Believe it or not, these techniques are used in quick sketches and highly detailed artworks alike.

Strokes, shapes and shades

You've practised mark-making with some basic strokes, shapes and shades; now try putting them all together. Three shades are used here: light, medium and dark (white, grey and black).

Here are a few more combinations of strokes, shapes and shading for you to draw:

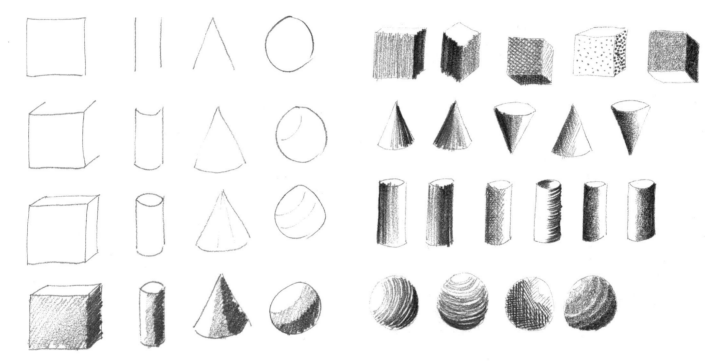

You'll notice that some examples no longer look flat and two-dimensional on the page, but appear more solid and three-dimensional (3-D). Of course, this is an optical illusion as you know the page is flat. However, they appear 'solid' because of the way the shapes are formed and shaded.

BABY BLOCKS STEP BY STEP (facing page)

This next optical illusion of baby blocks is fun to draw and gives you the chance to practise your handling of tone. Begin by drawing a diamond shape, as shown, and work your way through the steps.

KEY POINT
For the best effects when shading, follow the contours of the shape. Look at the directional shading in this pair of shapes and decide which looks more realistic.

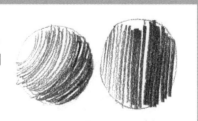

STEP 1

Start with a diamond shape.

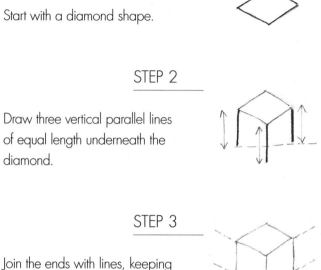

STEP 2

Draw three vertical parallel lines of equal length underneath the diamond.

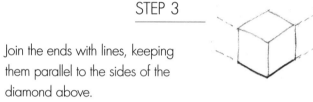

STEP 3

Join the ends with lines, keeping them parallel to the sides of the diamond above.

STEPS 4 & 5

Extend two lines and complete two more diamond shapes, ensuring that the lines are parallel and of equal length.

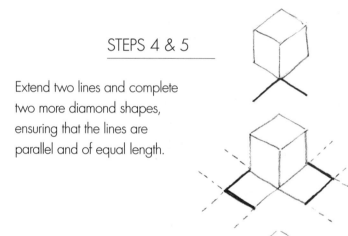

STEP 6

Draw five vertical lines of equal length.

STEP 7

Join the ends, keeping lines parallel.

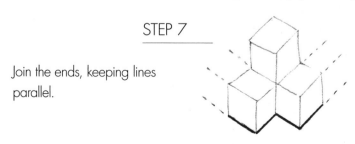

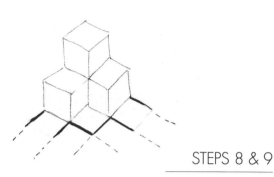

STEPS 8 & 9

Draw three more diamond shapes.

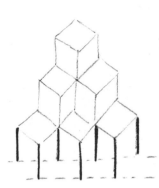

STEP 10

Draw seven vertical lines.

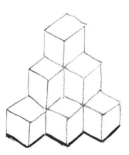

STEP 11

Join the ends to complete the bottom layer.

STEP 12

Finally, shade in as you wish.

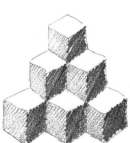

DRAWING A FENCE STEP BY STEP

Now that you've practised making basic marks, try this sketch of a fence that uses only the simple strokes, shapes and shades shown below.

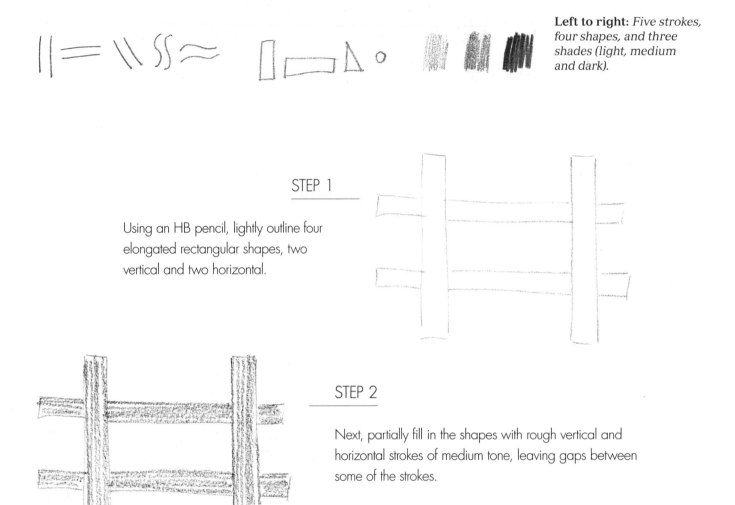

Left to right: *Five strokes, four shapes, and three shades (light, medium and dark).*

STEP 1

Using an HB pencil, lightly outline four elongated rectangular shapes, two vertical and two horizontal.

STEP 2

Next, partially fill in the shapes with rough vertical and horizontal strokes of medium tone, leaving gaps between some of the strokes.

STEP 3

Then, in a dark tone, add four vertical and six horizontal lines on the right-hand and lower edges of the shapes respectively.

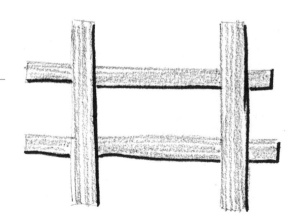

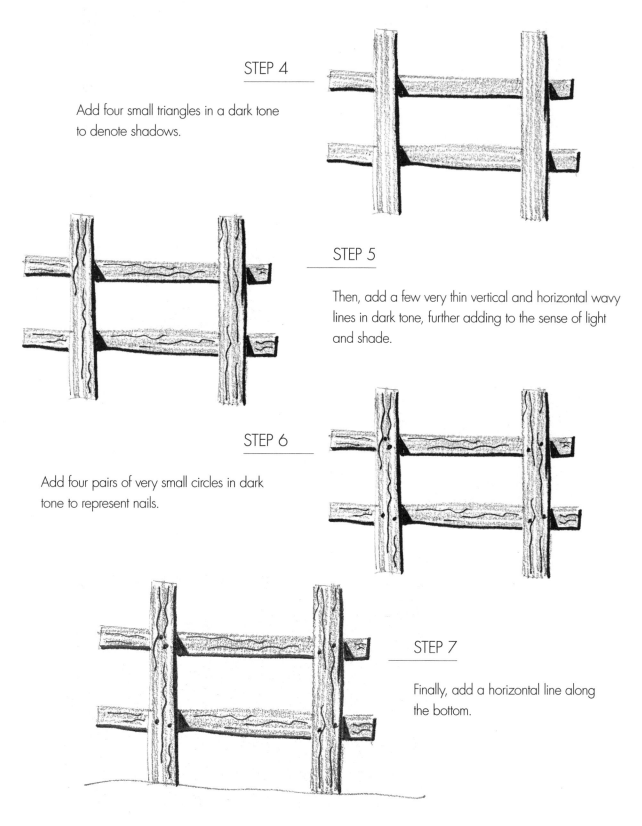

STEP 4

Add four small triangles in a dark tone to denote shadows.

STEP 5

Then, add a few very thin vertical and horizontal wavy lines in dark tone, further adding to the sense of light and shade.

STEP 6

Add four pairs of very small circles in dark tone to represent nails.

STEP 7

Finally, add a horizontal line along the bottom.

From this step-by-step exercise you can see how easy it is to create an effective sketch with a few simple marks. You'll also have noticed that combining strokes, shapes and shades has created a texture that gives the illusion of wood. We'll explore textures in more detail in Chapter 2.

Advanced shading techniques

BLENDING

Blending is a method of creating a smooth transition between adjacent tones and you will need to employ it often. Techniques include **swirling** and **smudging**.

To blend using swirls, make small, circular random strokes to create graduated tones from dark to light (or vice versa) across the dark/light tonal boundary. Use either a single pencil and different pressures, or different grades of pencil.

For smudging, use a blending stump, burnisher or tortillon for more controlled effects. To soften broader areas, other materials include a tissue, cotton bud, chamois leather or finger!

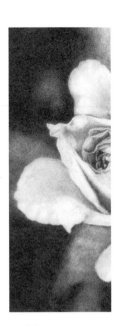

Use blending to soften outlines and create out-of-focus background effects; merge areas of adjacent, contrasting tones; and create very soft and fine textures such as petals or skin.

*Blending with a tortillon (**left**), tissue (**centre**) and finger (**right**).*

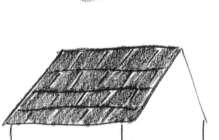
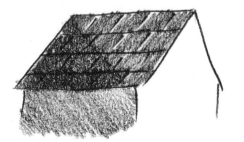

KEY POINT
Remember that your first marks on the paper will nearly always show through! Outlines are usually best drawn very faintly to avoid them being visible in the finished work. However, you can use this 'layering' effect to your advantage. In this drawing of roof tiles (left), even after a layer of darker-toned shadows on top is added you can still see the features underneath.

WHITE BITS

'White bits' are the brightest highlights, fine white lines and other white areas in a drawing. When shading, you may be wondering how to achieve the 'white bits' amid the darker tones. Methods of doing this include erasing, masking and drawing around.

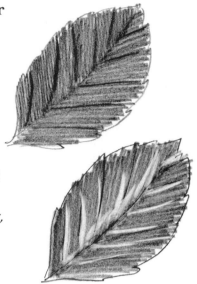

Erasing

You can use fine slivers of plastic eraser to remove strips of tone and create highlights. This technique is best with smooth, heavyweight papers where the eraser leaves cleaner, sharper marks. Alternatively, use a piece of a putty or kneadable eraser to lift out areas of tone, shaping the eraser according to the size you want.

 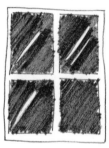

Masking

A mask gives more precise results. It's best to use heavyweight paper or overhead transparency film for this. Cut out the shape you want to reserve, then erase through the cut-out to reveal sharp-edged white bits underneath.

Drawing around

Simply outline the desired 'white bits' and very carefully shade around the outlines.

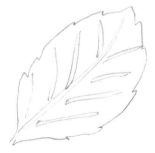 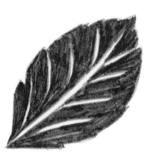

Indenting

Use a paper clip or similar rounded blunt object to make a shallow groove in the paper. When you shade your pencil will skip over the groove, leaving the 'white bits'. This method works best on heavyweight paper.

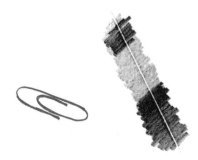

How to capture an image

Once you've chosen a subject to draw, the next step is to decide how you'll capture that image. It's a personal choice, but sometimes circumstances will dictate which method to use.

WORKING FROM LIFE

Sketching a subject from life is an obvious choice, whether that's indoors or *en plein air* (French for 'in the open air'). The advantage is that you have the essence and energy of the subject in front of you and you can capture that 'live' moment. However, a person or animal could move before you have finished your drawing and if you are outdoors, the weather and lighting conditions may change.

TAKING A PHOTOGRAPH

Whether you are using a proper camera or a cameraphone, taking a photograph is a good way to instantly capture subjects and record all the details to draw later at your leisure. Light and movement in the scene remain unchanged however long you take to draw. Be aware, though, that wide-angle and telephoto lenses will cause more optical distortions in your photograph than ordinary camera lenses.

Achieving the correct proportions

Once you've selected and captured your subject, the next hurdle is achieving the correct proportions on paper! You may be blessed with the ability to sketch a perfectly proportioned subject freehand every time. If, like the rest of us, you struggle, here are a few techniques to help.

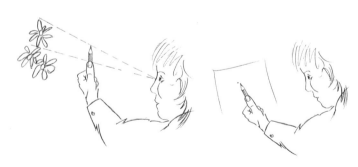

RULE OF THUMB

When drawing from life, you can use your pencil to measure subject dimensions. Hold your pencil vertically (or horizontally depending on the measurement), arm straight, one eye closed, and look with the other eye along your arm and line of sight to your subject. Use the pencil tip as one end of the measurement and your thumb as the other. Then, mark the measurements on your page, pencil tip first then another mark for the length to your thumb. Keep your arm extended for all measurements so that the subject retains its proportions. You can also use dividers or string to measure lengths as an alternative to pencil.

USING A GRID

Grids for measuring dimensions and scaling are usually used with photographs, but the grid can also be used as a viewfinder to estimate proportions (see p.17).

Scaling a drawing using a grid

In this example, I wanted to draw the subject double the size in the photograph. I used a 1cm (1/2in) grid printed onto a clear sheet taped securely over the photograph. Next, in faint lines I could erase later, I drew a grid of 2cm (1in) squares on the paper (that is, twice the size of the grid on the clear sheet). Finally, I drew the details from the photograph onto my page, a square at a time.

Notice that the grid squares are labelled with numbers and letters along the bottom and side, like map co-ordinates, to help me to identify each square.

Three methods of making a grid

(1) Print a grid of squares onto a clear sheet. To do this, I used my computer and created a 'table' of 1cm (1/2in) cells in word processing software, then printed this onto a sheet of OHP photocopy/ printer transparency.

(2) Draw a grid carefully in a fine permanent marker pen onto a clear, thin plastic sheet, remembering to label the squares along the edges.

(3) Make a viewfinder, then tape or glue a lattice grid of thin threads over the aperture.

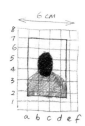
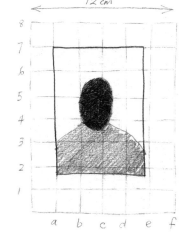

TRACING

If you want to use an existing photograph or image, tracing it is a quick way to transfer it to a drawing. You can use tracing paper or a light box

or hold the image and drawing paper against a back-lit window. Tracing is useful if you want to quickly outline a subject, make multiple copies of an image, or ensure the proportions are correct.

A light box is a flat box with an electric light bulb inside the box for illumination. The top surface of the box is made of opaque glass or plastic.

PROJECTION

For larger works, you can project your image onto your drawing surface, for example, paper affixed to a wall. You can then trace around the projected image.

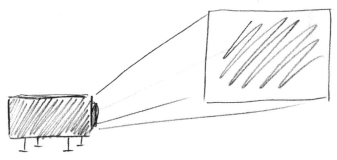

A variation of this is the 'camera obscura', meaning 'darkened room' in Latin. The device consists of a box with a hole in one side. Light from an external scene passes through the hole and strikes a surface inside, where it is reproduced, inverted (thus upside-down), but with colour and perspective preserved. The image can be projected onto paper, and can then be traced to produce a highly accurate representation. Not all artists favour copying or tracing methods but it's thought that famous artists like Leonardo da Vinci and Michelangelo may have used optics and lenses to create their masterpieces.

Time, size and positioning

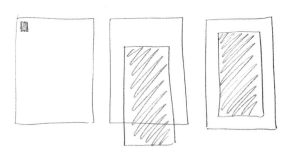

Before you start, think about the size of your planned drawing and the amount of time you have in which to complete it. There's no point in attempting a huge, detailed work if you have only half an hour to spare.

There will be occasions when you haven't allowed sufficient room on the paper for your subject. This happens to experienced artists, too! It's best to estimate roughly the size of your planned work so that you can be sure it will fit comfortably on the paper. Position your drawing in the centre of your page, not squeezed into one corner, ensuring that it's not so large or so far over to one side of the page that you run out of room.

Try to avoid squeezing your drawing into a small corner of your page (left) or running out of room on the paper (centre). Position your drawing in the centre of the page (right).

Achieving the correct proportions is linked to the idea of perspective, particularly where you have similar subjects, such as buildings or trees, in both the foreground and the distance.

Getting things into perspective

There are two main types of perspective: aerial (or atmospheric) perspective and linear perspective. We will look at aerial perspective in the next chapter (see p.51) and again when we take our drawing outdoors (see p.108), but for now we will concentrate on how to draw linear perspective.

Linear perspective allows you to create the illusion of depth in your work. We've seen how to create the illusion of a simple three-dimensional object using a few tones but, with perspective drawing, you can define objects and scenes on two-dimensional paper which in reality are arranged in three-dimensional space.

You'll notice from your observations that an object seems to get smaller as it recedes into the distance, until it appears to vanish. In drawing, this distant point is called a vanishing point and it lies somewhere on the horizon where the earth meets the sky. The horizon can often be your eye level, too. Linear perspective uses the vanishing point on the horizon to create three-dimensional visual effects. There are three types of vanishing-point perspective, namely one-, two-, and three-point.

ONE-POINT PERSPECTIVE: STEP BY STEP
Imagine you are standing in the middle of a railway track lined with telegraph poles, on a flat, featureless plain. The track lies dead straight in front of you and recedes to a point in the distance. You know intuitively that in reality the tracks and poles are the same distance apart, but they appear to get closer together; this is the illusion of perspective.

This exercise shows you how to create the illusion of depth by depicting objects receding into the distance. It uses simple horizontal, vertical and diagonal lines, so you may want to use your ruler.

STEP 1

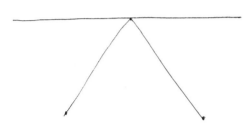

First draw a horizontal line (the horizon line) and mark a dot in the middle of it. This dot is the vanishing point (VP). Then make two dots below the horizon line and draw two diagonal lines to link these dots to the VP. These are the railway tracks.

STEP 2

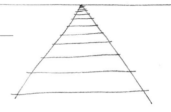

Next, draw short horizontal lines across the tracks so they get progressively narrower and closer together as they approach the VP. These are the railway sleepers.

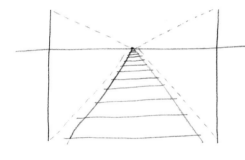

STEP 3

Now draw a vertical line on either side of the tracks with the tops extending to just above the horizon line. These are telegraph poles. Then, draw faint guidelines from the tops of the poles to the VP.

STEP 4

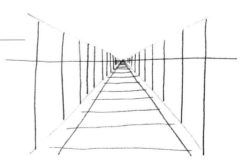

Next, draw more vertical lines, ensuring they become shorter and closer together as they approach the VP.

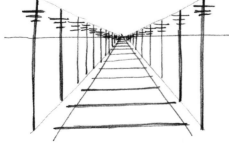

STEP 5

Draw short horizontal strokes at the top of each pole, then erase unwanted lines. If you wish to add more realism, draw the nearest sleepers and poles in thicker strokes and darker shades. Add shadows, if you like.

BOXES IN PERSPECTIVE: STEP BY STEP

STEP 1

First, make a dot in the middle of your page, then draw eight square shapes aligned in a square around the central dot (the dot is the VP and effectively your eye level).

STEP 2

Next, draw faint guidelines from the corners of the eight squares to the central dot, as shown. These are the lines of perspective.

STEP 3

Between the guidelines, draw short horizontal and vertical lines to give your 'squares' the appearance of depth.

STEP 4

Now complete the box shapes by drawing in the remaining 'sides' along the guidelines).

STEP 5

Finally, erase unwanted sections of the guidelines. Add more short vertical lines to some of the boxes to give the illusion of an open side. Shade the boxes as you wish.

KEY POINT

The ends of the boxes (facing you and on the opposite end) comprise vertical and horizontal lines only. The only diagonal lines are the perspective lines along the sides of the boxes.

TWO-POINT PERSPECTIVE: STEP BY STEP

If the structure you are drawing is not directly facing you, two-point perspective is needed. This uses two vanishing points on the horizon line.

In this example, we'll create the visual effect of viewing a street corner. Notice that when you overlap near and distant objects this helps to improve the impression of depth.

STEP 1

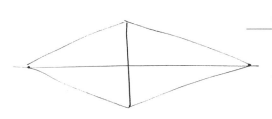

First, draw a horizon line and add two marks some distance apart. These are the two vanishing points. In the centre, draw a vertical line above and below the horizon line. This line represents the corner of a building. Draw faint diagonal guide lines from the ends of the vertical line to the two VPs on the horizon.

STEP 2

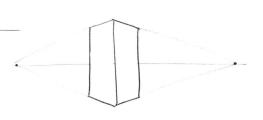

Next, draw two vertical lines between the lines of perspective to denote the width/depth of the building, then draw along the required section of the guidelines to complete your building shape. Erase the unwanted section of the horizon line (your building is not transparent!)

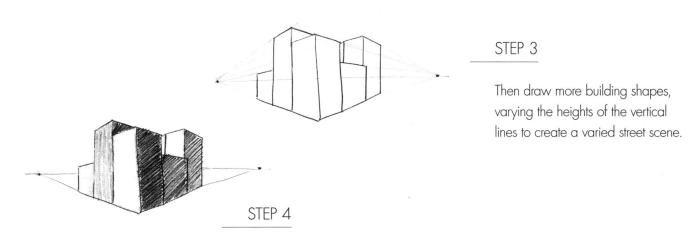

STEP 3

Then draw more building shapes, varying the heights of the vertical lines to create a varied street scene.

STEP 4

To finish, erase unwanted lines and use different tones to denote areas of light and shadow.

It can be difficult sometimes to find the horizon line and vanishing point in your scene of interest. If so, look for clues that will help you draw your lines of perspective, for example the edges of regular-shaped objects, or the lines of gutters, windows, doors and roofs on buildings.

THREE-POINT PERSPECTIVE: STEP BY STEP

Unsurprisingly, this type of perspective has three points! The third line of perspective is not on the horizon but extends vertically. You can observe this when gazing up at a tall church spire or skyscraper, or looking down into a very deep hole in the ground – you'll notice that the sides appear to bend inwards.

This exercise is more challenging to complete, but very satisfying. Note that there are no horizontal lines.

STEP 1

Start by drawing three points on your page, arranged in a triangular shape. These are the three VPs. Then, draw a long vertical line in the middle of your page to the height of the first storey of our imaginary building. Here, the vertical line is extended below the level of the bottom two VPs.

STEP 2

Next, draw faint lines of perspective to join the vertical line ends to the two bottom VPs. Then, mark the width and depth of your building as points on the two lines of perspective at the base of the building.

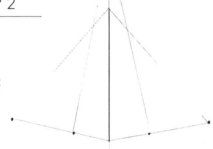

STEP 3

Then, from these two base points, draw the sides of the first storey upwards towards the top VP. Next, complete the top and bottom sides of the storey by drawing along the lines of perspective towards the bottom VPs. To add a second, smaller, storey, mark the desired position of the nearest bottom corner of the storey on the perspective line along the top of the first storey. Draw points on the perspective lines on the top sides of the building to denote the width and depth of the second storey, then extend faint perspective lines from these new points to the top VP. Next, mark the desired height of this storey and extend perspective lines towards the bottom VPs.

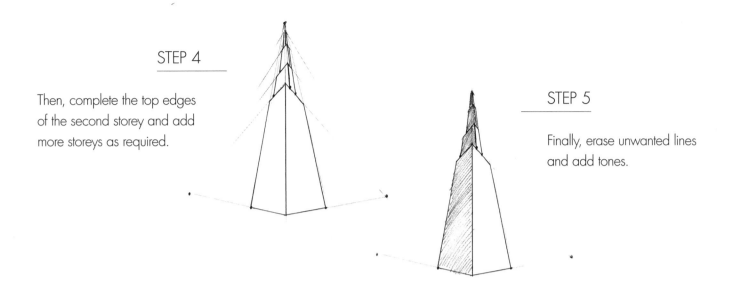

STEP 4

Then, complete the top edges of the second storey and add more storeys as required.

STEP 5

Finally, erase unwanted lines and add tones.

Here are two more examples of three-point perspective.

This is a tower viewed from above. Note the narrowing at the base of the tower.

Baby blocks appear very tall and distorted when viewed in this perspective.

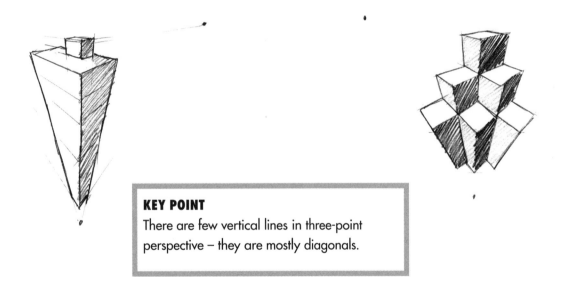

KEY POINT
There are few vertical lines in three-point perspective – they are mostly diagonals.

FORESHORTENING

Foreshortening differs from linear perspective in that foreshortening is a visual effect that causes an object to appear shorter than it actually is (and scale-distorted) because it's angled towards the viewer. Notice how the same-sized object (on the far left) appears disproportionately shorter when angled towards the viewer compared with the same-sized object on the far right, which is partially viewed from the side.

Fun with visual effects

You can create all sorts of optical illusions with perspective. Here are some examples for you to try.

MOBIUS STRIP STEP BY STEP

This is made from a single strip of paper that has one surface only. If you walked along its surface, you would never reach the end!

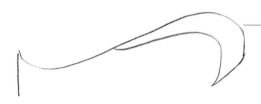

STEP 1

First, sketch a horizontal S-shaped curve and add a short vertical stroke on the left end and a diagonal stroke on the right. Add a second smaller curve, starting halfway along the first curve, and join it to the short diagonal on the right.

STEP 2

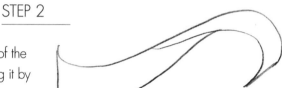

Now add a third curved stroke, starting from the base of the vertical line, and join it to the second curve, overlapping it by about a third.

STEP 3

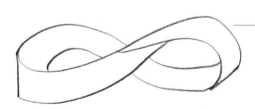

Next, add a fourth curved stroke from the top of the vertical line and then a fifth, smaller curve underneath, joined to the first curve. Draw two final slightly curved strokes on the right.

STEP 4

Finally, add tones to denote shadows and create a more three-dimensional effect.

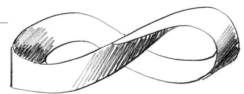

MOBIUS TRIANGLE

This strip also has a single surface. The artist M. C. Escher used this type of illusion in his work.

The Mobius triangle is an intriguing optical illusion. It is created from three sets of four parallel lines of different lengths.

 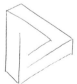 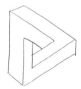 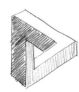

ANAMORPHIC DRAWING

This final three-dimensional illusion is not quite an anamorphic drawing (a very distorted drawing that looks natural under a certain viewing condition/ angle) but it is easier to draw.

STEP 1

Begin by drawing around your hand on a sheet of paper.

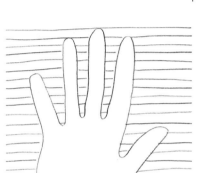

STEP 2

Then, draw evenly spaced horizontal lines across the page, leaving the hand area blank.

STEP 3

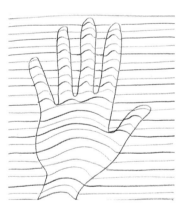

Draw curved strokes across the hand to join up the horizontal lines.

STEP 4

Finally, add shading to create a three-dimensional effect.

By now you'll be feeling quite an expert at making marks on paper! You'll also have noticed that when we combined different strokes, shapes and shades we started to create textures, for example, the illusion of wood in the fence exercise (p.32). The next chapter will build on the elements we've covered so far and explore textures in greater detail.

Exploring shading and textures

Some of your drawings will require you to portray clearly distinguishable elements or realistic features. For this, you'll need to know how to create convincing textures.

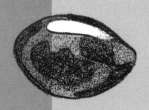

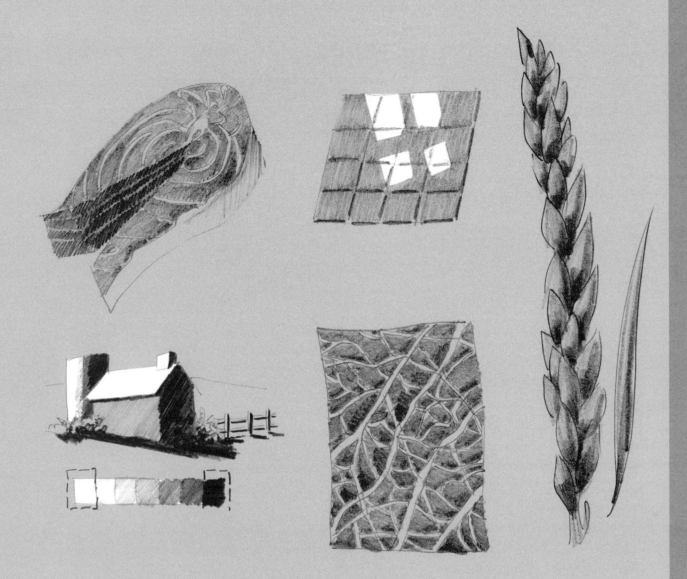

This chapter shows you how to create a wonderful range of textures in detail, from simple woodgrains to more complex fabric patterns and fur, so that you'll be able to describe almost anything visually.

The examples are designed to be easy and quick to draw. You can work through the step-by-step exercises or simply use them as a reference for the subjects later in the book, or for your own work. They give you just a flavour of how to create different textures, as there is not the space to consider complete subjects at this level of detail. You will have the opportunity to sketch larger works in the forthcoming chapters.

The exercises use the strokes, shapes and shades you've already practised and begin with easily manageable subjects that quickly build your confidence, using samples from familiar objects. But before we start drawing our textures, we need to consider the importance of light! If there's no light at all we can't see a thing; but when we do have light (whether it's from the sun or a light-bulb), our subjects become visible. We can then begin to understand how light produces all the bright and dark tones in the textured subjects we are looking at.

Different ways to use tones

The use of simple black, white and grey values to denote bright and dark tones (light and shade) can transform our drawings and bring them to life. We'll consider three ways to use these tones: to create the illusion of three-dimensional objects, to create depth and to show texture.

SHADING AND THREE-DIMENSIONAL OBJECTS

We saw in earlier exercises like the baby blocks (see p.31) that a combination of plain light and dark tones creates the illusion of three-dimensional objects – that is, the objects appear to have volume, or solid form, because of the particular way they are shaded.

It is the source or direction of light that determines which areas have dark or bright tones. We use lighter tones to denote brighter areas in direct light (or no shading at all to denote highlights) and darker tones for areas in shade. Of course, when the direction of light moves, the tones on objects reflect that.

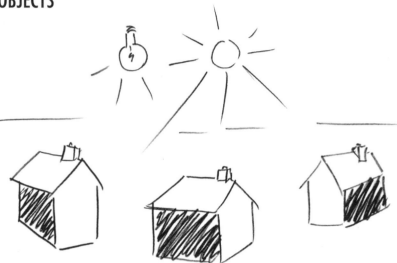

Areas in direct light are brighter (lightest tones) and areas in shade (darkest tones) are always on the opposite side of the light source.

Tonal key and tonal contrast
The terms tonal key and tonal contrast describe the different mood effects we create when we vary the range of tones to simulate different lighting conditions. Tonal key is the overall 'tone' of a drawing and creates a sense of atmosphere.

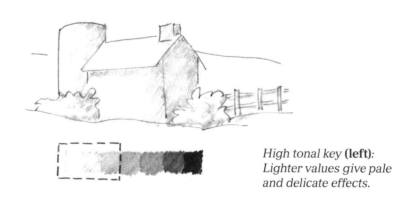

High tonal key (left): Lighter values give pale and delicate effects.

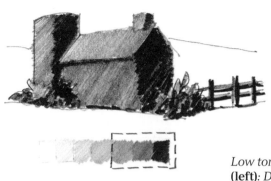

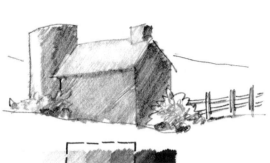

Low tonal key **(left)**: *Darker values overall convey drama.*

Middle key **(left)**: *Mid-range tones or a complete range of tones convey calm and tranquillity.*

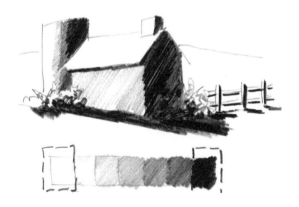

Tonal contrast is the difference between light and dark areas in a picture. The greater the difference (contrast) between light and dark tones, the more striking the effect will be and the more you're drawn to look at these areas. Lighter tones also look more pronounced when they appear next to very dark tones.

Sometimes tonal contrast and tonal key can mean the same thing – for example, a low tonal contrast of adjacent pale values is the same as a high tonal key.

High tonal contrast **(above)**: *Tones from extreme ends of the scale give sharp contrast and dramatic effect, for example brilliant sunlight and dark shadows on a clear, sunny day.*

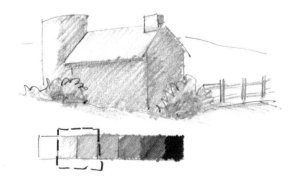

Low tonal contrast **(left)**: *A narrow range of shades from anywhere on the tonal scale give a muted effect, for example on a cloudy or misty day where everything appears duller and softer.*

Shadows

The brighter the light source, the darker the shadows will be (high tonal contrast) whereas in duller lighting conditions shadows become much less distinct (low tonal contrast).

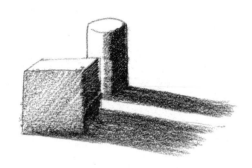

The length of shadow cast by an object depends on the elevation of the light source. At low elevations the cast shadows are much longer, for example, as seen with a setting sun or a low-level lamp.

Tonal simplification

This term describes the reduction of the number of tones to create a simple tonal picture. The more you practise this, the easier it is to recognize the tones in a subject. You might also use this technique when making preparatory sketches for a drawing or painting.

Try closing one eye, or half-closing both eyes, to see the lightest and darkest tones more easily.

Then, it's a case of choosing how many tones to use in between.

If you find it hard to distinguish tones, take photographs with a digital camera and view them in black and white without the distraction of colour. However, be aware that converted images can sometimes lack tonal range and appear washed out because colour hues are lost.

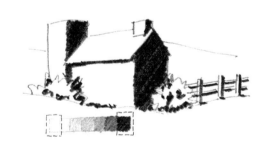

Using two shades

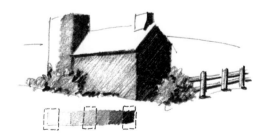

Using three shades

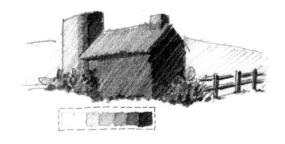

Using all shades

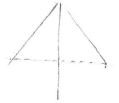 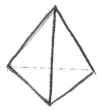 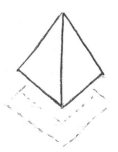 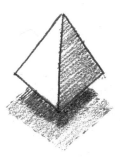

This pyramid, shaded in a few simple tones, is hovering so you get the chance to indicate the shadow beneath it. Notice the direction of shading on the pyramid side which gives the illusion of solid object with a steeply-stepped surface.

Shading a pyramid

Here's a chance for you to test your shading skills by sketching this three-dimensional pyramid.

> **TIP**
> A good method to observe tones on illuminated surfaces is to use a lamp and some plain white objects like a box, cone or ball. You begin to see what's there, not what you think is there.

SHADING AND DEPTH

You can also use tones to create the illusion of depth in a picture. Generally, the darkest tones are in the foreground and fade to the lightest tones in the distance, as illustrated here. This effect is known as 'aerial' or 'atmospheric' perspective. In this example, the shapes resemble hills and the darker ones appear to be closer than the lightest.

Overlapping shapes and graduated shading create the illusion of depth: dots, sketchy, cross-hatched and swirls.

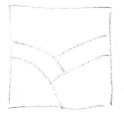 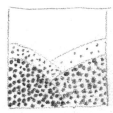 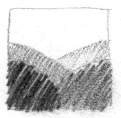 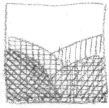 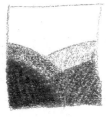

SHADING AND TEXTURE

Whether you're sketching or drawing, textures are a fundamental part of your work. Creating texture usually involves more complex marks than shading. Whatever the subject, you'll use textures to distinguish different features and to translate your ideas successfully on to paper. Strokes and shapes provide an essential framework, but the addition of a texture layer gives structure, context and individuality.

Texture is defined as the appearance of a surface. Here that could be an object, substance, or scene before us which we are attempting to capture on paper. The appearance of that 'surface' is simply a mixture of tones arranged in a particular way to describe something smooth, rough, shiny or matte. Understanding the nature of textures and how to create them using various marks will transform your work.

What makes a texture visible?

We see texture when sunlight (or light from a light-bulb) hits a surface and bounces back to our eyes. The way the light bounces varies according to the surface type.

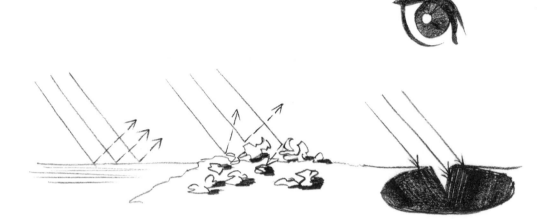

Left to right: *Smooth surface; rough, uneven surface; non-reflective surface.*

Smooth, shiny surface

More light bounces off smoother, shinier surfaces, thus they look brighter (lighter-toned) because more light reaches our eyes. Surface tones appear sharper (hard edges), more even, with more highlights (for example, a mirror, polished steel, glass).

Rough, uneven surface

Less light reaches us after hitting rougher, uneven surfaces because light bounces in different directions or is not reflected. Surfaces appear less bright (mixed tones), with softer edges and uneven tones (for example, rusty metal, tree bark, wool, earth).

Non-reflective surface

Surfaces that reflect little or no light appear very dark-toned because little or no light bounces off them (for example, matte black surfaces such as those of stealth bombers).

Working out the tones

At one end of the scale there are dazzling, shiny surfaces, such as sun glinting on water, when light bounces straight back to us; we see this as the lightest tone (plain white). At the other end of the

scale there are dark, matte surfaces which we see as the darkest tone (black) because there is no light reflected off them. In between are myriad mixed surfaces where light bounces off in different directions so we see different mixes of tones (lights and darks), that is, different textures.

Unless we are in a completely flat and featureless desert, we are generally surrounded by a rich variety of textured objects and landscapes. The trick is to work out what the dominant textures are and to translate these into simpler black/white/grey tonal arrangements on paper.

If you're not sure how to identify textures, start by asking yourself if the surface is shiny or matte, rough or smooth, and if it has a single tone or mix of tones; then you can work out which tones are dominant and how they are arranged.

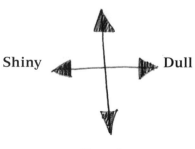

Texture and scale

The appearance of surface textures also changes with scale, depending upon whether the same subject is viewed close up or from a distance. You'll obviously see much more detail at close quarters, so you'll need to draw the same subject in different textures.

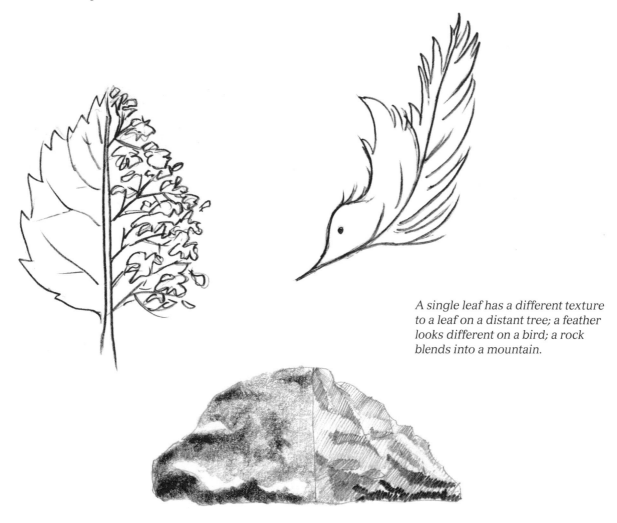

A single leaf has a different texture to a leaf on a distant tree; a feather looks different on a bird; a rock blends into a mountain.

As we go through the book and look at progressively larger subjects, we'll explore these other textures. The techniques for creating the marks are no different – we'll just be using the light and dark marks in different combinations and contexts, and building our drawings in the same way that we built simple objects from strokes, shapes and shades.

Creating textures

The following pages show you in detail how to create a variety of textures step by step. You can choose whether to work your way methodically through the exercises, browse them, or simply use them for reference. Cartridge paper was used for almost all the examples.

WOOD TEXTURES

Wood is a common construction material so you won't have difficulty finding the real thing to draw. Its textures range from matte and rough (bark) and matte and smooth (planed timber) to shiny and smooth (polished wood).

Some of the easiest textures you can draw are found in wood. Use sketchy strokes and swirls, following the direction of the woodgrain. I used HB pencil for most of these examples; pen and ink can also be very effective, though it is more time-consuming.

The textures of wood are mostly in a mid-tonal key with low tonal contrast. This texture can be used for many other surfaces too.

Smooth wood surface (HB pencil)

STEP 1

Draw two vertical strokes.

STEP 2

Then add vertical strokes in a uniform medium tone, leaving gaps between a few strokes.

STEP 3

Finally, add four slightly darker vertical strokes to suggest woodgrain.

Rough wood (HB pencil)

STEP 1

Draw two vertical strokes.

STEP 2

Next, add fairly thick vertical strokes in a medium tone, leaving gaps between some strokes.

STEP 3

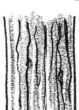

Lastly, add several thin wavy vertical strokes in a dark tone to emphasize the grain.

Bark (HB pencil)

STEP 1

After making two vertical strokes as before, start by drawing vertical jagged zigzag strokes.

STEP 2

Roughly thicken the zigzags in very dark tone.

STEP 3

Shade one side of the zigzag lines in medium tone and leave the other side blank.

Sawn timber (HB pencil)

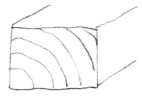

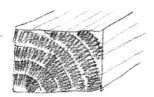

STEP 1

First, draw a rectangle containing six concentric curved strokes; then add three diagonal lines to the top and side of the rectangle.

STEP 2

Next, sketch short, closely spaced zigzag strokes in light/medium tones along one side of each curved line, leaving the other side of the curved line blank so there's a gap between each curve. On the top surface and side, where the concentric curves touch the cut edge, add a few parallel lines.

STEP 3

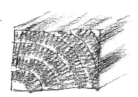

Now shade parallel bands of light tone along the top surface, with gaps between the bands. Add similar parallel bands on the side, but sketch them in a darker tone.

STEP 4

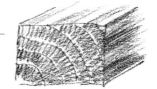

Finally, fill the side in a very light tone.

Knotted wood (HB pencil)

STEP 1

Draw two vertical lines and an ellipse shape in a dark tone.

STEP 3

Next, darken short sections of some of the wavy strokes and add dark strokes inside the ellipse.

STEP 2

Add several wavy strokes in a medium tone, bunched in the middle around the ellipse.

STEP 4

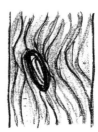

Finally, lightly overshade in wavy vertical strokes in light/medium tone.

Woodgrain detail (Pen and ink)

Draw a selection of wavy vertical strokes and squashed elliptical shapes to create this woodgrain effect. Pen and ink, shown here, or biro are ideal, but you can also use other media depending on the size of your work.

METAL TEXTURES

Metal textures range from shiny and smooth (polished metal) to matte and smooth (cast iron) and matte and rough (rusty metal). The texture is fairly easy to create using sketchy strokes and swirls and by following the direction of any grain in the metal.

It's worth noting that shiny metal surfaces have high tonal contrast whereas matte metal surfaces have more uniform textures in mid-tones with low tonal contrast.

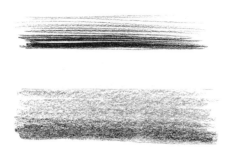

Shiny, smooth metal bar (HB pencil)
Use fine sketchy strokes in graduated tones from light to dark, top to bottom, leaving gaps between some strokes and the top section blank.

Matte, slightly rough metal bar (Graphite)
Create this bar with softer, sketchy strokes in graduated medium tones, leaving no gaps between the strokes.

Rusty metal bar – matte, rough texture (Charcoal)

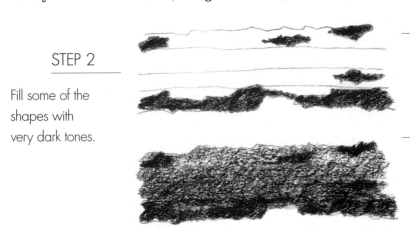

STEP 1

Begin by sketching a few assorted jagged shapes.

STEP 2

Fill some of the shapes with very dark tones.

STEP 3

Lastly, fill with soft horizontal strokes, graded in light to dark tones from top to bottom.

Shiny ring segment – smooth, shiny texture (Graphite)

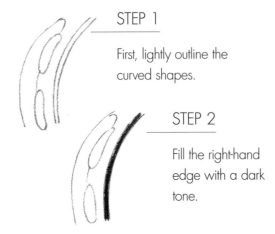

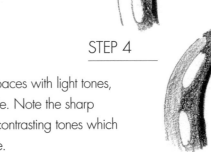

STEP 1

First, lightly outline the curved shapes.

STEP 2

Fill the right-hand edge with a dark tone.

Use medium tones to fill in between some of the shapes.

STEP 3

STEP 4

Finally, fill the remaining spaces with light tones, leaving the two ovals white. Note the sharp boundaries between the contrasting tones which give the shiny appearance.

WATER TEXTURES

Simple, sketchy strokes usefully describe this universal element which can be in a liquid, gas, or solid form. Plain, clear water is colourless, has a smooth surface texture and, like most other liquids, has no shape or form. It is usually defined by its location, for example in a container, a lake, or flowing in a stream. In itself, water can be difficult to draw but it often has sparkling highlights and reflections from its surroundings and comes to life when these contextual features are added. Here, we'll look at a few close-up water textures – larger water features are explored on pp.122–131.

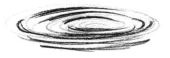

Ripples – smooth, shiny texture (HB pencil)
Simply draw concentric ellipses or circles in sketchy strokes. Uniform tones suggest gentle ripples, whereas thicker contrasting strokes imply bigger waves.

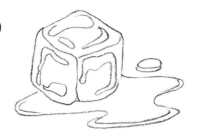

Ice cube – smooth, shiny texture (HB pencil)
Simply outline a cube and blob shapes in medium-toned strokes.

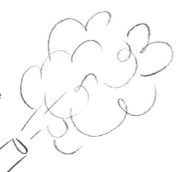

Steam – matte, rough texture (HB pencil)
Water in its gaseous form looks misty and opaque. A few billowing sketchy lines are sufficient to suggest the presence of steam.

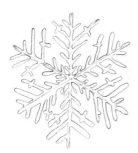

Snowflake – smooth, shiny texture (HB pencil)
Carefully outline rounded geometric shapes in delicate, light tones.

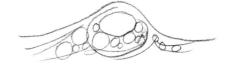

Bubbles on a liquid surface – smooth, shiny texture (HB pencil)
Sketch curves and circle shapes in medium tones.

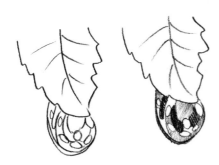

Droplet on a leaf – smooth, shiny texture (HB pencil)
Draw an elongated circle containing small circle-shaped highlights and long blob shapes. Fill the latter with very dark tones, then infill between the shapes with light tones. Notice the high tonal contrast which emphasizes the highlights, giving sparkle.

STONE AND CERAMIC TEXTURES

Both stone and ceramic have similar smooth and shiny or matte textures and often
display more complex shapes and patterns than wood and metal textures.

Marble – polished, shiny stone (3H, 4H pencils)

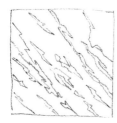

This has a smooth surface and a high tonal key with low tonal
contrast. It needs to be drawn in delicate sketchy strokes in light
tones, following the 'grain'.

STEP 1

Begin by lightly outlining the thin,
diagonal jagged shapes.

STEP 2

In a medium tone, fill the shapes
and darken parts of the shape
edges.

STEP 3

Finally, partially cover all over with
streaks of light tone.

**Gemstone – polished,
shiny stone (HB pencil)**

Here a high tonal contrast
emphasizes the highlights on
the smooth faceted surface and
shiny surface texture.

STEP 1

First, outline the rounded blob
shapes.

STEP 2

Fill with swirly strokes in light,
medium and dark tones, gently
blended.

Rock – rough, matte stone (Charcoal on slightly textured paper)

Rock has a rough surface and low tonal key.

STEP 1

Start by outlining the irregular shapes.

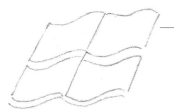

STEP 2

Fill the shapes with gently
blended swirly strokes in
mixed tones.

Roof tiles – matte ceramic (HB pencil)

STEP 1

Begin by outlining
the tile shapes.

STEP 2

Fill with strokes of graduated tones from
medium to light, with very dark-toned
shadows along the bottom edges. This
area of roof tiles has a high tonal contrast.

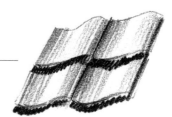

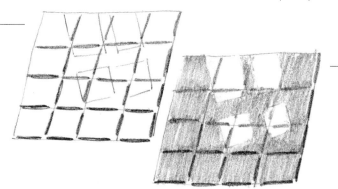

Ceramic tiles – shiny texture (Graphite)

STEP 1

Draw a very faint outline of a slightly distorted square divided into 16 smaller equal squares. Add a superimposed offset grid of four squares.

STEP 2

Shade the tile edges in medium tones, except for the intersections at the corners and the outside top and left edges. Shade the edges of the bottom two rows in dark tones.

STEP 3

Next, shade the grid in uniform light tones except the four offset squares (reflections), which are left blank. Gently erase the edges of the offset squares so no guidelines show.

Earth, derived from rock – matte texture (Charcoal)

STEP 1

Draw small circular shapes (stones) shaded in dark tones on the right-hand edge and beneath (see left).

STEP 2

Fill the remaining area with soft sketchy strokes in slightly varied pressures (see far left, beneath the stones). The stones in the finished drawing are left blank.

Bowl – matte ceramic (Charcoal)

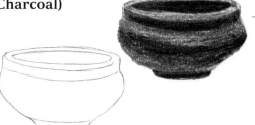

STEP 1

Outline the ellipse and curved shapes.

STEP 2

Fill with sketchy strokes in dark, medium and light tones, following the curves of the bowl. Shade the centre of the ellipse and the three horizontal bands in dark tones, with the remainder in medium and light tones.

Diamond – polished shiny stone (HB pencil)

STEP 1

Outline the overall diamond shape and inner geometric shapes.

STEP 2

Then fill with sketchy strokes in light, medium and dark tones.

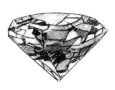

PLANT TEXTURES

The plant kingdom encompasses a huge range of vegetation, so we'll focus on just a few textures here. We're still using the same basic strokes, shapes and shades as before, but now with more advanced blending techniques to achieve a softer look as opposed to the harder edges of wood, metal and stone. Still keeping things simple, the examples are of single items. Obviously there's nothing to stop you from adding to these as you gain confidence!

Grass – smooth, matte, narrow leaf (HB pencil)

STEP 1

Use long, sketchy strokes to outline the leaf shapes from base to tip, and add a centre spine.

STEP 2

Fill with dark and medium tones, leaving gaps between some strokes.

Holly leaf – smooth, shiny texture (HB pencil)

STEP 1

Outline the leaf shape, centre spine and a few veins.

STEP 2

Add dark-toned sketchy strokes radiating outwards and upwards from the spine to the leaf edges, leaving some white areas. Blend the dark tones around highlighted areas and use an eraser to create 'soft' edges to a high-contrast effect.

Pine needles – smooth, very thin leaves (HB pencil)

Use dark, thick strokes to draw the stem, then add needles in dark, 'flick' strokes radiating outwards and upwards from the centre stem.

Simplified bay laurel leaf – smooth, matte texture (Graphite stick)

STEP 1

Outline the leaf, spine and veins.

STEP 2

Use swirly, blended strokes to shade along the leaf veins. Apply slightly darker single strokes on the lower edges of veins. The low tonal contrast and mid-tonal key convey the matte surface.

Apple mint leaf – rough, matte texture (Charcoal)

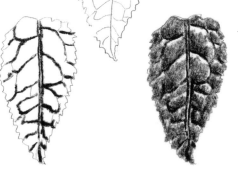

STEP 1

Lightly outline the jagged edge of the leaf then the veins.

STEP 2

Emphasize a few of the veins in very dark tones.

STEP 3

Use swirly strokes to fill each section in between the veins. In each section, from top to bottom, blend from medium to dark tones leaving the top part of each section blank (white). Notice the high tonal contrast between the very dark and white areas, and how the blend of medium and very dark tones creates a three-dimensional 'lumpy' effect.

Thorny stem – mixed textures (2B pencil)

STEP 1

Begin by outlining the stem and thorn shapes.

STEP 3

Fill in the medium-tone areas with vertical sketchy strokes.

STEP 2

Fill in the thorn shapes with very dark tones, then lightly outline areas of medium tone.

STEP 4

Finally, shade the entire stem in a light tone.

Petal – smooth, matte texture (2H pencil)

This delicate texture can be described by pale sketchy strokes or blended tones, and has the same texture and high tonal key as skin.

STEP 1

Outline the petal shape and add a few veins radiating from the stem.

STEP 3

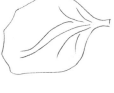

Lightly erase the outlines before adding the two darker-toned areas in soft sketchy strokes in the direction of the veins.

STEP 2

Outline four main tonal areas (white, very light, light, and light/medium).

STEP 4

As step 3, but use graduated blending with swirls in very light tones to create the soft appearance.

PLANT TEXTURES – FRUIT

We'll look at a few fruit textures now, including seeds and nuts (which are the fruits of flowering plants). Like the vegetation examples, these fruits were chosen because of their different textures and tones and the shading techniques they call for, plus the opportunity for you to practise creating 'white bits'. You'll notice that many fruits have mixed textures.

Strawberry – mixed textures (HB pencil)

STEP 1

Draw a grid of curved strokes.

STEP 2

Add small, dark-toned ellipses with medium-tone centres at each grid intersection, then add outlines of semi-circular blobs around each ellipse. Shade over the fruit in a light/medium tone, leaving the blobs blank.

STEP 3

Shade the lower half of the fruit in a medium/dark tone.

Kiwi fruit – mixed textures (HB pencil)

STEP 1

Outline a central irregular blob with pairs of lines radiating outwards. Add thin ellipses to each segment.

STEP 2

Shade the ellipses in light, medium and dark tones. Add small curved strokes above each ellipse.

STEP 3

Shade the inner segment areas in medium tones and the outer areas in light tones, leaving the lines between the segments blank. Shade the centre in light tones.

Raspberry – mixed textures (Charcoal)

STEP 1

Outline a group of diamond shapes, each containing smaller blob shapes (highlights).

STEP 2

Shade each diamond from top to bottom, graduating from medium to dark tones, but leaving the highlights blank.

STEP 3

Add very dark tones to the lower section of each diamond.

Citrus peel – mixed textures (HB pencil)

STEP 1

Draw roughly parallel curved rows of small circular dark-toned shapes.

STEP 2

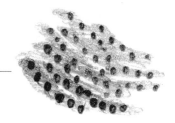

Shade over the rows with stripes of medium tone.

Hazelnut – mixed textures (Graphite)

STEP 1

Outline the overall shape and divide into three sections.

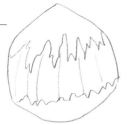

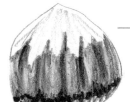

STEP 2

Fill the top section with light-toned strokes radiating down from the apex, the mid-section with vertical stripes of medium/dark tones, and the base with closely spaced zigzags.

Almond – mixed textures (Graphite)

STEP 1

Outline the almond shape and inner elongated wavy-edged blobs.

STEP 2

Fill the blobs with light tones and the surrounding areas with strips of medium/dark tones.

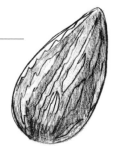

Brazil nut – rough, matte texture (HB pencil)

STEP 1

Draw the nut outline and divide into horizontal sections filled with zigzag strokes.

STEP 2

Fill the sections with alternate medium and dark tones.

**Wheat ear
– mixed textures (Graphite)**

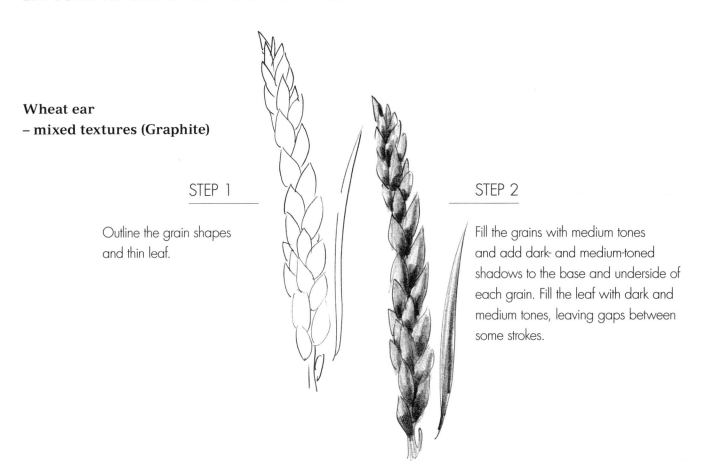

STEP 1

Outline the grain shapes
and thin leaf.

STEP 2

Fill the grains with medium tones
and add dark- and medium-toned
shadows to the base and underside of
each grain. Fill the leaf with dark and
medium tones, leaving gaps between
some strokes.

PLANT TEXTURES – VEGETABLES

Some vegetable textures can be surprisingly complicated to draw, especially the
cabbage leaf. However, the same technique used for the cabbage is also used to create
strands of overlapping fur, hair, and areas of dense vegetation such as grass stems.
Vegetables give you further opportunities to practise creating 'white bits' as well as
negative shapes.

Corn – smooth, shiny texture (HB pencil)

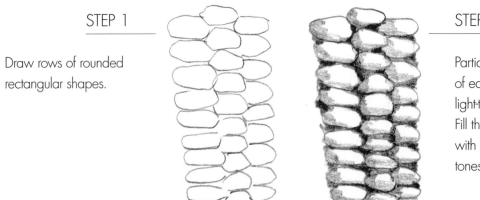

STEP 1

Draw rows of rounded
rectangular shapes.

STEP 2

Partially fill the base
of each shape with
light-toned shadows.
Fill the negative spaces
with medium and dark
tones.

Mushroom – matte, smooth texture (HB pencil)

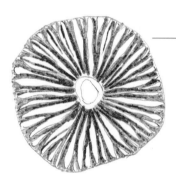

STEP 1

Outline one large roughly circular shape containing two smaller concentric circles in the centre. Fill between the inner and outer circles with outlined elongated ellipses radiating outwards from the centre.

STEP 2

Fill the trapped spaces with medium and dark tones.

Tomato – smooth, shiny texture (HB pencil)

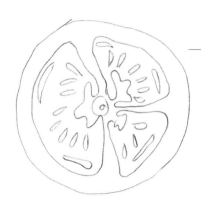

STEP 1

Outline two large concentric circles with a small circle in the centre. Draw roughly triangular blobs to divide the overall shape into three segments. Fill each segment with tiny ellipses to represent the seeds and add some highlight shapes.

STEP 2

Shade each segment in dark tones, leaving the seeds and highlights blank. Finally, shade the remaining areas in a light/ medium tone.

Cabbage leaf – rough, matte texture (HB pencil)

STEP 1

Outline a latticework of different-sized veins.

STEP 2

Fill between the veins in light and medium tones. Lastly, add darker-toned shadows to create the illusion of a three-dimensional leaf.

PREPARED FOOD TEXTURES

We've already covered many different textures, so just a small selection of prepared foods is included here. We'll look at larger food items in the chapter on still life. Interestingly, many prepared foods (for example, butter, cheese, pastry) do not have much texture at all.

Cheddar cheese – smooth, semi-matte texture (HB pencil)
Outline a rectangle and fill with small, random, angular blobs, filled with darker graduated shades to denote shadows.

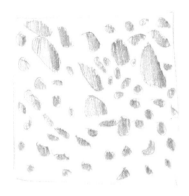

Slice of white bread – matte, rough texture (HB pencil)
Outline a rectangular shape and fill with different-sized blobs to denote air bubbles. Fill with graduated light/medium tones to denote shadows.

Fish steak – semi-matte, rough texture (HB pencil)

STEP 1

Draw the overall shape, then use double lines to outline the bones and concentric rings of fat.

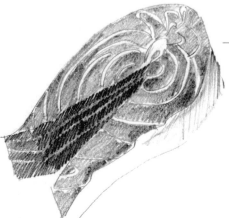

STEP 2

Fill between the lines of bone and fat with graduated light and medium tones, leaving the veins of fat blank. Use darker-toned sketchy strokes for areas of shadow.

FABRIC TEXTURES

Fabrics tend to be matte and smooth and contain a variety of strokes, shapes and shades in repeated patterns. A range of flat and draped fabrics is illustrated in these exercises. Techniques range from simple strokes and shapes to more complex shapes and advanced blending techniques. Feel free to extend the pattern designs as you wish!

Cotton or loose weave fabric (HB pencil)
Use sketchy cross-hatch strokes in a medium tone.

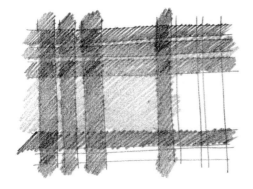

Cotton check (HB pencil)
First, sketch faint vertical and horizontal outlines, then fill the vertical and horizontal bars with sketchy strokes in a uniform medium tone. Note that these first marks will show through automatically to give darker tones where bars intersect. Finally, work over the whole area in pale, lightly sketched diagonal strokes.

Tweed (1) (Graphite)

STEP 1

Sketch alternating blocks of five or six short horizontal and vertical alternating strokes in a medium tone.

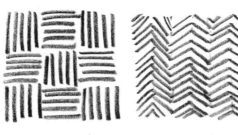

STEP 2

Overlay the entire area with vertical sketchy strokes in a uniform light tone.

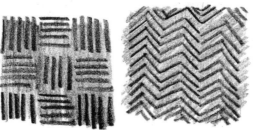

Tweed (2) (Graphite)

STEP 1

First, sketch rows of horizontal zigzag strokes in medium tones.

STEP 2

Overlay with light-toned diagonal sketchy strokes. Unintentionally, this design looks almost three-dimensional.

Leather belt detail (HB pencil)

STEP 1

Lightly outline the shapes.

STEP 2

Darken the horizontal and vertical edges of the leather in medium and dark tones. Add two rows of small ellipse shapes (stitching), and partially fill with very dark tones along the top and left-hand edge to denote shadow.

STEP 3

Fill the main shapes with blended swirls in medium tone, leaving the stitches white.

STEP 4

Finally, overlay two vertical areas of dark tone to denote shadows.

Wool (HB pencil and graphite)

This very soft fabric requires muted tones.

STEP 1

With a pencil, lightly outline a grid of vertically orientated rectangles. Then, in graphite, sketch light-toned small ellipses in each rectangle at alternating diagonal angles.

STEP 2

Partially fill the spaces at the line intersections with light and medium tones.

STEP 3

Finally, with a blunt point, overlay the area with quick sketchy strokes in a light tone.

Houndstooth pattern (Charcoal)

This fabric has a more complex pattern of geometric shapes.

STEP 1

Outline a diagonal criss-cross grid, then fill in a block of 3 x 3 small, evenly spaced squares in a regular pattern of medium- and very dark-toned sketchy strokes.

STEP 2

Add two 'ears' and two 'legs' to each square (see detail, below left).

STEP 3

Fill the 'legs' in matching medium and dark tones (see detail, below right).

Cotton check drape (HB pencil)

STEP 1

Lightly sketch the main folds.

STEP 2

Then add a distorted square check pattern.

STEP 3

Fill the distorted squares with sketchy strokes in four tones ranging from dark to light.

STEP 4

Finally, sketch the shadow shapes over the fabric in medium and dark tones (shadow shapes are shown below).

Silk drape (4H, 2H pencils)

Like wool, this is another fabric requiring soft, muted tones.

STEP 1

Using a blunt 2H pencil, lightly sketch the fabric fold outlines.

STEP 2

Lightly erase so the marks will not be visible at the end. (Using this method you can achieve lines fainter than it is possible to draw them.)

STEP 3

Carefully add blended strips of medium and light tones using delicate swirl strokes.

STEP 4

Work over the strips with blended tones from dark to light using 4H to 2H pencils.

STEP 5

Finally, use a finger or tissue to smudge all over, then create highlights with an eraser. Notice how the shading indicates the folded fabric instead of a fabric pattern.

The technique for creating folds can be applied to any unpatterned fabric texture – all you need to do is add shading to denote any shadows and highlights. For patterned fabrics, you'll also need to distort the pattern into 'folds' as shown in the cotton check example.

Now you can enjoy identifying these different textures in objects around you, for example, the tweed textures could also represent woven material such as raffia, or the pattern on aluminium chequer-plate such as you might find on ladders or external stairs.

LIVING TEXTURES

These textures include various coverings (shell, feathers, hide and fur) which may appear challenging to draw at first, but are very rewarding once accomplished.

If you have an interest in natural history or field work, you may be required to record items you find, so being able to draw accurate representations and textures is a definite advantage. Animals are a very popular subject, so I've included a few examples.

Different combinations of techniques are required to draw these subjects. The trick is to observe what's there, not draw what you *think* is there. If you're not sure where to start, go back to basics and break the subject down into its components of dominant lines, shapes and shades and you'll soon find it easier to tackle these examples. Obviously, a single feather looks different from the appearance of feathers on a bird, but the focus here is on samples of common textures. Note that fur and hair share the same drawing techniques.

Feather

A feather has a high tonal contrast and can be described by sketchy strokes or blended tones. You can produce a simple outline or go for a more detailed picture.

STEP 1

Outline the main shape of the spine and blades with minimal texture.

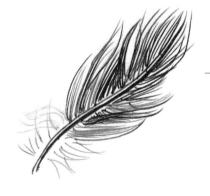

STEP 2

Next, draw a single stroke on one side of the spine in very dark tone (with a blunt point). Use dark-toned sketchy strokes in 'flicking' movements to add the upper blades which radiate outwards and upwards from the centre spine. Use medium-toned strokes for the lower blades.

STEP 3

Add lighter-toned downy blades at the base of the spine. Draw a dark-toned centre stroke then add short pale fronds to emphasize softness (see inset). Over-shade the blade area on the upper side of the spine in a medium tone, graduating to lighter tones next to the spine. Over-shade the lower side of the spine in graduated darker tones. Leave a strip of spine white.

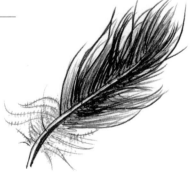

Feather (left) and detail of downy feather at the base of the feather (below).

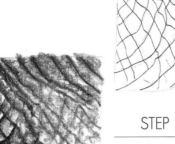

Elephant hide (Charcoal)

Softer, graduated tones are used to describe this rough, matte texture. It's drawn in the same way as the cabbage leaf, except the tones are more blended and the 'white veins' on the cabbage leaf are now dark creases in the elephant hide.

STEP 1

Sketch an outline grid in light, medium and dark tones according to the depth of fold in the hide.

STEP 2

Fill the remaining areas with a range of light- to dark-toned swirls, leaving some areas blank.

Scales (Graphite)

Every creature is beautiful in its own way! These fish, snake and lizard scale textures look similar; like the cabbage and hide examples, the textures are based on a grid of geometric shapes.

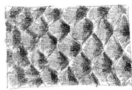

Fish scales

STEP 2

Fill areas of overlap or recess with darker tones, to denote shadows. Remaining areas are filled with graduated lighter tones or left blank.

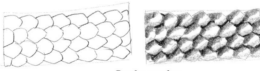

Snake scales

STEP 1

First outline the shapes.

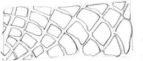
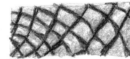

Lizard scales

HARD COVERINGS

These include a mixture of smooth and rough, matte and shiny textures. The shells here have regular patterns.

Snail shell (HB pencil)

STEP 1

Outline the overall shapes then fill with concentric semi-circles following the contours of the shell.

STEP 2

Add stripes in dark tones then partially fill the remaining areas with medium-toned sketchy strokes.

Sea shell (HB pencil)

STEP 1

Outline the overall shape and fill with strokes radiating from base to tip to denote ridges on the shell.

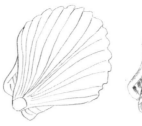
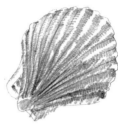

STEP 2

Fill each 'rib' with sketchy zigzag strokes in light/ medium tones. Add any shadows in darker tones.

Beetle wing (HB pencil)

STEP 1

Outline the shape and fill with long vertical strokes.

STEP 2

Then, infill with medium and very dark tones leaving narrow strips blank to indicate the shiny surface.

FUR

Fur comes in many varieties, so textures will vary accordingly. It is composed of a mass of tiny hairs so it may seem difficult to capture on paper, especially if it is black. The best approach is to look first at the overall tones (try half-closing one eye). If there is a narrow tonal range the fur is probably smooth, whereas a mass of different tones indicates rougher and/or coloured fur. The following exercises show a selection of fur types and two ways to draw each example.

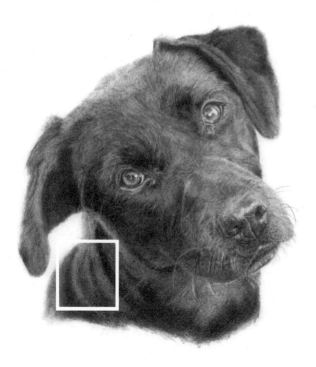

(a) (b)

Short smooth fur (black labrador coat) (HB pencil)
To draw this section of smooth neck fur (highlighted), either (a) outline concentric, curved strips for the subtly different tones, then fill each section with sketchy strokes in light, medium and dark tones. The strokes are all in the same direction, following the line of fur. Or (b) draw the same sections but now fill with swirls. Then, gently shade and blend the entire area in a medium tone.

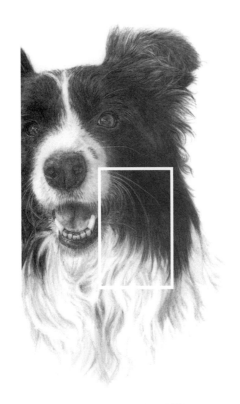

Long fur detail (border collie) (HB pencil)

To draw, either (a) sketch long, light/medium-toned, slightly curved, tapering strokes following the fur direction. Then overlay with shorter sketchy strokes in dark tone. Or (b) use the same tones as (a) but use swirls rather than strokes and softly blend the edges.

(a) (b)

 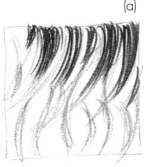 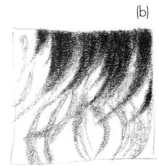

(a) (b)

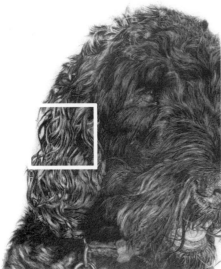

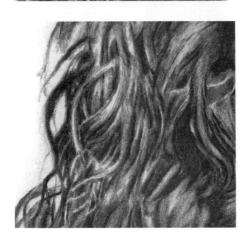

Curly fur detail (cockapoo) (HB pencil)

This is an example of curly fur from an ear. To draw, either (a) sketch overlapping groups of short, semi-circular and 's'-shaped strokes in dark tones, or (b) first outline the curly hair shapes. Then, edge sections of the shapes in dark and medium tones, and fill the gaps between the shapes with dark tones. Leave some areas of the shapes white to denote glossy fur highlights.

These are the strokes to use when drawing fur or hair, and the method you choose will depend on whether you are producing a quick sketch or a more detailed drawing.

FIRE TEXTURES

Fire has a smooth, silky appearance that can be difficult to capture. These simplified examples have dark backgrounds to help emphasize the bright flames. Flames do not look as bright against a background of bright, sunny sky (low tonal contrast). Notice that many flames look like elongated 'S' shapes, similar to the shapes used for fur. Both of these fire examples have high tonal contrast.

Candle (Graphite)

STEP 1

First outline the candle and aura shapes.

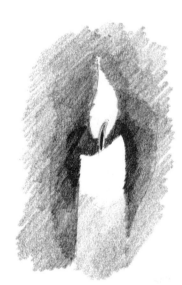

STEP 2

Then simply fill with diagonal sketchy strokes in successive dark, medium and light tones.

Flames (HB pencil and charcoal)

STEP 1

First outline the S-shaped flames.

STEP 2

Shade the flames in HB light and medium tones, leaving some areas white. The background is completed in dark charcoal.

What's your style?

Here are some different drawing styles – just for fun!

By now, you'll be quite accomplished at drawing strokes, shapes and shades on the page, and should be able to create almost any texture.

Here are some examples of the same subject, interpreted in a range of artistic styles.

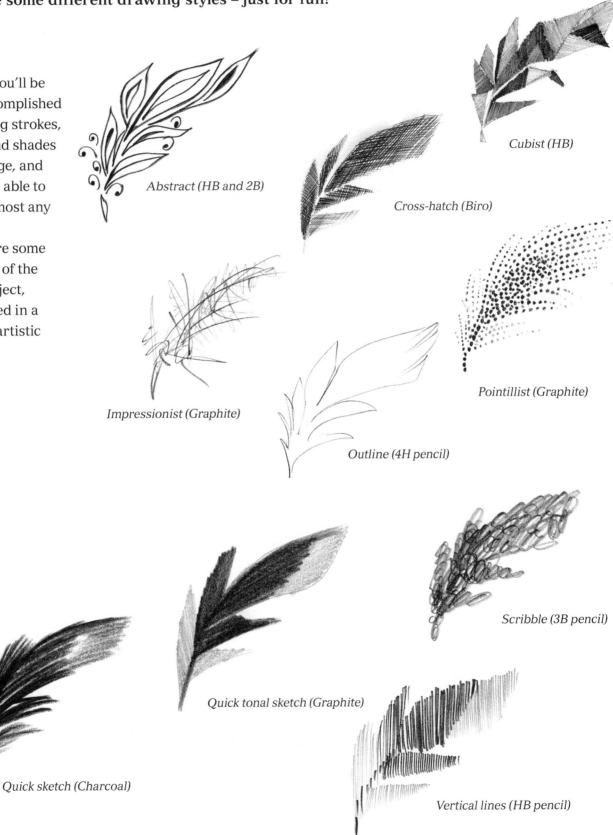

Abstract (HB and 2B)

Cubist (HB)

Cross-hatch (Biro)

Impressionist (Graphite)

Pointillist (Graphite)

Outline (4H pencil)

Scribble (3B pencil)

Quick tonal sketch (Graphite)

Quick sketch (Charcoal)

Vertical lines (HB pencil)

Chapter 3

Still life

In this chapter, we find out how to draw a range of still life subjects, from single objects to themed collections, in exercises that range from easy to challenging. We bring together the elements we've practised and 'wrap' our textures around various shapes to create different still life scenes, adding perspective, shadows and backgrounds to bring them to life.

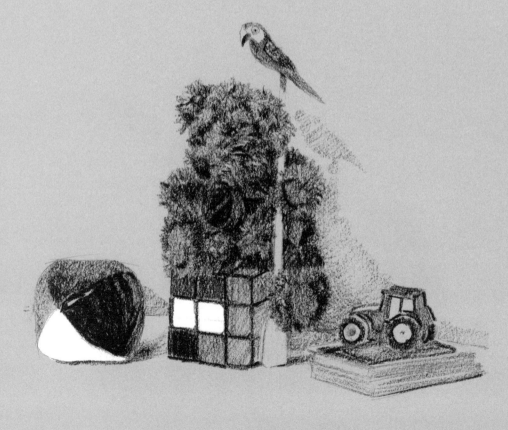

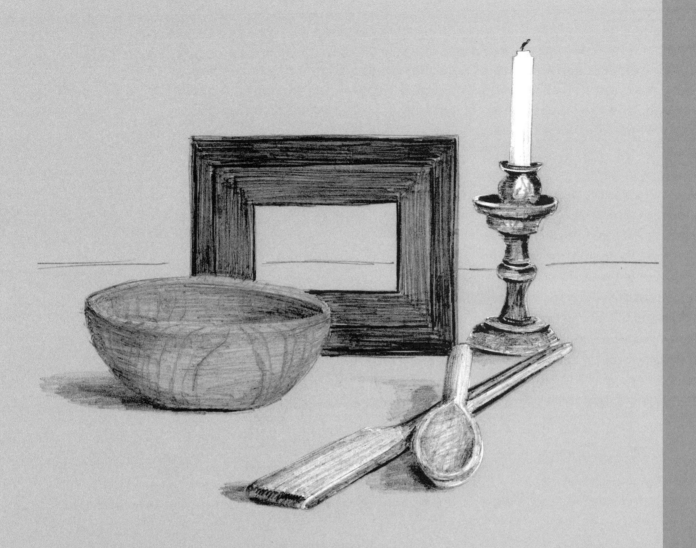

The term 'still life' refers to a drawing or painting that depicts an arrangement of inanimate objects; for example, natural objects such as plants and fruit, or man-made items such as books and jewellery. A still life describes the world around you and shows how to look at ordinary objects in a different light. In the 1960s, Andy Warhol's painting of Campbell's soup cans famously used still life to challenge conventional perceptions.

A still life can be a single item (ideal for a quick sketch if you're short of time) or it can be multiple items carefully arranged for a particular effect. Whatever your subject, capturing a still life on paper is something you can do at almost any time, whether it's during a coffee break, on a train, on holiday or indoors on a rainy day. You can leave some of the step-by-step examples in this chapter as quick sketches or spend more time on them and add detailed tones and textures. Equally, you can use them as a basis for other media, such as paint.

Composition

Still life subjects are a matter of personal choice. Some objects, such as food, drink and flowers, have been frequently depicted throughout history, although how they were drawn or painted usually reflected contemporary beliefs, styles and techniques.

You may want to choose subjects with a special meaning or significance (for example, personal, historical, cultural, religious or political) or unified theme (for example, related to music, travel, work/play/sport, gardening, art or baking). Still lifes can be thought-provoking and intended to evoke emotions in the viewer, or they may be of random objects selected from a drawer, bag or shed. Whatever your choice, your still life will only be really successful if you have composed it in an interesting way.

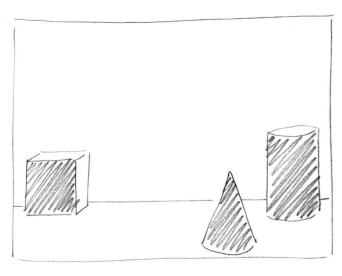

ARRANGING YOUR OBJECTS

Still life objects can be arranged in various ways, for example, by size, height, colour, texture, lighting, medium, symmetry or viewing angle. Asymmetric arrangements tend to work best, with taller objects to one side, though you should try to avoid grouping all the similar tones together on one side. Items of contrasting textures are often combined in a still life picture and generally a mixture works well.

Look at these simple arrangements and think about the different effects and points of focus created with the same still life objects. Themes include isolation, strength and togetherness.

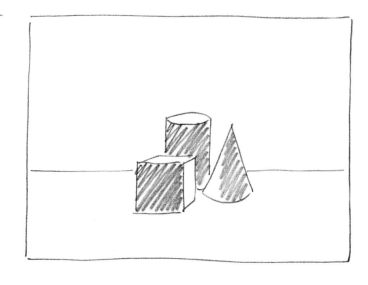

Once you have a pleasing arrangement of items, the next thing to consider is how you will position these on your page, remembering that it's best to have the focal point off-centre. Choose a drawing size that suits your style, whether that's large and sketchy or smaller and more detailed.

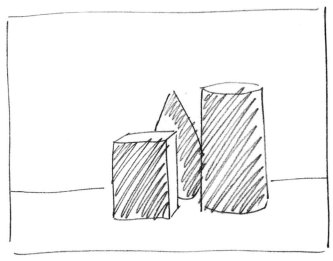

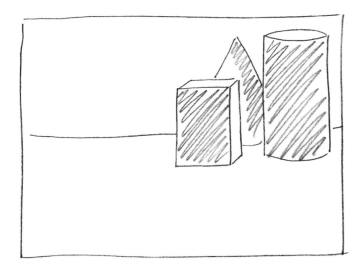

Items off-centre, in the background and in the foreground. Altering the position of objects on your page also gives different effects.

There are a bewildering number of rules about composition. Different artists favour different arrangements, such as an odd number of objects or using the 'rule of thirds', where the drawing area is divided into three horizontal and three vertical areas with subjects placed at the intersections. Having said that, it's best to experiment until you find an arrangement and balance of objects that looks pleasing to the eye. As you're doing this, think about the negative spaces, the size and shape of your still life objects, their position in relation to one another and their placing within the overall drawing frame. Ask yourself if there's a dominant feature or focus of attention and if the items look good together. Sometimes moving, removing, adding

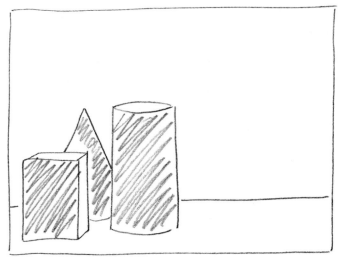

or changing an object can transform your composition. You can also seek inspiration by studying the works of masters.

When planning your composition, try sketching out your ideas as thumbnail pictures first – this is much easier than working on a full-sized drawing.

Begin with simple objects

If you're new to still life, it's best to start with objects of simple shapes and textures so you can focus on capturing the light, shade and perspective without the added distraction of awkward shapes or multiple colours and textures. Once you master simple subjects you'll be confident enough to draw more complex ones. The important thing is to achieve the best likeness of your subject's shape and proportions. If you can do this, you'll be rewarded with much better finished drawings.

Try these two still life sketches showing identical overlapping white objects, but with different backgrounds. The shapes are chosen for their simplicity and minimal texture; you practised these earlier in the book, but now they've gained shadow and background effects. The light source is in the centre-left background. The shadows on the objects are shown in sketchy strokes that fade from dark to light, as do the shadows on the ground (cast shadows).

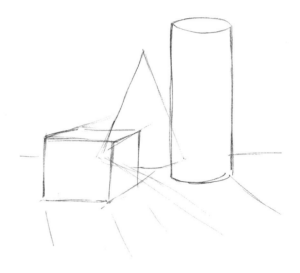

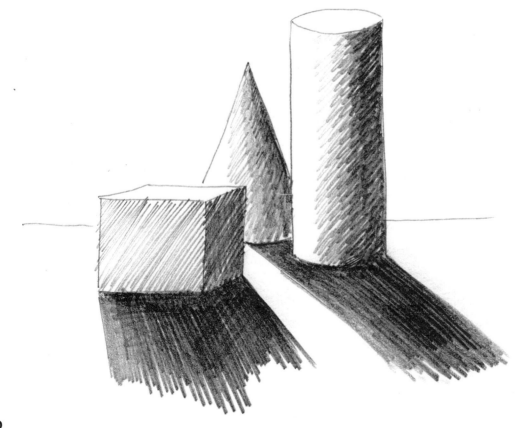

A still life sketch with simple white objects in two steps: thumbnail outline (above), then a version in HB pencil with added shadows in sketchy strokes and no background (left).

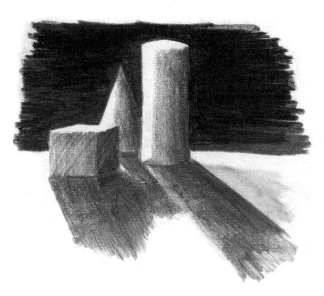

A more detailed sketch with a dark background, using charcoal; the final image (right) is cropped to tidy up the edges.

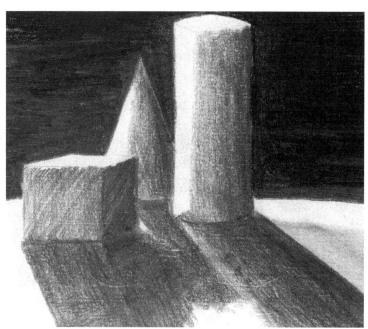

CAST SHADOWS

You can easily work out where to draw any cast shadows by locating the light source, then the surface beneath that source. In this example, the point on the surface directly beneath the light source is also the vanishing point.

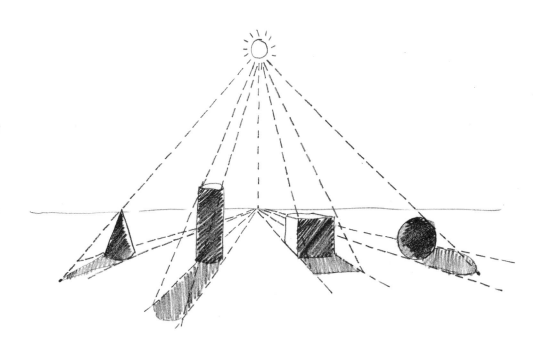

Components of a shadow

We've seen how different lighting conditions affect how objects appear, and the same is true for shadows – they look different in direct or diffuse light. In direct light (for example, electric spotlight or a bright sunny day), the contrast between the very dark and very light tones on the sphere is much sharper (high tonal contrast), and the cast shadows are also darker and more defined. In diffuse lighting conditions (for example, at sunset, or on a dull or misty day) there is less difference between the tones (low tonal contrast, narrow tonal range) and the cast shadows are less well defined.

Notice there is also a lighter patch of tone (reflected light) on the underside of the sphere caused by light reflecting off the surface the sphere is resting on. There is nothing to mark the 'edge' of the sphere's highlighted area, but we're able to work out that the sphere is a separate object and not joined to the background 'whiteness'.

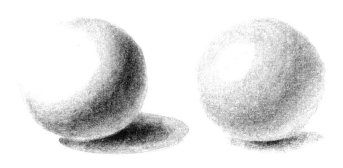

Shadow effects from a sphere in direct light (left) and diffuse light (right).

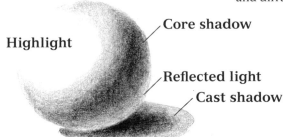

Components of a shadow: highlight, core shadow, reflected light, cast shadow.

Highlight

Core shadow

Reflected light

Cast shadow

Recognizing tones

Sometimes, it can take a while to learn how to recognize tones and translate the colours we see into black, white and grey shades on the page. Here's where the tonal strips you practised can help – simply hold one up and compare it to the subject you're drawing, closing one eye to help define the tones. You should then find it easier to gauge their gradations.

Wood still lifes

PENCIL

For our first still life, we'll use something close to hand as a subject – a pencil! I chose a single pencil with a barrel painted two darker colours with a white band and added a pencil sharpener shaving for interest. The pencil is viewed in close-up at one end to exaggerate the perspective view along the pencil barrel. If required, use a ruler for the straight lines. Notice how the addition of shadow really brings this picture to life. The pencil has a 'smooth wood' texture.

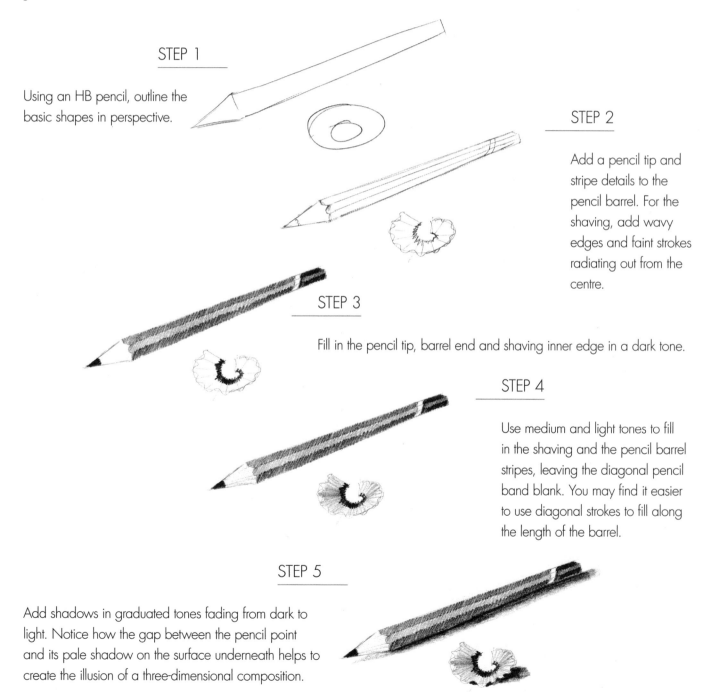

STEP 1

Using an HB pencil, outline the basic shapes in perspective.

STEP 2

Add a pencil tip and stripe details to the pencil barrel. For the shaving, add wavy edges and faint strokes radiating out from the centre.

STEP 3

Fill in the pencil tip, barrel end and shaving inner edge in a dark tone.

STEP 4

Use medium and light tones to fill in the shaving and the pencil barrel stripes, leaving the diagonal pencil band blank. You may find it easier to use diagonal strokes to fill along the length of the barrel.

STEP 5

Add shadows in graduated tones fading from dark to light. Notice how the gap between the pencil point and its pale shadow on the surface underneath helps to create the illusion of a three-dimensional composition.

BOOKS AND PAPER

Books and paper are easily available and make attractive still life subjects. They are of course derived from wood, and both of these exercises use 'smooth wood' textures.

The books in particular are nice regular shapes to draw and as they have plain covers it's easy to work out the tones. They're stacked at interesting perspective angles and have a studious air. A few strokes are all that's needed to give the impression of pages. A still life such as this can be just a quick sketch or you can add strokes and shades for a more detailed piece.

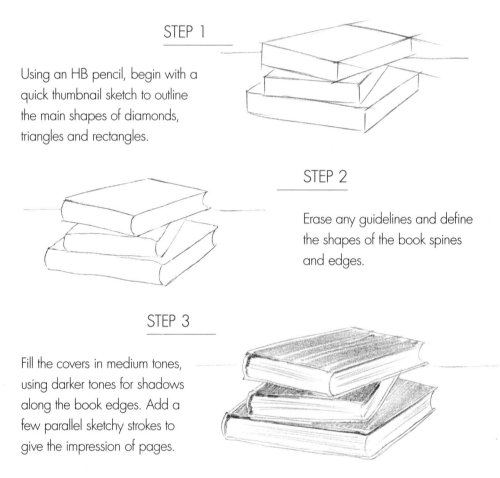

STEP 1

Using an HB pencil, begin with a quick thumbnail sketch to outline the main shapes of diamonds, triangles and rectangles.

STEP 2

Erase any guidelines and define the shapes of the book spines and edges.

STEP 3

Fill the covers in medium tones, using darker tones for shadows along the book edges. Add a few parallel sketchy strokes to give the impression of pages.

A piece of white crumpled paper is easy to achieve as it can be any shape and presents interesting and imaginative aspects. You needn't worry about the precise proportions, which is an extra advantage!

The folds and creases are similar to those in fabrics so similar techniques are used.

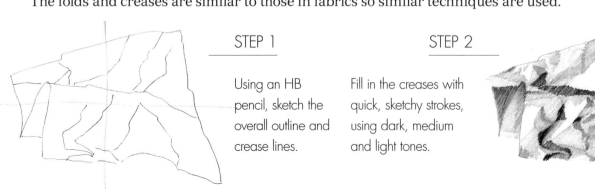

STEP 1

Using an HB pencil, sketch the overall outline and crease lines.

STEP 2

Fill in the creases with quick, sketchy strokes, using dark, medium and light tones.

KINDLING STICKS

Sunlight from a window illuminates these kindling sticks on a table. The softened background shadows give a slightly out-of-focus appearance, and the contrast between white surface and dark background creates an interesting atmosphere. The dried kindling is mostly pale with a slightly darker woodgrain and the texture is of course that of rough wood.

STEP 1

With an HB pencil, outline the kindling and shadow shapes.

STEP 2

Add strokes to denote the rough wood grain.

STEP 3

Use a medium/dark tone to thicken and slightly darken some of the woodgrain strokes.

STEP 4

On the largest piece of kindling, infill with very dark strokes to denote the rough wood grain shadows, using a 2B pencil. Add very dark-toned shapes to the irregularly shaped kindling.

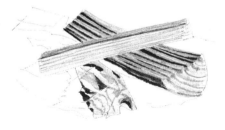

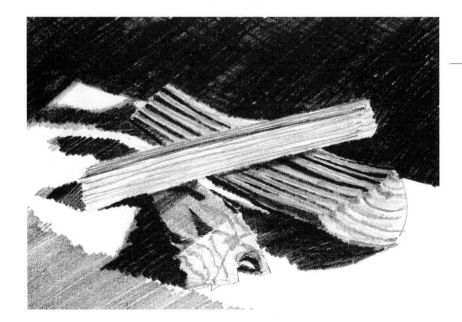

STEP 5

Again with the 2B pencil, add a layer of light to medium tones all over the sticks. Add the very dark-toned background and shadows under the kindling, then use medium tones to add the foreground detail and soften the kindling shadows.

HOUSEHOLD OBJECTS

For this still life I selected wooden items of assorted shapes in both smooth and knotted wood textures: a pale brown spoon and a coarse-grained bowl; a mid-brown spatula and candle holder; and a dark brown empty picture frame. The spoon appears foreshortened because of its alignment and proximity to the viewer.

Remember to draw initial outlines in very light strokes so that they're not visible in the finished piece. Ellipses can be tricky to show in perspective, but as they're symmetrical you can draw them in two halves, which you may find easier. Don't worry if you don't get it right first time or your objects are not quite 'straight' – this is normal and part of the learning process. You'll quickly improve with practice, especially if you reflect on your work and consider how you might draw things next time.

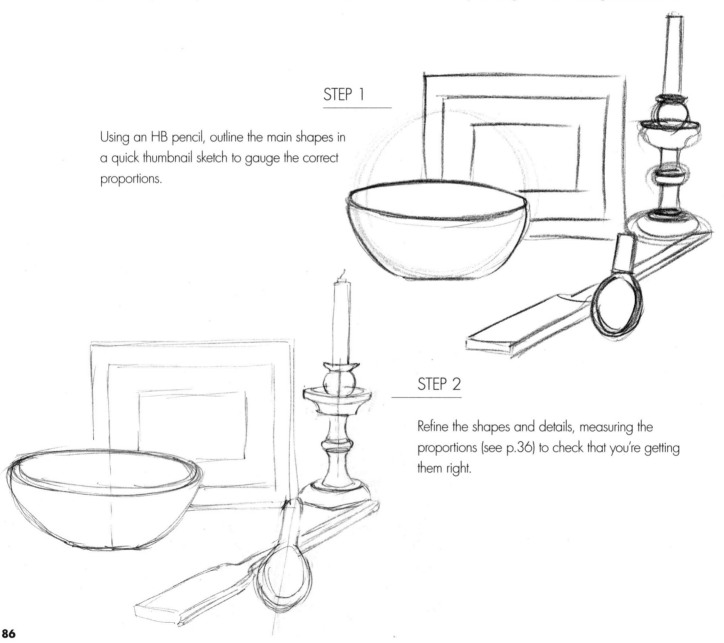

STEP 1

Using an HB pencil, outline the main shapes in a quick thumbnail sketch to gauge the correct proportions.

STEP 2

Refine the shapes and details, measuring the proportions (see p.36) to check that you're getting them right.

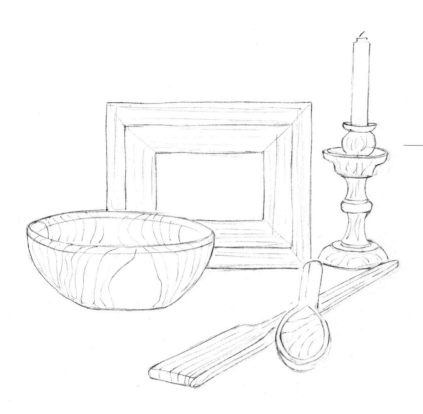

STEP 3

Add the different woodgrain details to help define the object shapes, then use a 2H pencil to slightly thicken the woodgrain strokes on the bowl, spatula and spoon.

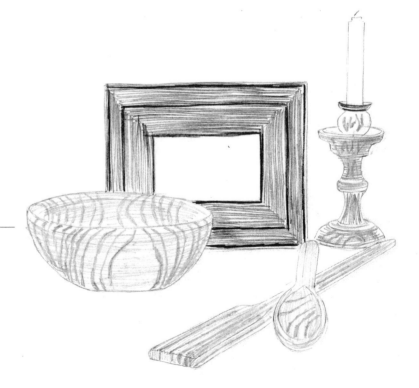

STEP 4

Add horizontal and vertical medium to dark strokes to the picture frame with both HB and 2B pencils. Then add light-toned areas of contour shading to the bowl and spoon, medium tones to the candle holder and light-toned straight strokes to the spatula.

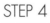

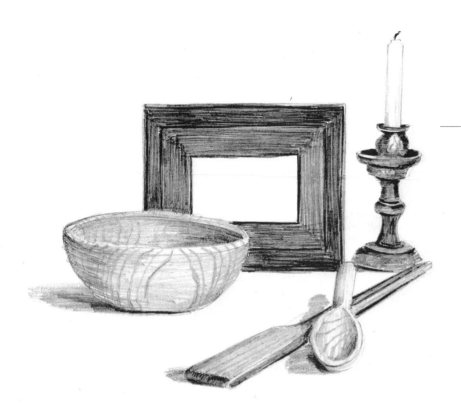

STEP 5

With HB and 2B pencils, fill the picture frame with medium to dark tones. Add medium to dark-toned shadows under the objects.

STEP 6

With a 2H pencil, add a horizon line to the background. Over-shade areas on the bowl, spatula and spoon in medium tones, and use light tones to slightly extend the shadow areas.

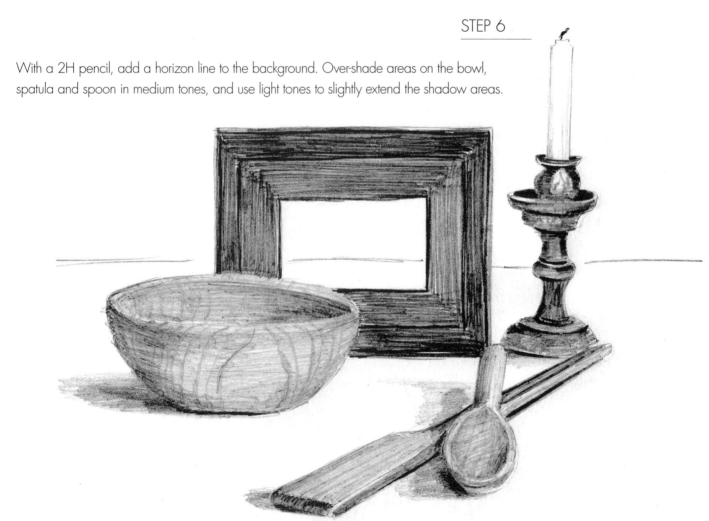

Metal still lifes

SHINY SILVER KEY

By now you should be good at finding shapes in objects and identifying tones! A plain silver (or brass) key is a good subject with which to practise tonal simplification. Notice how the sharp contrast between the very dark and bright tones, reflecting the way light bounces off the different rounded and flat surfaces, creates the effect of a shiny surface. The areas left white on the key look especially reflective.

STEP 1

First, with an HB pencil, divide your drawing area into four to help you estimate proportions, then outline the main shapes – mostly rectangles.

STEP 2

Create rounded edges on the rectangles and use faint lines to outline three main tonal areas: dark, medium and light.

STEP 3

With an HB pencil or charcoal, use very dark tones to draw strokes lengthways just inside the top and bottom edges of the key shank, leaving the centre strip blank. Add dark tones to all the shadowed edges of the key, to the left of the key face and areas on the handle. Add medium tones to the top and bottom shank edges, key face and handle. Leave the remaining areas blank.

LOCK AND CHAIN

This second metal example introduces complex interlocking curved shapes in an object with simpler textures. There is an interesting mix of dull and shiny brass metal textures in this composition and more complicated rounded shapes, especially the interlocking links in the chain. This works well as a line or tonal sketch and the softer tones of a graphite stick suit the subject matter. Notice how the rough, weathered, dull-coloured lock with a rusty lever has fewer highlights than the shiny chain and slide.

The still life theme is 'security' but you could include the key and wonder what you might be unlocking.

STEP 1

With a graphite stick, outline the shapes roughly first to establish proportions.

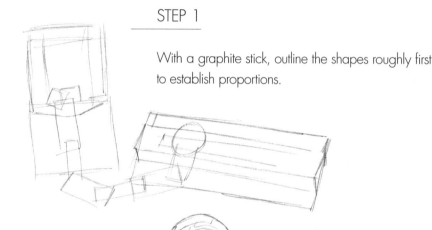

STEP 2

Carefully outline the lock, slider, and interlocking chain links in more detail, then roughly outline the areas of dark, medium and light tone on the lock.

STEP 3

Add bands of well-defined horizontal light/medium-toned strokes for the slider and dark, medium and light tones for the lock and chain. Use contour shading for the curved chain links and lock shackle.

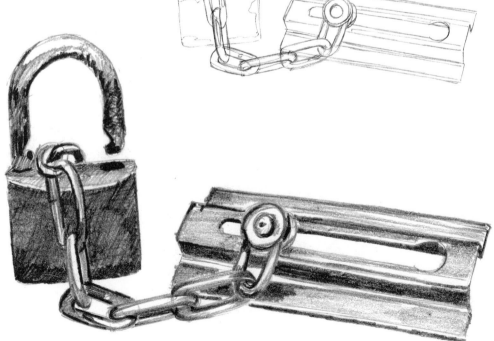

SCISSORS AND RING

This thought-provoking composition is a more challenging exercise to draw because of the shapes and the perspective of the scissors, with a low viewing angle and proximity to the viewer. Softer tones are used to create the slightly out-of-focus elements. The shiny silver metals are drawn in grey (light/medium) tones and care is required to draw the ellipses. Just a few shapes and shades give the impression of solid objects.

Notice the difference between the paler tones of the scissors compared to the sharp contrast of dark and light tones of the lock and metal chain. However, both compositions convey a sense of shiny metal.

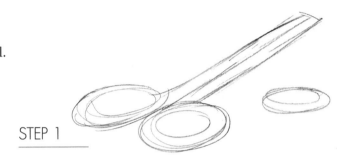

STEP 1

With a graphite stick, outline the main shapes in quick sketchy strokes.

STEP 2

Next, outline the main areas of dark and medium tones.

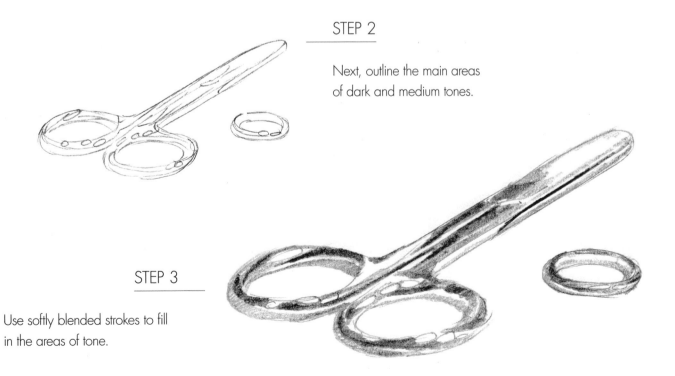

STEP 3

Use softly blended strokes to fill in the areas of tone.

Water and glass still life

Clear water and glass often have similar textures and can be sketched with a few strokes, as shown in this example of a window frame, glass and bottle. Like water, clear glass is colourless and defined by its context, for example, by reflections of surrounding features or contrast with them.

If you want to add more tones and detail, try drawing the glass of water, below, with all its reflections and refractions. I added a pair of half-closed spectacles to give the impression of a break from work. The spectacle lenses are left blank; the illusion of clear glass here is helped by drawing the arm behind the lense in a lighter tone. The shape of the drinking glass is described by the pattern of light and dark tones – a mixture of simple thin spiky dark shapes, rounded blobby highlight shapes, and areas of pale blended tones.

The glass is straight-sided, but the high viewing angle creates the appearance of narrowing towards its base. I used the 'water ripple' and 'water droplet' textures for the objects and

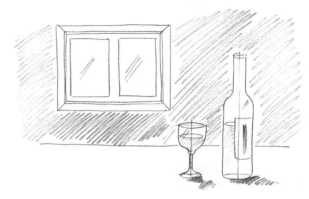

The guidelines down the centre of the glass and bottle will help you to draw symmetrical shapes.

kept the background plain white to simplify the composition. You could try different-coloured backgrounds and observe the effects.

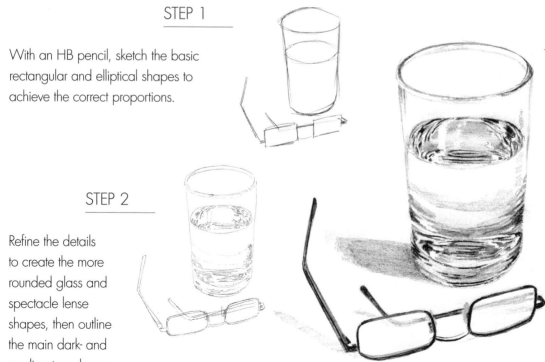

STEP 1

With an HB pencil, sketch the basic rectangular and elliptical shapes to achieve the correct proportions.

STEP 2

Refine the details to create the more rounded glass and spectacle lense shapes, then outline the main dark- and medium-toned areas.

STEP 3

Fill in the sharply defined areas of dark tones on the glass and spectacle arms, then add the medium-toned areas on the glass and spectacle lenses. Finally use pale, blended tones for the water and spectacle lenses. Gently erase any unwanted guidelines.

Stone and ceramic still life

Outlines and scribbled strokes describe this arrangement of different-patterned blue, white and cream china on a shiny black stone surface. The textures are a mix of 'marble', 'gemstone' and 'ceramic tile' (see pp.58–9). The objects are grouped together in ascending order of height and the eye is led to the tallest item on the right, the candle holder. At first the cup was upright, but I decided the arrangement looked more interesting with the cup on its side. This proves you should always try different arrangements, no matter how slight the alteration – don't just accept the first configuration that looks good.

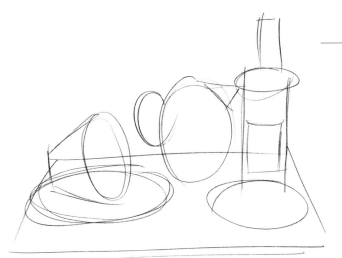

STEP 1

With a 2H pencil, outline the main shapes in quick, sketchy strokes, noting the perspective.

STEP 2

Refine the shapes more carefully, especially the ellipse shapes in the cup and saucer, jug and candle holder. Next, sketch the patterns on the china.

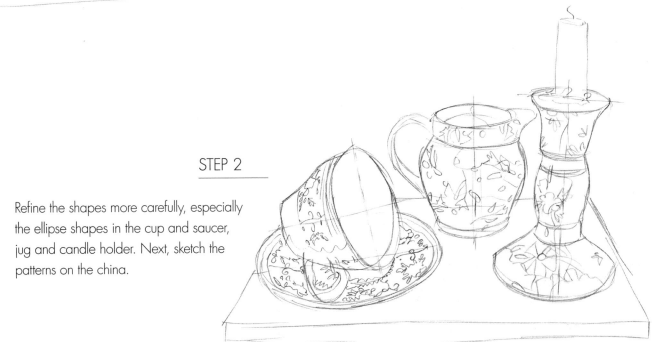

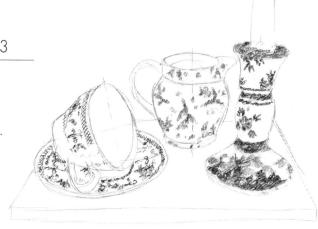

STEP 3

Make sure that the ellipse shapes are symmetrical, adding new guidelines to check this if needed. Add the patterns in quick, scribbled and zigzag strokes in patches of dark and medium tones.

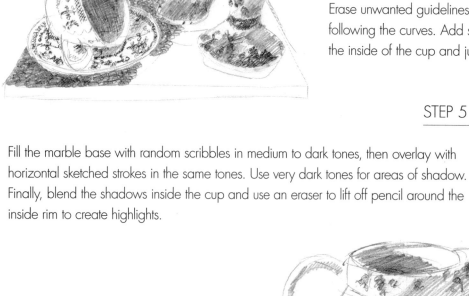

STEP 4

Erase unwanted guidelines and add contour shading to the china, following the curves. Add shadows in darker, graduated tones to the inside of the cup and jug.

STEP 5

Fill the marble base with random scribbles in medium to dark tones, then overlay with horizontal sketched strokes in the same tones. Use very dark tones for areas of shadow. Finally, blend the shadows inside the cup and use an eraser to lift off pencil around the inside rim to create highlights.

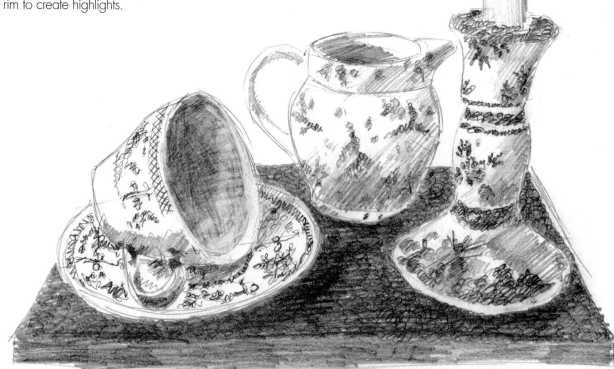

Plants and flowers

SPIDER PLANT

This spider plant *(Chlorophytum comosum)* was sketched with graphite stick on watercolour paper which itself adds interesting texture. I sketched the container first, then employed the 'grass' leaf texture (see p.60) to create the jaunty foliage of long thin pointed leaves and to capture the angles of the leaves as they bent downwards. The unshaded leaves look as though they are bathed in light, giving a soft airiness to the sketch. The shadows were added last.

BUNCH OF HERBS

This simple arrangement of freshly cut mint, chives and rosemary incorporates shiny, spiky and rough leaf textures. To create it yourself, use the plant textures of pine needles, grass, and apple mint leaf described on pp.60–1.

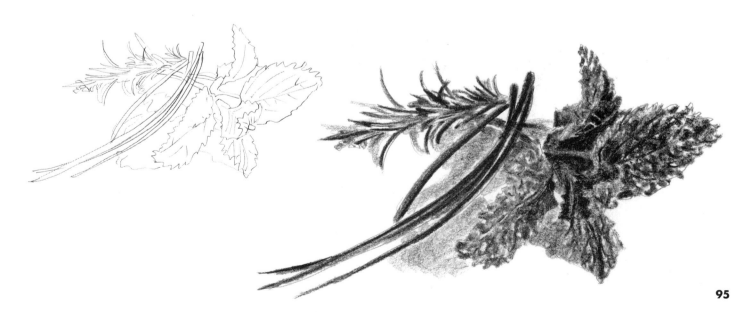

SINGLE ROSE

Flowers are a popular still life subject and they have often featured in famous works of art including lilacs in a vase by Manet, sunflowers by Monet, and irises and roses by Van Gogh. A single red rose conveys the meaning of love and passion, but also respect and great courage. This detailed rose is drawn without its vase and uses the shiny leaf and petal textures described on pp.60–1. It was drawn in HB pencil in three blended tones, and the outlines were lightly erased in the final step.

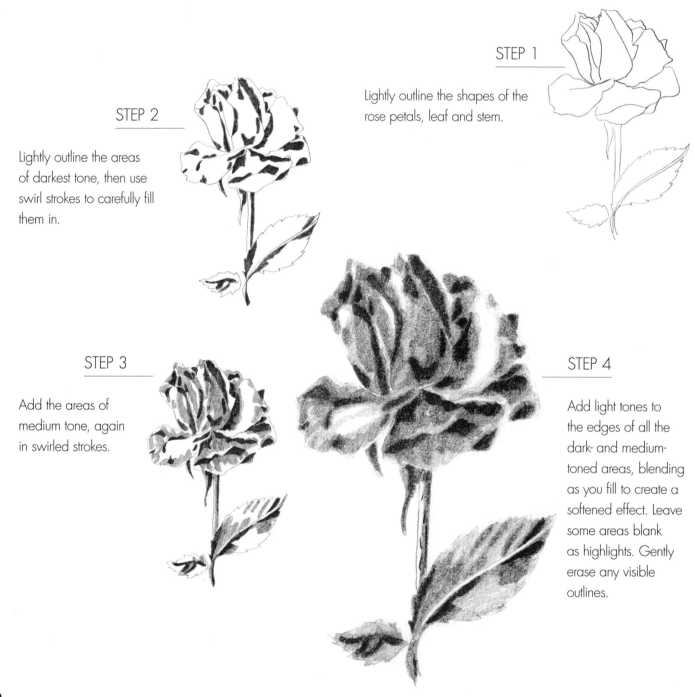

STEP 1

Lightly outline the shapes of the rose petals, leaf and stem.

STEP 2

Lightly outline the areas of darkest tone, then use swirl strokes to carefully fill them in.

STEP 3

Add the areas of medium tone, again in swirled strokes.

STEP 4

Add light tones to the edges of all the dark- and medium-toned areas, blending as you fill to create a softened effect. Leave some areas blank as highlights. Gently erase any visible outlines.

Fabric still life

The overlapping strands and soft textures of this ball of wool, drawn with graphite, make this a more challenging but very satisfying subject. Just two tones are used: dark and medium.

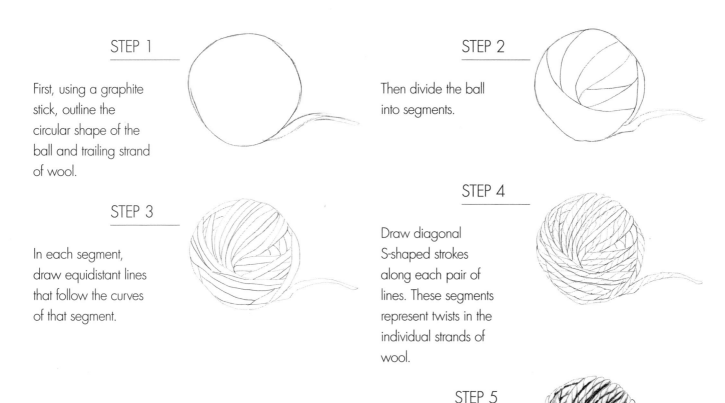

STEP 1

First, using a graphite stick, outline the circular shape of the ball and trailing strand of wool.

STEP 2

Then divide the ball into segments.

STEP 3

In each segment, draw equidistant lines that follow the curves of that segment.

STEP 4

Draw diagonal S-shaped strokes along each pair of lines. These segments represent twists in the individual strands of wool.

STEP 5

Add dark-toned shadows along the edges of most of the strands of wool, following the line patterns and tapering towards the edge of the ball. Also add dark tones along many (but not all) of the S-shaped lines.

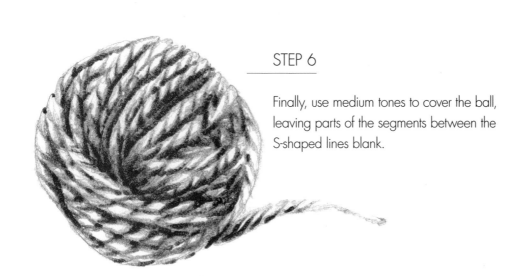

STEP 6

Finally, use medium tones to cover the ball, leaving parts of the segments between the S-shaped lines blank.

Fruit still life

This fruit still life drawn in HB pencil encompasses several different textures, including the citrus peel we looked at on p.63. You can assemble the materials for this easily by placing a selection of different fruits in a bowl and arranging them until they look pleasing to the eye.

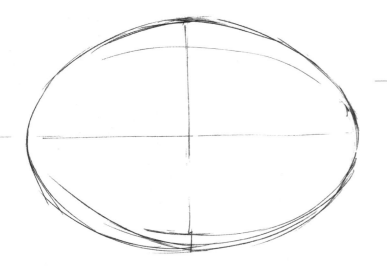

STEP 1

First, outline the symmetrical bowl shape. I drew a cross to help map out the oval shape; the horizontal line is one-and-a-half times longer than the vertical line.

STEP 2

Sketch the shapes of the fruit, still using your cross as a guide. I started with the largest fruit, the almost circular orange in the foreground, which filled nearly half the bowl.

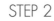

STEP 3

With faint pencil lines, add prominent features such as the fruit stems and largest dimples in the peel.

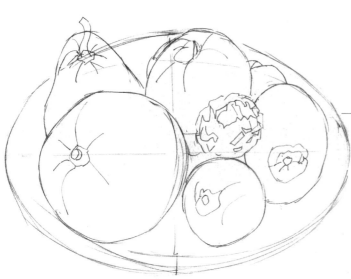

STEP 4

Outline the areas of uniform tone. In faint pencil lines, roughly outline the areas of darkest tone and the brightest highlights (sometimes it can help to close one eye to see these), and add a base to the bowl.

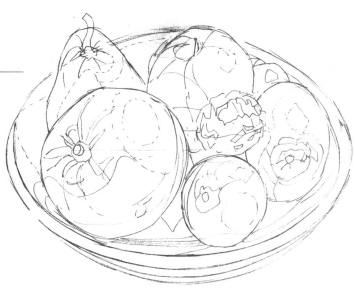

STEP 5

Now you can begin to add tone. Use even pencil strokes to shade the darkest areas. The apple has dark strokes that follow the contours of the fruit from stem to base; the passion fruit has irregular geometric shapes; the citrus fruits have strings of very small circular shapes and the pear has a few dark skin blemishes.

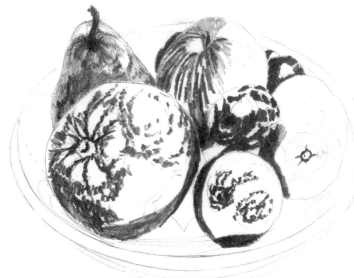

STEP 6

Use light, even tones to shade in the rest of the fruits, following the contour shapes. To create more realistic fruit, leave the brightest areas of highlight blank. Finally, add a few more shadows in the bottom of the bowl.

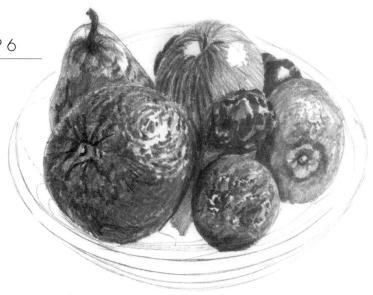

Still life themes

PREPARED FOOD

Still life sketches can also be themed. This 'prepared food' arrangement brings together several elements in a single composition, requiring the use of perspective, multiple textures, and light and shade. The idea is not to spend too long on this still life exercise, but simply to create a quick sketch with loose tonal strokes.

The variously placed objects give the composition height, width and depth, while the high/medium tonal key gives the arrangement a pale, delicate effect. The mood is one of calm and tranquillity. The medium tones provide a hint of texture on the bread, cheese, napkin and egg, as well as subtle reflections on the glass tumbler and marble pestle and mortar. Darker tones are used for shadows and the texture of the decanter, and simple one-directional strokes describe the small wooden table.

None of the objects are outlined, but you can still distinguish their shape and texture – the white china plate is left almost completely blank, defined by its shadows and the objects upon it.

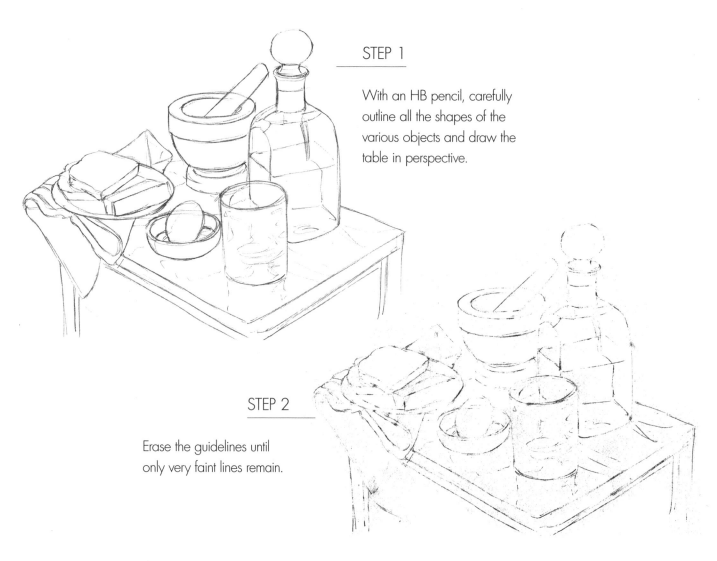

STEP 1

With an HB pencil, carefully outline all the shapes of the various objects and draw the table in perspective.

STEP 2

Erase the guidelines until only very faint lines remain.

STEP 3

Now have a go at filling in the outlined shapes. Use
diagonal sketchy strokes in medium/dark to light tones,
resisting the temptation to draw outlines around the objects!
If you make a mistake, simply erase that area and redraw.

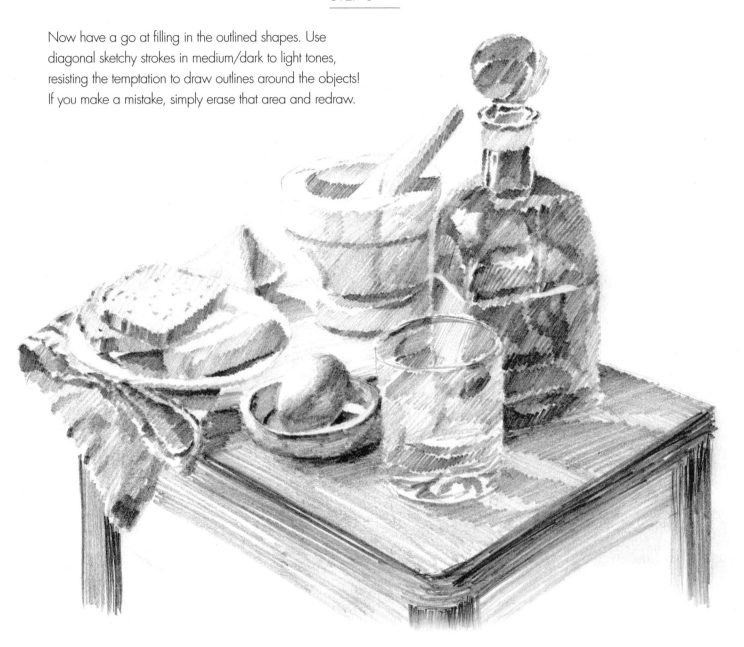

TOYS AND GAMES

Once you master drawing a few objects, you can begin to experiment with compositions and expand your still life works to include more background details. The wall behind this playful collection of toys and games, drawn with HB and charcoal pencils, is made visible by the cast shadows.

Translating colours into black and white can be difficult and I half-closed my eyes to gauge the relative tones of the bright primary colours of the cube, tractor and juggler's thud. It's not easy to achieve fine detail with charcoal, but it's perfect for the texture of the teddy bear's fur.

Although the toys are motionless, the high tonal contrast adds an air of movement and action to this composition. Teddy, armed with his staff, looks ready for action.

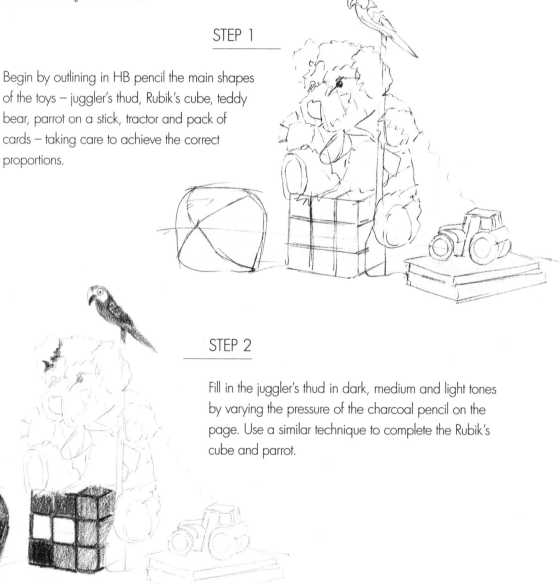

STEP 1

Begin by outlining in HB pencil the main shapes of the toys — juggler's thud, Rubik's cube, teddy bear, parrot on a stick, tractor and pack of cards — taking care to achieve the correct proportions.

STEP 2

Fill in the juggler's thud in dark, medium and light tones by varying the pressure of the charcoal pencil on the page. Use a similar technique to complete the Rubik's cube and parrot.

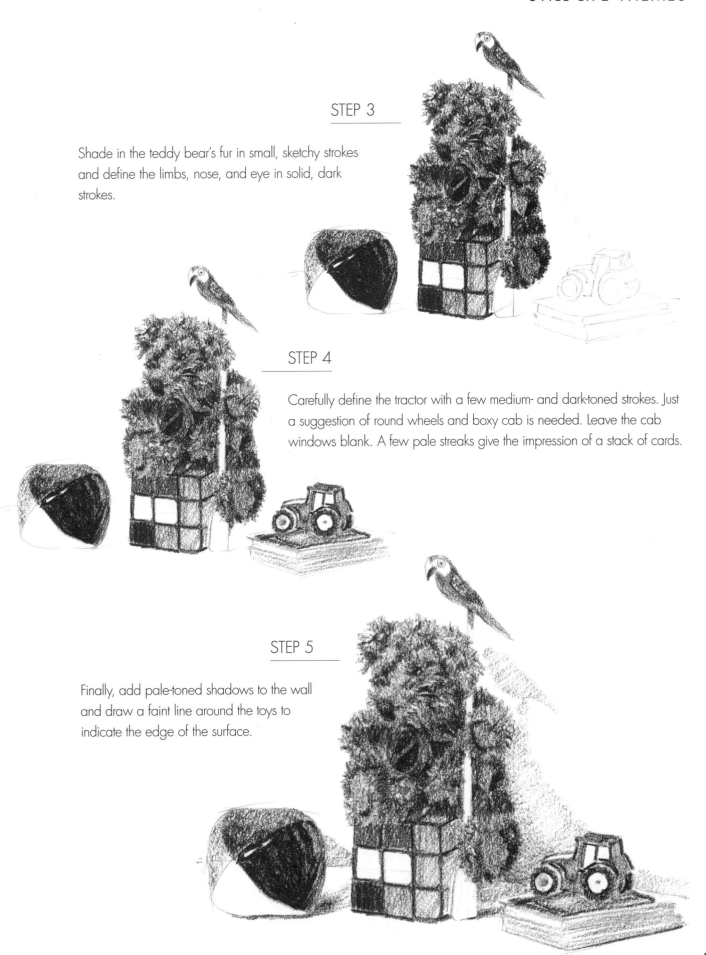

STEP 3

Shade in the teddy bear's fur in small, sketchy strokes and define the limbs, nose, and eye in solid, dark strokes.

STEP 4

Carefully define the tractor with a few medium- and dark-toned strokes. Just a suggestion of round wheels and boxy cab is needed. Leave the cab windows blank. A few pale streaks give the impression of a stack of cards.

STEP 5

Finally, add pale-toned shadows to the wall and draw a faint line around the toys to indicate the edge of the surface.

MANTELPIECE

This mantelpiece theme, in two-point perspective with unusual angles, is a simple yet effective graphite sketch of a flower vase and collection of family photographs above a fireplace. Cast shadows give a hint of the wall behind the mantelpiece.

HIKING

Here a sketch in graphite pencil of a boot, map, compass and whistle evokes the theme of hiking in the great outdoors. The leather texture of the boots was easy to create with light, sketchy strokes on the rough-toothed cartridge paper. The objects look well together despite their very different sizes and appear momentarily abandoned by their owner. They are arranged around the map, which rises up like a mountain. The soft mid-tonal key adds to the pleasant air of recreation and momentary time-out.

WINDOWSILL

If you're feeling adventurous, a windowsill can offer interesting possibilities. You can choose a small or large window and draw as much or as little of the background as you like. This windowsill, filled with kitchen items, has a rural vista. Aerial perspective is used to create the illusion of depth and distant objects are sketched in paler tones. Some objects, such as the weights on the scales, are too small to be drawn in detail but contour strokes help to define their shape.

STEP 1

Using an HB pencil, lightly outline the assorted shapes of the objects on the windowsill as well as the window frame, floral drapes, and background view of fields and hedges.

STEP 2

Add the background view in pale tones, then use small blocks of medium/dark and light tones in soft swirl strokes to complete the office weighing scales.

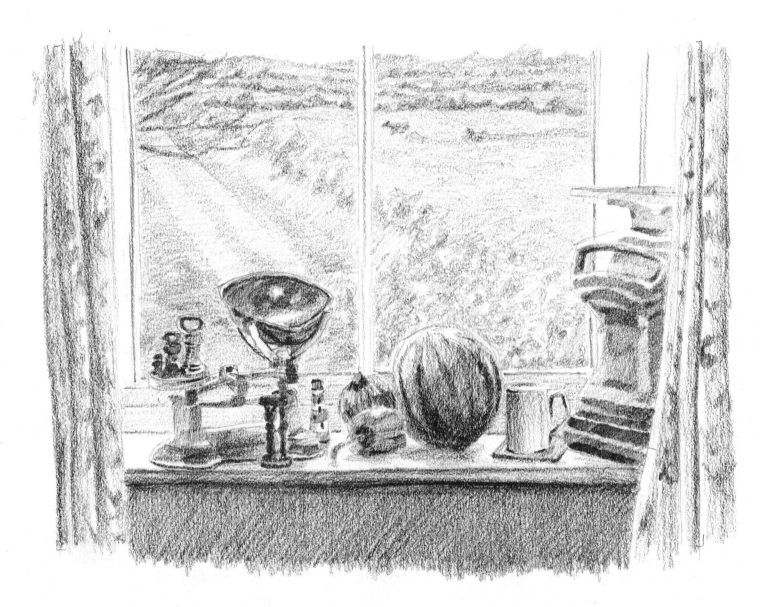

STEP 3

Use contour strokes sparingly and add minimal areas of dark, medium and light tone to describe the remaining windowsill objects, sill and surround. Complete the wallpaper below the sill in rough, sketchy strokes.

Through the door

By now you should have lots of ideas about creating your own still life arrangements. Whether they are small and detailed or bold, expansive compositions, I'm sure you'll have just as much fun choosing your items and inventing themes as you will when drawing them. Don't be afraid to try different materials, methods or sizes as you explore your creativity in drawing.

You've probably found some of the techniques easier and more enjoyable than others. Those such as stippling and swirling are more time-consuming than, say, sketchy strokes, but sometimes you may want to sketch quickly to capture an observation; at other times you may prefer to sit down and relax while you add detail and tone to a piece of work.

There's no escaping the fact that detail takes longer than quick sketching – it cannot be speeded up. The results look different, too. I liken it to baking a cake. Like sketching, a simple sponge is relatively quick and easy to do; but a fully decorated and intricately iced celebration cake takes much longer and cannot be rushed. Yet, however daunting the project, if you enjoy the process you'll be absorbed in your work and won't notice the time passing. It's the same for any absorbing, enjoyable activity, whether it's walking, gardening, shopping or reading.

The close-up viewing angle creates these distorted shapes in three-point perspective. The wall diminishes towards the left, the door towards the right, and the frame curves inwards at the top and bottom.

The final picture in this section isn't really a still life but it leads us nicely into the next chapter, where we step through the door to consider objects and scenes to be found outside.

Chapter 4

Outdoors

In the previous chapter you learnt how to describe various shapes, shades and textures and bring them together in drawings of increasing complexity that explore perspective and form. In doing so, you will have begun to see objects from an artist's viewpoint, recognizing tones and learning how to simplify details in order to capture your impressions on paper in different materials. In this chapter, you'll discover how to develop these techniques and draw larger objects in wider settings, starting with small landscapes closer to home before venturing into bigger scenes.

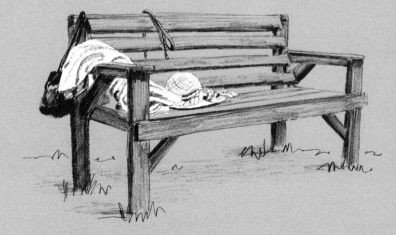

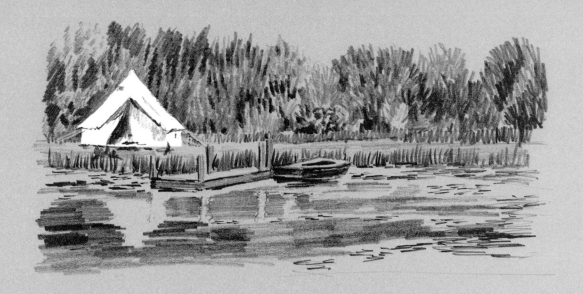

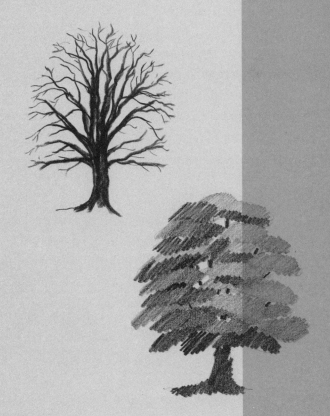

When faced with a landscape it can be hard to know where to start drawing! If in doubt, draw what is there – as opposed to what you think is there – and if necessary go back to basics. Take time to think about the features you'd like to include in your composition and make a few thumbnail sketches to see how your scene will look on paper. Quickly outline the main shapes and features, adding perspective lines if necessary, and remembering that you don't need to include everything in front of you – if something is spoiling the scene from your point of view, you can just leave it out. As you become more experienced you can choose to resize or move objects, or even add extra details.

Selecting a landscape

The first step is to choose a landscape location, which could be somewhere you've visited just once or maybe see every day. You don't need to choose an impressive panorama or famous beauty spot because small corners can be equally interesting. If you don't have access to a pleasing outdoor subject, photographs are a great alternative.

Once you have decided on a location you can select your scene; a viewfinder is useful here. View the same scene from different angles until you find a pleasing aspect.

In the landscape, you'll notice that colours become subdued and bluer in the distance, that tones become lighter and textures and details less obvious. This effect is known as aerial perspective. As you practise, you'll find it easier to translate the colours and features into pencil tones.

Map

The effect of aerial perspective (left), with darker tones and more detail in the foreground compared with the background.

As with still life, it's important to achieve the correct shapes and proportions of your subject at the start of your drawing as this will really help to improve the look of your work. It can be difficult to judge object sizes as they recede into the distance; a grid can be used to help assess proportions, if needed (see p.37).

Garden view

One of the easiest ways to begin drawing landscapes is to sketch a view through a window or doorway. You can choose to draw as much of the view as you like. In this example, a garden landscape is seen through an open doorway, as shown by the vertical lines on either side. Although this is a small scene, there is an interesting mixture of shapes: angular garden furniture and wheelbarrow; rectangular paving, fence panels, and cornerstones in the wall; and blob-shaped plants and stonework. You can choose to leave this as an outline sketch, or draw the view in different lighting conditions, or add textures.

STEP 1

With an HB pencil, outline the main shapes quickly to achieve the correct proportions and perspective.

STEP 2

Firm up the outlines of the objects, slightly darkening the foreground furniture and leaving the features paler in the background to give the sketch some depth.

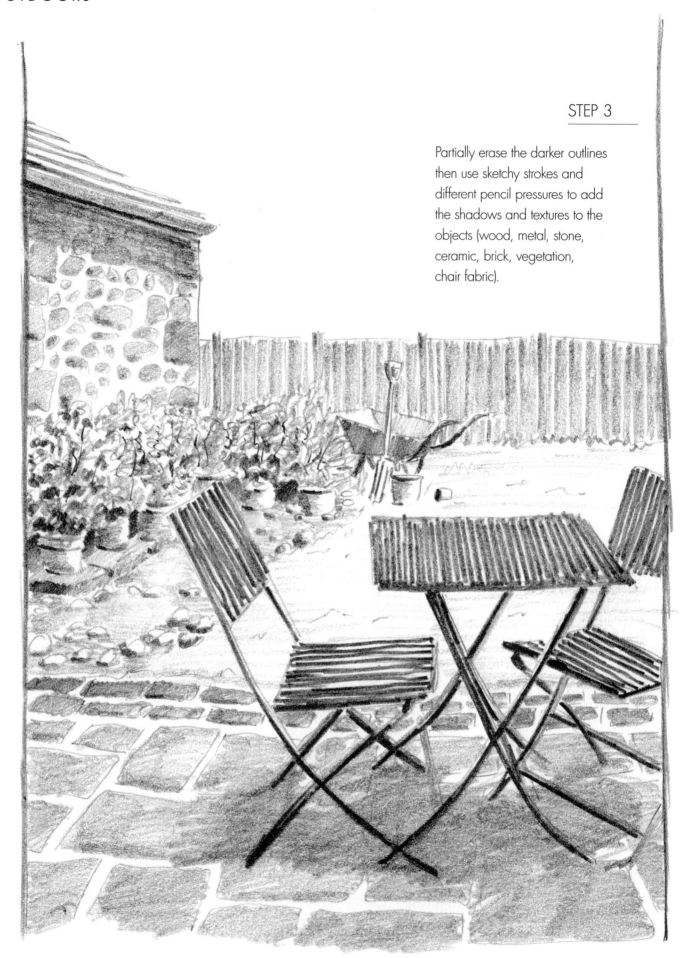

STEP 3

Partially erase the darker outlines then use sketchy strokes and different pencil pressures to add the shadows and textures to the objects (wood, metal, stone, ceramic, brick, vegetation, chair fabric).

Roofscape

Here, the window view of a sea of rooftops was drawn in one-point perspective with the roof lines converging in the distance. Note how the texture details change with scale, from darker, more detailed features in the foreground to simple outlines and paler tones in the distance.

STEP 1

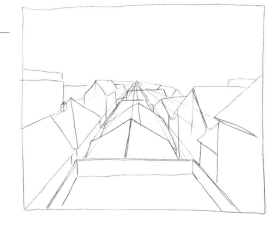

Using an HB pencil, mark your vanishing point on the horizon then outline the various roof and building shapes in one-point perspective.

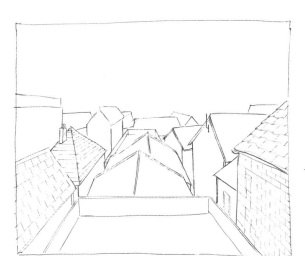

STEP 2

Partially erase the guidelines so they won't show in the finished work, then add roof tile and brickwork details in the foreground.

STEP 3

Fill the shapes with sketchy strokes in different directions to create different roofing material textures (tiles, slates, corrugated sheets, concrete). Add individual brick and stone details in the foreground to emphasize their proximity to the observer. Finally, add cable and chimney details.

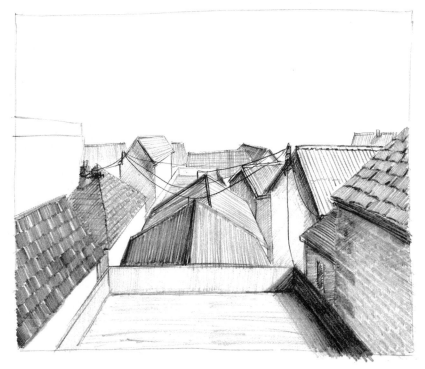

Urban street scene

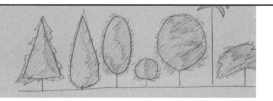

A quick sketch is a great way to record instant impressions and note details for later reference, such as the stone and railing details shown here. Also, you can sketch anywhere!

In this pen and ink sketch, the road lines draw you into the urban scene, while the wall and hint of tree on the left arouse curiosity. The tree is sketched in a few short, wavy strokes. The railings add interest and the gap between the roofs and distant buildings provides atmosphere and a sense of scale, emphasizing the different heights of the features.

Record smaller items in more detail for later reference, such as this stone pillar above a doorway and the metal railing.

Bench in a park

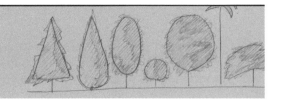

This park bench presents an interesting mixture of shapes, and the collection of items on it creates a narrative, suggesting that the dog-loving owner is not very far away. It's important to draw the correct shapes and proportions at the start. Notice how the mix of very dark and pale tones adds a touch of depth and realism.

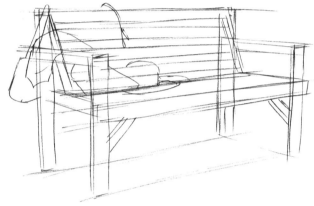

STEP 1

With an HB pencil, roughly sketch the main rectangular shapes of the bench. Add outline shapes for the handbag, hat, jacket and dog lead, using guidelines to help you draw them in the correct proportion and perspective.

STEP 2

Define the shapes more clearly and erase any unwanted guidelines.

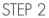

STEP 3

Add straight, sketchy strokes in medium and dark tones to define the woodgrain of the bench. Use dark-toned cross-hatch shadows for the handbag and bench, and light/medium-toned blobs for the fabric folds in the jacket. Add pale criss-cross strokes for the straw hat and U-shaped strokes for the dog chain. Finally, add a few zigzag and broad, flat, pale strokes for the grass.

Community garden

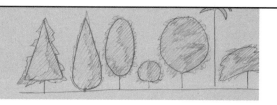

A community garden or allotment is a plot of land made available for individuals to grow food for the family or for a joint endeavour by a group of people. If you don't have time to sketch a whole plot, then draw just a few features. Alternatively, a planter, window box or potted plants make equally good subjects. The rows of plants draw you into the scene, with darker tones in the foreground giving the illusion of depth. This sketch shows it's possible to create a garden with simple strokes and tones.

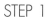
STEP 1

Using an HB pencil, sketch the outline shapes of the shed, greenhouse, planted areas and dominant plants, such as the runner beans on the left.

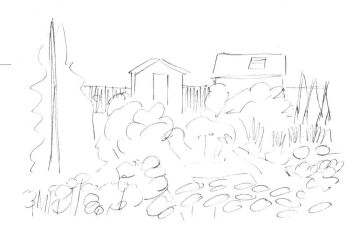

STEP 2

Add blocks of sketchy strokes in different directions and blob shapes to create a variety of textures – wooden shed, glass greenhouse, vegetables, herbs, flowers and foliage.

Winter landscape

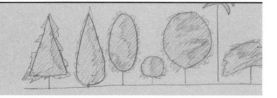

Charcoal strokes drawn on smooth white paper describe this upland winter scene. The very simple but effective criss-crossing thick and thin lines represent field boundaries in a snow-covered valley, and a few strokes define lines of fencing, a farmhouse and tree-speckled hedges.

Notice the lack of edges to this sketch; it appears to fade into the background, whereas the garden scene on p.111 has definite borders (the door frame). This type of drawing or painting is called a vignette.

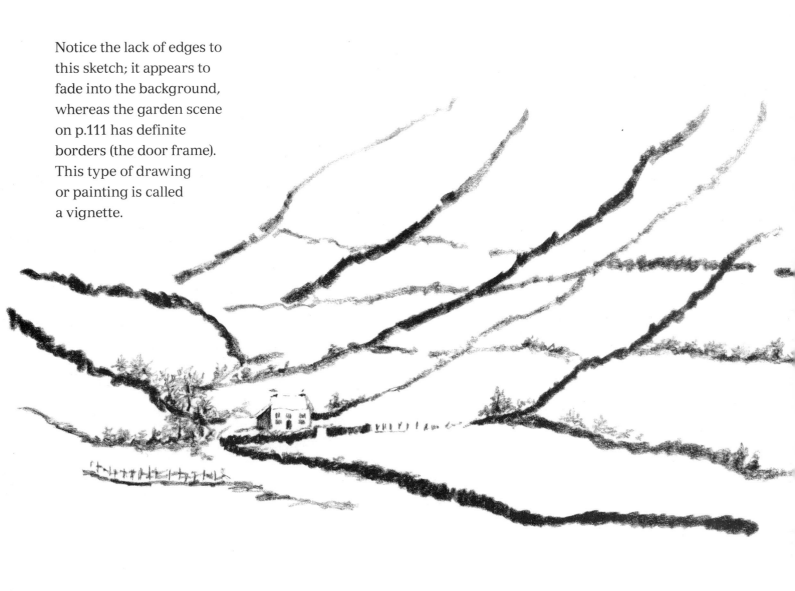

This scene is satisfying and relatively easy to create, especially if you leave out the farmhouse (it can be tricky to draw fine-lined features in chunky charcoal).

Trees in the landscape

Trees are common objects in many landscapes. Their appearance changes with season and scale (close-up or distant), so their textures vary accordingly. Here we'll look at examples from three main tree groups: palms (tropical trees), needle-leaf trees such as firs (conifers) and broadleaf trees such as oak.

At first, trees can appear overwhelmingly complicated subjects to draw, so rather than trying to capture every detail it's best to start with a basic overall shape then add simple textures. As you practise, you can add more detail, especially to trees in the foreground. We'll start with single trees and trees in landscape settings.

Some basic tree shapes, left to right: pyramidal, columnar, oval, shrubby, circular, fountain, broad, vase, windblown and weeping.

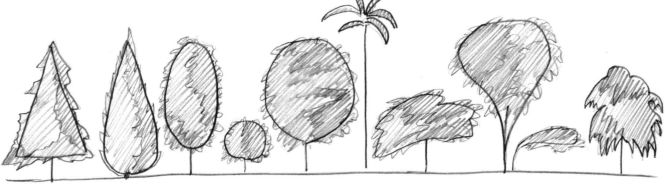

PALM TREE

This is an easy tree shape to draw, using sketchy strokes for the trunk and leaves. A mix of dark and light tones results in a more lifelike tree.

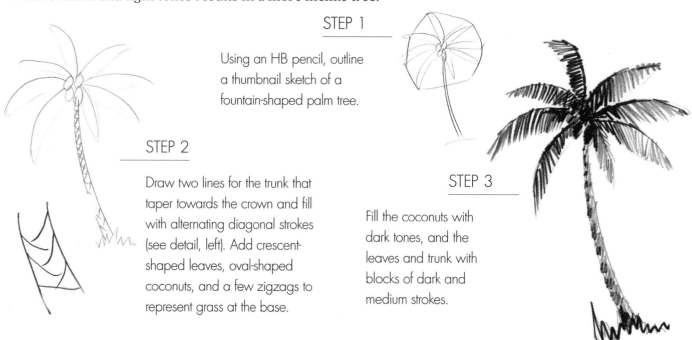

STEP 1

Using an HB pencil, outline a thumbnail sketch of a fountain-shaped palm tree.

STEP 2

Draw two lines for the trunk that taper towards the crown and fill with alternating diagonal strokes (see detail, left). Add crescent-shaped leaves, oval-shaped coconuts, and a few zigzags to represent grass at the base.

STEP 3

Fill the coconuts with dark tones, and the leaves and trunk with blocks of dark and medium strokes.

CONIFER

Conifers have cones and needle-like leaves and they often appear darker than broadleaf trees. Most look the same all year because they shed their needles continuously rather than having an autumn leaf-drop.

STEP 1

With a graphite stick, outline the pyramid shape of this single conifer and its elongated blobby branch shapes.

STEP 2

Fill with blocks of short vertical and diagonal strokes in medium and dark tones. Use darker tones on the left side to denote areas of deeper shadow. (If you wish to create a silhouette, use dark tones only.)

Conifers are often seen in large stands. Distant trees can be sketched merely as thin strips of dark- and medium-toned vertical strokes. Less distant conifers can be drawn as single vertical strokes with horizontal zigzag branches.

Conifer textures at different scales: stands drawn in aerial perspective with distant trees in paler tones, and individual trees in zigzag strokes.

BROADLEAF TREE

These trees can seem formidable to draw but just remember to focus on the overall shape first – you don't have to draw each leaf. If you add tones, outline major areas without adding much detail. Remember to leave gaps in the canopy as trees are not solid!

STEP 1

With a graphite stick, draw a faint circular outline first and add blob shapes for the main areas of light and dark tones.

STEP 2

Fill the blob shapes with sketchy strokes in dark and medium tones. Add a few short, thick, dark strokes to indicate branches.

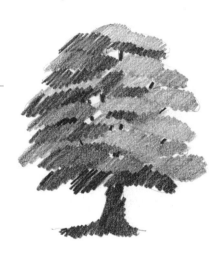

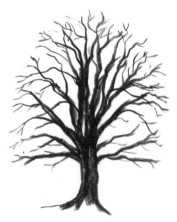

Single winter broadleaf tree.

Broadleaf trees are mostly deciduous, bear flowers, fruit or nuts, and shed their leaves in winter. Deciduous trees look very different when their branches are bare and you can see their structure clearly, as in this example.

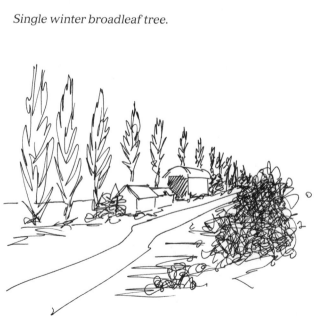

These two quick pen and ink sketches record a row of poplars and a viaduct bank covered in trees. They are not very detailed, but the use of perspective and scribble lines captures the essence of each scene.

TREES IN A RURAL LANDSCAPE

This rural scene, drawn with a graphite stick and 4H pencil, shows how a mixture of elements in a gently undulating landscape can be created easily on paper. The small road winding past fields and hedges into the distance and the use of aerial and linear perspective present the illusion of space and depth; the tones become lighter in the distance, the road narrows and fence height diminishes. Trees are portrayed in different ways in the scene.

STEP 1

Outline the main landscape features: fields, trees, hedges, hills, road, foreground fence.

STEP 2

Sketch distant features in strips of light tone (using light pressure). Use sketchy medium/dark diagonal strokes to complete the trees in the middle distance.

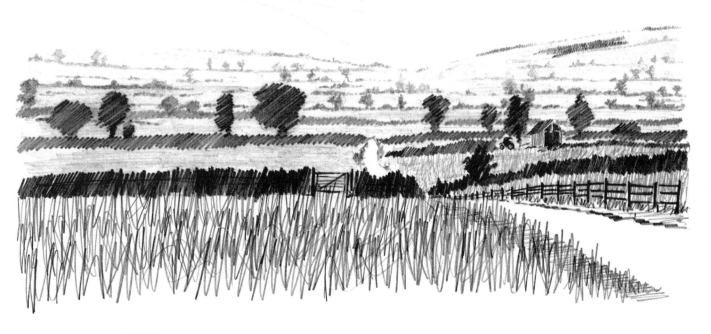

STEP 3

Sketch rough, vertical, zigzag strokes to create the illusion of standing crops in the foreground fields. Use shorter strokes for more distant fields. Define other elements in sketchy strokes (hedges, trees, barn and tractor). If needed, use an eraser to gently lighten the tones in the distance to add an air of soft, bright haze. Use a 4H pencil to shade the fields in rough horizontal strokes.

Water in the landscape

Although water is a vital element in the landscape, it is usually defined by its surroundings as it has no shape or colour. However, its appearance can change depending on whether it lies within the soil or is shaped by a stream, river, lake or ocean, and it may be coloured by soil, algae, chemicals or reflections.

The water surface can reflect the sky, surrounding landscape and man-made structures such as bridges, while underwater features such as rocks may also be visible. Reflections can be mirror-like or splintered into thousands of shapes, depending on whether the surface is calm or rough, still or moving. This versatile element can also be found as snow, ice or in clouds as water vapour.

Drawing water may appear difficult at first, but careful observation usually reveals simple repeating patterns. We'll look at this element in different environments in examples that range from easy to more challenging.

STILL, CALM WATER

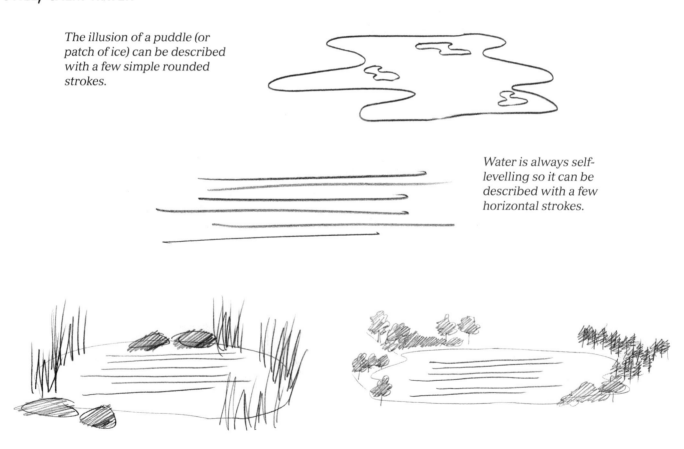

The illusion of a puddle (or patch of ice) can be described with a few simple rounded strokes.

Water is always self-levelling so it can be described with a few horizontal strokes.

Simply add a few boundary details such as vegetation to achieve a sense of scale. Here, the same horizontal strokes imply calm, still water and could represent a small pond or a large lake.

LAKE AND MOUNTAIN VIEW

This view of mountains and a lake through birch trees was sketched with a graphite stick on smooth white paper. It presents an interesting view of overlapping shapes and uses a range of textures.

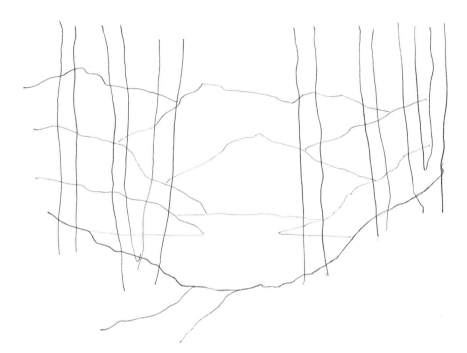

STEP 1

Outline the main features first (tree trunks, mountains, lake), then erase the 'mountain' outlines from the tree trunks.

STEP 2

Use very light pressure to fill in the mountains with sketchy strokes in graduated pale tones, the strokes radiating downwards and outwards from each summit. In places, leave small gaps between successive shapes to represent highlights.

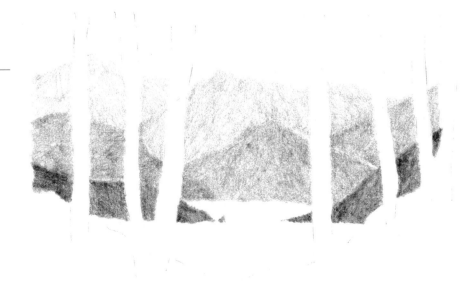

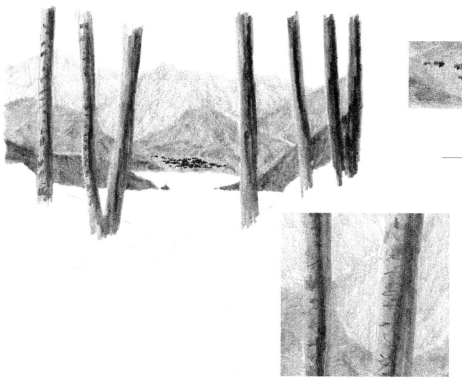

STEP 3

Sketch the town in very small dark-toned regular shapes placed semi-randomly (see detail above). Shade the cylinder-shaped tree trunks using vertical sketchy strokes and graduated tones from dark to light to represent shadow and highlights. Add the bark details in medium and dark tones (blobs and short, thin, horizontal strokes).

STEP 4

Add two boats as triangular shapes. Leave the lake blank to denote calm, still water. Its brightness is emphasized by the surrounding darker tones. Sketch the ground in rough, dark strokes following the direction of the slope, then add a few tones scattered along the path.

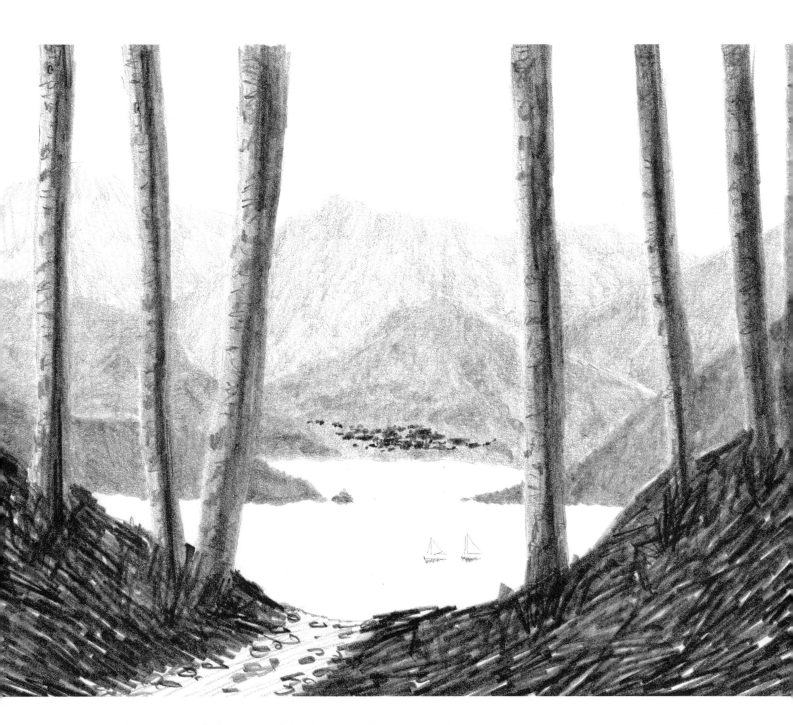

Finally, crop the image to tidy the edges of this sketch and show a more pleasing composition.

BOAT ON THE WATER

Horizontal strokes also suggest peace and tranquillity, as in this graphite drawing of a rowing boat moored alongside a small jetty with a tent pitched on the bank.

In the final sketch, notice that no outlines are used to show the edges of the tent and upper edge of the boat; instead, they are defined by the background vegetation.

STEP 1

Outline the shapes first, including the dense vegetation in the background.

STEP 2

Use rough, short, sketchy strokes in dark, medium and light tones to describe the background shrubs, trees and vegetation textures at the water's edge. Use dark tones to denote the shadows in the tent canvas.

STEP 3

Shade the water in blocks of dark, medium and light horizontal strokes. Use uniform tone to define areas of smooth water, and fine dark lines to describe surface ripples and broken reflections. The tent and jetty post reflections in the water should be left blank.

MOVING WATER

Where it is not contained, water falls to sea level in streams and rivers. Moving water can be very tricky to capture on paper, but you can create the impression quite simply with a few sketchy strokes, as shown here.

Lazy zigzag strokes indicate gentle waves on the surface of deeper water (left), while vertical lines suggest water pouring over a waterfall (below).

In the scene below, the horizontal strokes represent fast-moving water approaching an impending drop. The swirling strokes on the white background indicate misty clouds of spray at the base of the waterfall.

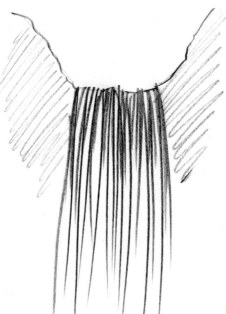

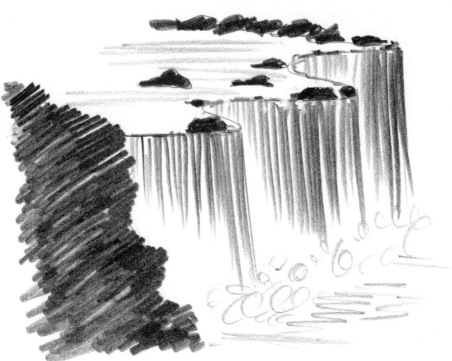

Dashed strokes represent light or intermittent water flow, as in this watering can spray. Note that the shapes are defined by areas of tone only, not lines.

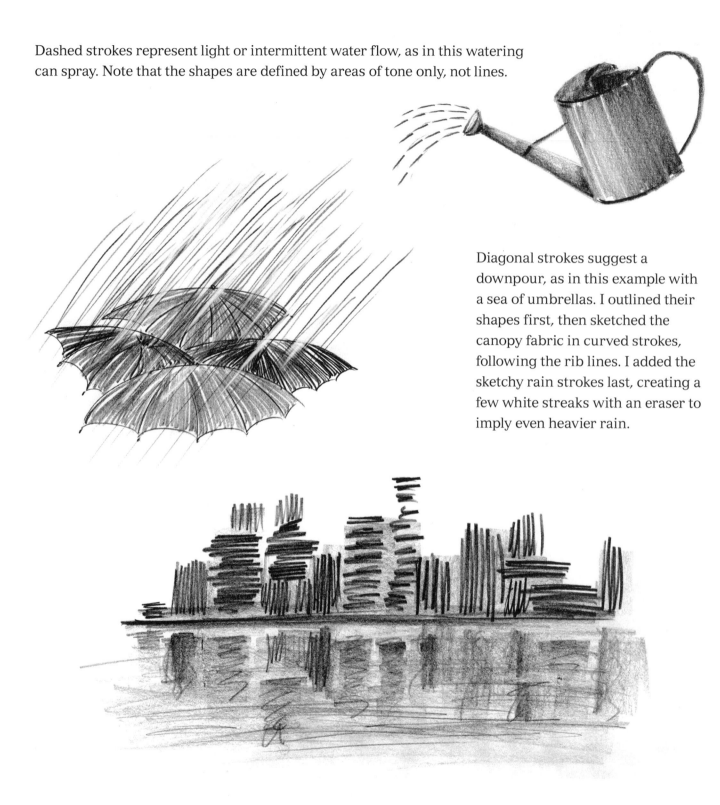

Diagonal strokes suggest a downpour, as in this example with a sea of umbrellas. I outlined their shapes first, then sketched the canopy fabric in curved strokes, following the rib lines. I added the sketchy rain strokes last, creating a few white streaks with an eraser to imply even heavier rain.

A much larger body of moving water is depicted in this abstract image of a river with city skyline. It was completed with sketchy strokes in graphite stick.

BRIDGE AND BECK

Here, a bubbling stream is sketched in soft, pale tones following the direction of the water flow. This is a more complex sketch, but tackling it in three stages will make it easily manageable.

STEP 1

With a graphite stick, roughly sketch the outlines of a bridge and stream.

STEP 2

Outline blob-shaped pebbles in the stream and rows of stones in the bridge. Sketch the vegetation as strings of leaf shapes and zigzags for grass.

STEP 3

Roughly fill the stones in the bridge with light and medium tones, adding dark tones along their lower edges and underneath the arch. Add light-toned patches to the water to denote an uneven surface, then add darker-toned edges to the stones in the stream. Sketch the vegetation along the bank in medium-toned short vertical strokes (grass), circles (individual leaves), and darker V-strokes (ferns).

SEASHORE

Try to capture the essence of moving water in this scene with waves breaking on the shore. The high tonal key and low tonal contrast give this landscape a peaceful, summery atmosphere.

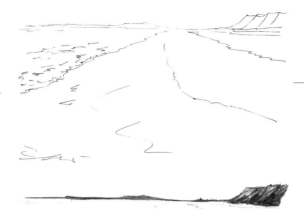

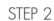

STEP 1

With a graphite stick, sketch the shoreline, horizon and low cliffs.

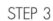

STEP 2

Apply light and medium tones to define the silhouette of land on the horizon and the cliffs in the middle distance.

STEP 3

Sketch small swirling strokes in darker tones to describe the breaking waves, then linked, curving strokes in lighter tones to define the incoming waves. Add patches of uniform tone in sketchy strokes to show areas of wet and dry sand, then put in the beach debris in small scribbly strokes.

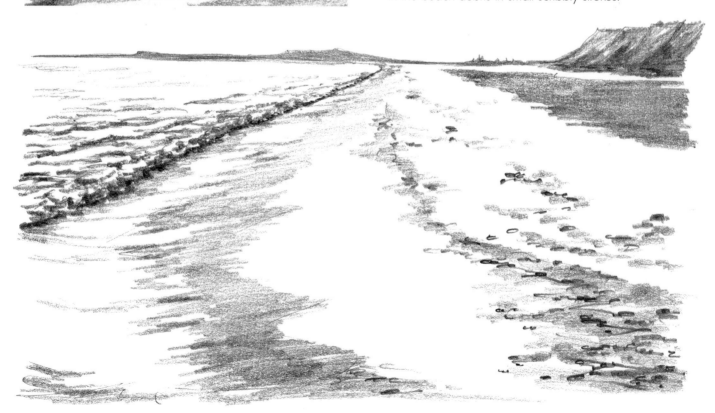

LIGHTHOUSE

Moving water does not get more
dramatic than a stormy sea. This
example uses very loose strokes
to describe the tumultuous water,
contrasting with the simple lines of
the sturdy lighthouse.

With a graphite
stick, sketch the
main shapes of
the lighthouse
surrounded by
breaking waves
and spray.

Use closely spaced medium-toned vertical strokes
for the stripes of the lighthouse and dark-toned
strokes for the upper balcony and lamp housing.
Add the waves in very loose swirly strokes, using
the edge of the graphite stick.

Skies

The element of air is all around us and the sky is where we see its effects most clearly – for example, when the wind is blowing, when weather systems bring changing seasons, and when thermals give rise to clouds and rain. Air is mostly invisible, except in mist and fog.

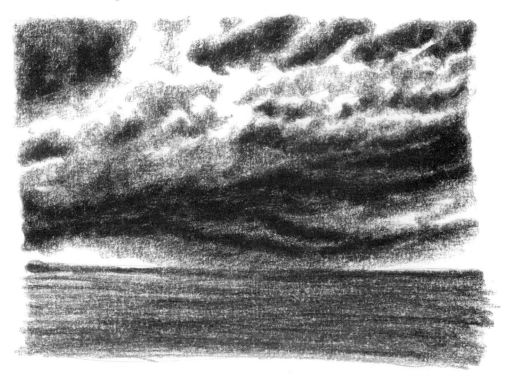

This stormy sky with low, menacing clouds over darkened fields has hints of brighter weather in the distance beyond the falling rain. Completed in charcoal, the drama is created with the high tonal contrast, which is perfect for this skyscape. Soft, blended, swirling strokes define the billowing clouds.

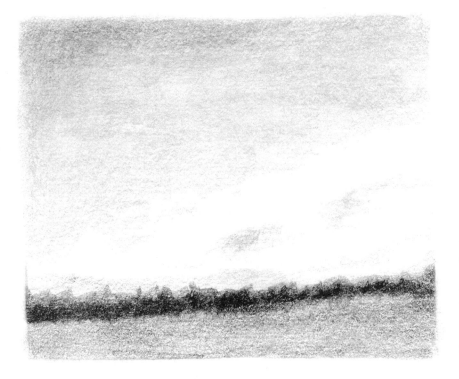

By comparison, this sunny sky created very softly in graphite has low tonal contrast. The darker tones are confined to the row of trees in the landscape below. I used very light pressure to sketch the horizontal strokes of the sky with the flat of the graphite lead, then blended the area with a cotton cloth. To create a more realistic sky, I added slightly darker tones in the top left-hand corner and erased a few areas to give the impression of clouds.

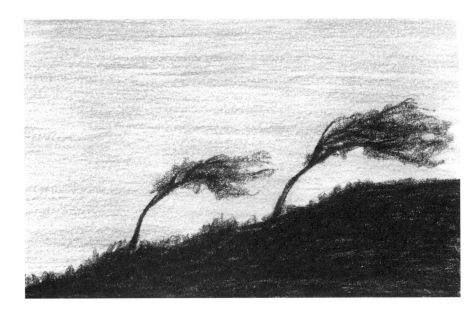

More dramatic effects were created in charcoal pencil in this high tonal contrast sketch of trees silhouetted against a pale sky. Light, horizontal strokes define the sky, then the edge of the charcoal pencil is used to describe the windblown trees and softer foliage.

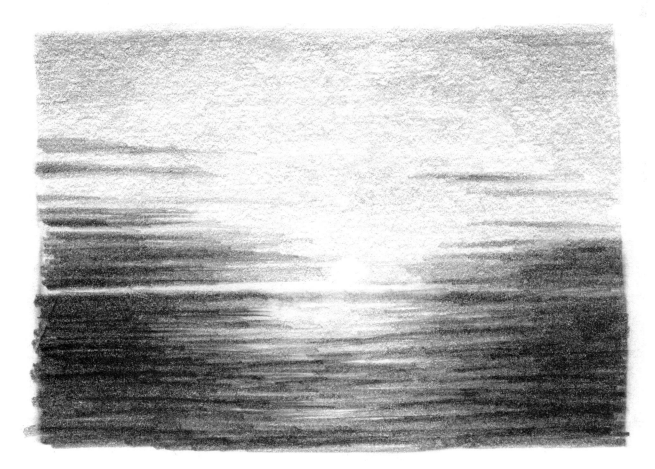

This sunset scene uses horizontal strokes in light-, medium- and dark-toned graphite. A few medium-toned streaks in the sky indicate clouds and the ribbon of white defines the horizon. I created the sea with single strokes of varying pressure, drawn from the outer edges and tapering towards the centre. Where areas of sun glinted on the water I left the paper blank, but I used an eraser to create a small circle for the sun itself.

Iconic vehicle

Vehicles are very common objects in modern landscapes and this Land Rover is an iconic example, known throughout the world since 1948. It's important to get the shapes and proportions correct at the start of the drawing, so you may find it helpful to use a grid (see p.37).

There are no new shapes or shades in this drawing, though you do need to take extra care when sketching the various elements. In the case of trees, no one will know if you draw a few branches out of place in your particular subject, but it's important to draw vehicle components more accurately.

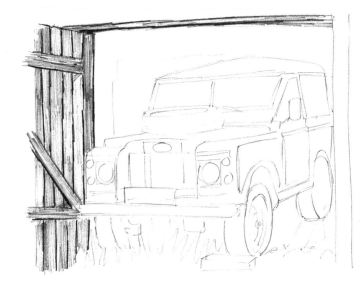

STEP 1

With an HB pencil, outline the vehicle and surrounding barn. Use wood textures to complete the door and upper part of the door frame.

STEP 2

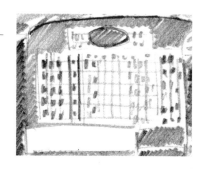

Fill the background with dark and medium tones, taking care to avoid sketching over the vehicle. Next, block in the front wing and bonnet panels in medium- to dark-toned diagonal strokes, leaving some white strips to indicate a shiny metal texture. In darker tones, fill in around the circle shapes and squares to emphasize the headlamps and lights and add an oval shape in medium tones for the name badge. Add the radiator grille – a simple grid pattern with a few small squares of medium tones (see detail, above).

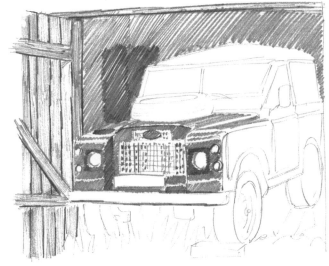

134

STEP 3

Add blocks of medium to light tones to the remaining bodywork panels, then apply very dark tones to define the wheel arches. Use a few diagonal strokes to denote the reflective windscreen glass. The tyre on the bonnet is defined by a few curved and ellipse strokes and the tread by short alternating diagonal strokes.

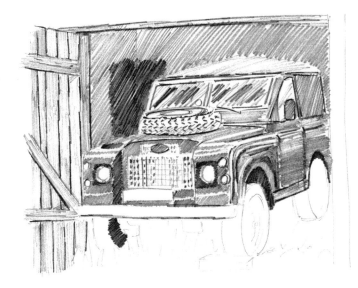

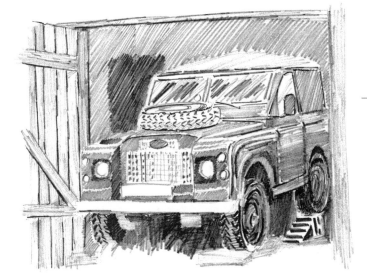

STEP 4

Complete the other tyre treads in the same way. Draw the negative spaces of the wheel ramp as a series of dark strokes and use darker strokes to fill in the spaces underneath the vehicle.

STEP 5

Add vegetation to the foreground as short vertical strokes, then erase small streaks, cutting into the dark shading under the vehicle to create a spiky grass effect. Lighten the door panels by lifting the pencil off with an eraser and add thin dark lines to the door surround to enhance the wood texture. Adjust any tones, for example, darkening the garage background slightly, and neaten edges, such as along the vehicle roof.

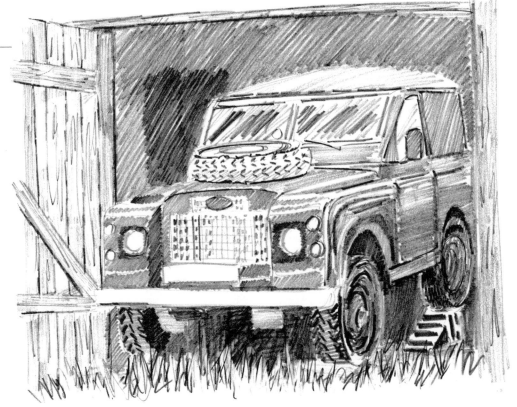

Historic building

This historic building, The Bury in southern England, is challenging to draw because of the intricate architecture, vegetation details and two-point perspective. Sometimes it can be difficult to work out the perspective and find the vanishing point in a landscape, but if there are buildings, as in this example, you can usually follow the line of roofs or windows.

STEP 1

Identify the vanishing points then lightly sketch perspective lines in HB pencil to help you achieve the correct shapes and proportions of the house, vegetation, overhanging branches, driveway and gateway.

STEP 2

Once you have achieved the desired shape and proportion, erase any unwanted guidelines. Refine the window, roof and stonework outlines on the house.

STEP 3

Sketch the outlines of overhanging branches and individual leaves and shade in medium- and dark-toned sketchy strokes.

STEP 4

In medium and dark tones, sketch the chimneys, window surrounds, lines of the roof tiles and shadows in perspective. Add a few rectangle shapes to the walls of the house to give the impression of brickwork. Complete the stone gateposts and adjoining brick walls in softly shaded medium-toned swirls.

STEP 5

Add shrubs along the front of the house in medium- and dark-toned sketchy strokes.

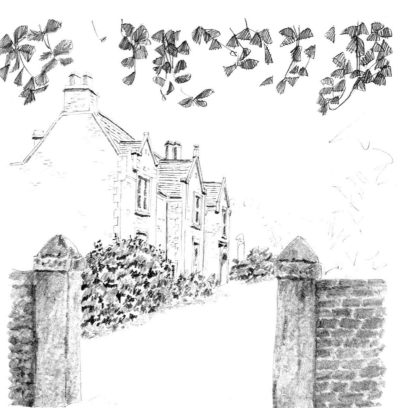

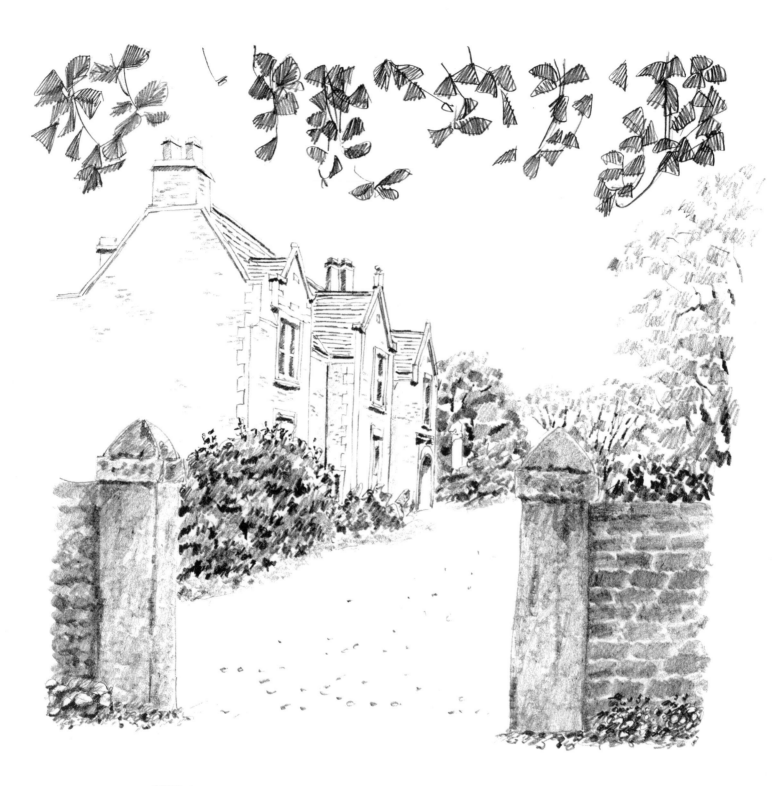

STEP 6

Add the distant trees and foreground vegetation on the right hand side in medium and light tones. In dark/medium tones add the small plants at the base of the wall in the foreground. Finally, add a few pebbles to the driveway.

Nightscape

This nightscape in HB pencil and graphite stick is in two-point perspective and shows two well-lit apartment blocks set against a night sky backdrop. It's an example of drawing negative spaces (see p.26). Obviously, it's difficult to sketch at night, so you may prefer to draw from memory, make notes or quick reference sketches at the time, or take reference photographs.

STEP 1

With an HB pencil, sketch the overall shapes and lines of perspective to achieve the desired proportions.

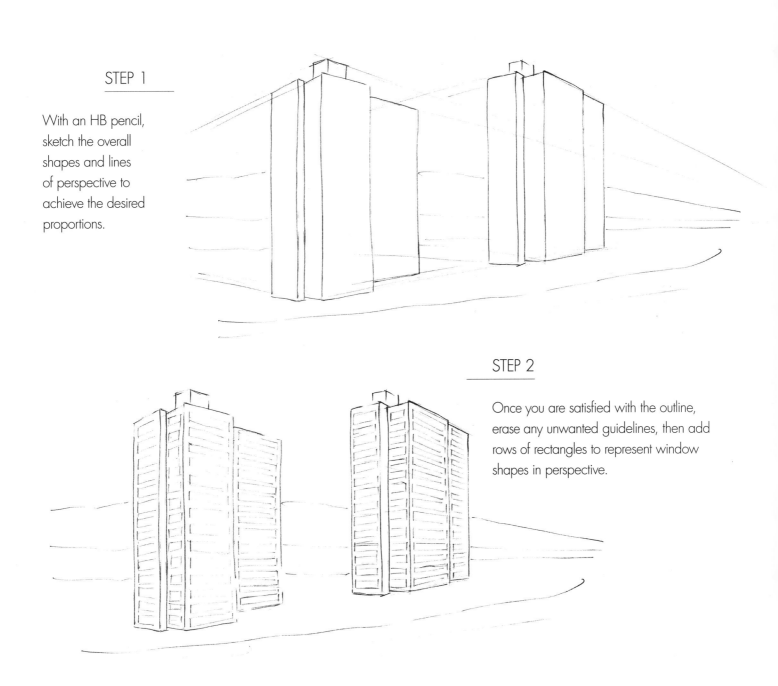

STEP 2

Once you are satisfied with the outline, erase any unwanted guidelines, then add rows of rectangles to represent window shapes in perspective.

STEP 3

Add vertical strokes in medium- to dark-tone graphite stick to denote the left hand edge of individual windows (see detail, above).

STEP 4

Using light- to medium-toned vertical and horizontal strokes, fill in around the windows to create a lattice-like grid, leaving the window shapes blank to represent the illuminated windows (see detail, left). Add slight shadowing in medium to dark tones to the roof structure and some of the walls.

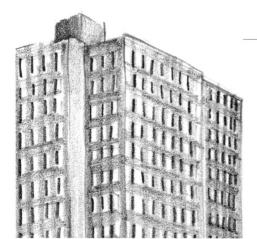

STEP 5

Next, add the very dark-toned background hill and medium- to dark-toned foreground areas. Begin to fill the night sky with sketchy, diagonal, medium-toned strokes, taking care not to draw over the apartment blocks. Add a few dark-toned vertical strokes to the foreground to give the impression of street lamps.

STEP 6

Complete the night sky in dark tones, sketching more than one layer if needed. Add dark-toned vertical strokes to denote fencing details at the base of the apartment blocks (see detail, left). Finally, you may decide to crop the image to neaten the edges of the sketch.

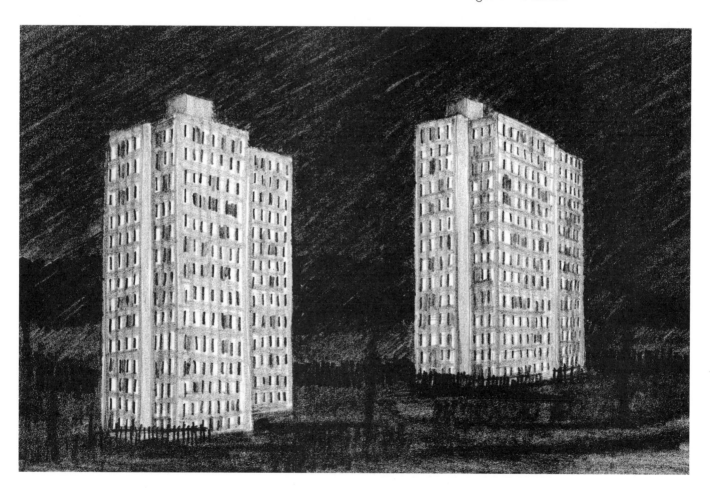

We have now covered a range of landscapes and elements within them, but while they have been full of detail and texture they have been devoid of living things. These will be the subject of the next two chapters – animals and people.

Chapter 5
Animals

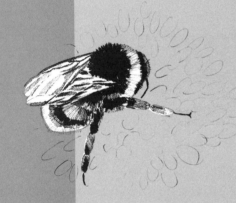

Animals have always been a popular subject for artists; on cave walls around the world there are pictures of horses, bison, cattle and deer dating back to prehistoric times. So, as part of a long tradition, we now look at drawing a variety of animals, including wild species, domesticated animals and pets. Animals are no more difficult to draw than anything else, but they won't necessarily remain still as long as you would like. The trick is to get all the strokes, shapes and shades in the correct place without delay!

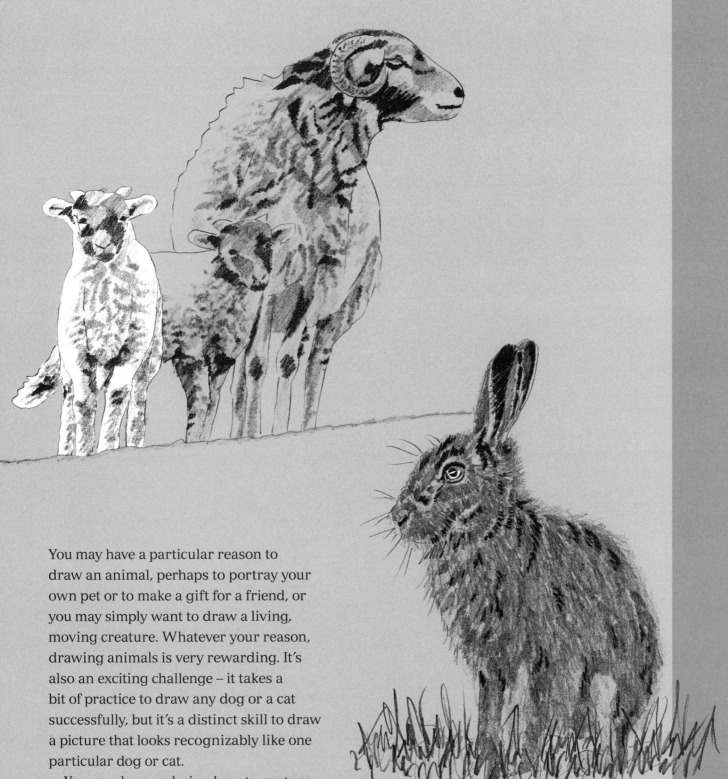

You may have a particular reason to draw an animal, perhaps to portray your own pet or to make a gift for a friend, or you may simply want to draw a living, moving creature. Whatever your reason, drawing animals is very rewarding. It's also an exciting challenge – it takes a bit of practice to draw any dog or a cat successfully, but it's a distinct skill to draw a picture that looks recognizably like one particular dog or cat.

You may be wondering how to capture a likeness when you have features such as eyes, ears and noses to master and the complex textures of fur to reproduce convincingly. However, this is where you reap the rewards of all your drawing practice so far, gauging correct proportions and drawing subtle changes in tone. We'll start with simple sketches and work towards much more detailed portraits at the end of the chapter.

Choosing your subject

It's best to start by sketching something straightforward, like a single animal, and building technique and confidence rather than attempting an ambitiously large and detailed subject, such as a herd of cattle, and becoming thoroughly disheartened. Begin by sketching an animal such as a family pet, whose habits and poses you are familiar with. Pick one that's likely to be in the same position for a while, such as a sleeping dog, or a cat dozing on a sunny windowsill. If you don't have a pet at home, there are plenty of other places you can find animals to draw, such as parks, farms or wildlife sanctuaries.

If your subject is moving, you'll only be able to sketch a quick impression. Birds are rarely still for long, but you can always capture features in quick sketches or photographs for reference later, especially if you want to produce a more detailed piece of work. Later, as you become more experienced, you can draw multiple subjects in different settings.

Keep it simple and start with a small, single subject rather than a group of large animals.

CATCHING A POSE

Think about the subject you'd like to capture and use your observational skills to consider suitable poses. It might be an animal in action or repose; a head-and-shoulders portrait; a whole animal; or, when you have had some practice with animal drawings, a group of animals complete with background.

Be realistic and allow sufficient time to produce your sketch or drawing. It's a simple fact that bigger, more complex, subjects take longer to draw! The amount of time you have will dictate the style, size, and amount of detail you can include.

Use reference material about your chosen subject if necessary, including preliminary sketches and photographs. The latter are useful as they can show details you may have forgotten to sketch at the time. Photographs are also great if your chosen subjects are species that are not local or move too quickly for you to sketch, such as birds on a feeder. Remember that if you use someone else's photographs, most images are copyright protected and you will need to ask permission to use them if you wish to go any further than making drawings for your own practice and pleasure.

If you photograph your subject it's best to use natural light outdoors, though you should avoid your subject looking directly into the sun. Think about how much detail you'll need in your photograph (how near your subject is) but beware of photographing at very close range as foreshortening may occur to varying degrees according to the length of your lens and the conformation of the animal.

If possible, photograph at the animal's eye level and with their eyes in focus. Take plenty of reference photographs from different angles, and remember you can always add, omit, or change background details in your drawing.

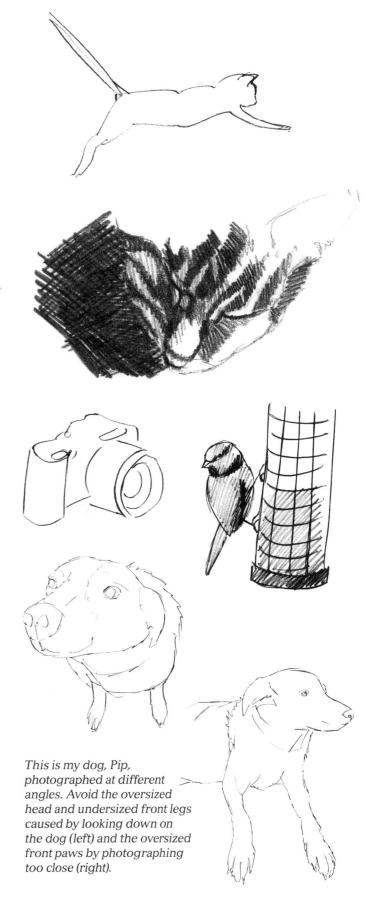

This is my dog, Pip, photographed at different angles. Avoid the oversized head and undersized front legs caused by looking down on the dog (left) and the oversized front paws by photographing too close (right).

Planning your picture

Once you've chosen your subject and pose, the next step is to plan your drawing on the page. If your subject is looking to one side, as in this cat sketch, allow more space in front of it so that it doesn't appear squashed at the edge of the page (or frame).

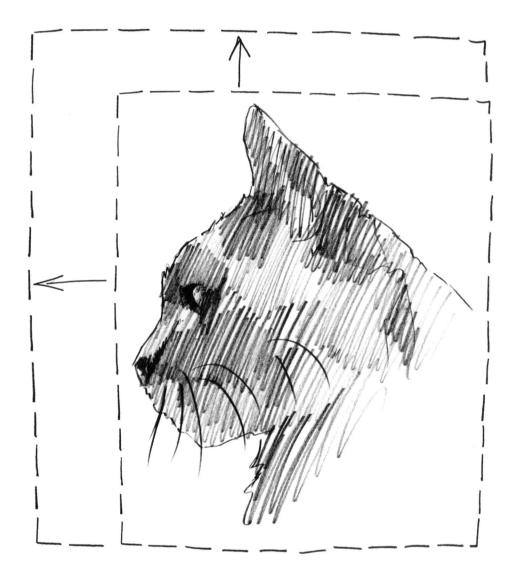

Similarly, avoid protruding features such as ears touching the paper edge and if you crop a subject, don't chop it in half, crop at a limb joint, or cut off the head – it's best to crop a tail! Except for head portraits, if you do trim a picture, leave at least three quarters of the subject visible.

MULTIPLE SUBJECTS (facing page)

If you think your subjects may not fit into your composition, you can always reposition them – tracing outlines onto separate sheets and moving them around until you find a pleasing arrangement is an easy way of doing this. Alternatively, leave the least important ones out altogether. It's best to place your main subject slightly off-centre rather than in the middle of the scene, and a viewfinder can help you with this when planning your drawing.

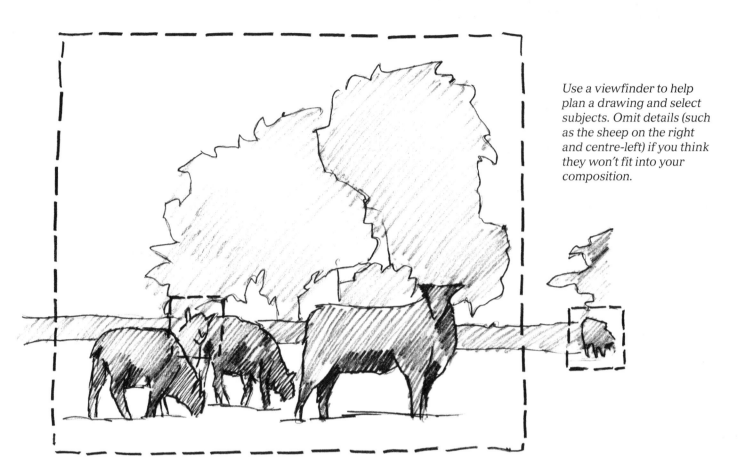

Use a viewfinder to help plan a drawing and select subjects. Omit details (such as the sheep on the right and centre-left) if you think they won't fit into your composition.

Two subjects will look better if they overlap rather than just touching or standing slightly apart. Move subjects if necessary, as in this example where the sheep on the left was moved to the right.

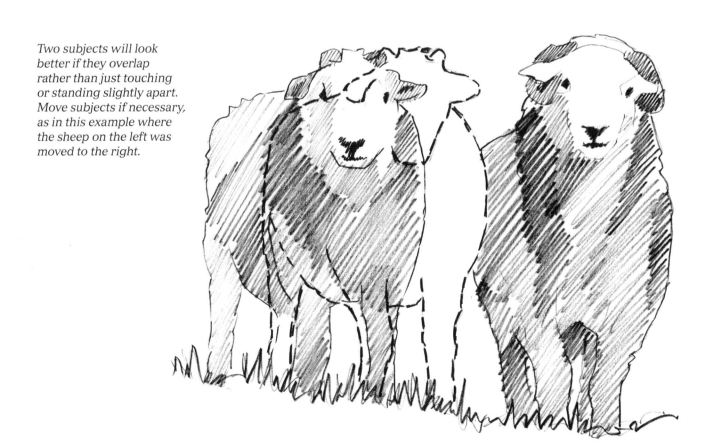

Shapes and proportions

When drawing animals, it's very important to place the features correctly at the start. First, quickly sketch the overall shapes and proportions, then add other lines that characterize main features such as wings or limbs. Simply draw what you see before you, taking care not to draw your preconceived idea of what the animal should look like. You'll find it soon becomes easier to sketch characteristic animal shapes, which are often best seen in profile. You can add textures later, when you become more proficient.

Divide your subject into easier sections to draw. Use body parts to measure proportions by judging their relative size. For example, is the body four times the length of the head? Is the front leg the same length as the body? (See p.36 for different ways to estimate proportions.)

Animals come in all shapes and sizes and can often be defined with just a few lines. We'll start the exercises with an insect or two – very small animals! – before studying larger species.

I selected a butterfly because it is a simple symmetrical shape, with a very thin body compared to its huge wings. Once you have outlined the wings, you can fill them with a variety of patterns.

STEP 1

With an HB pencil, sketch the shapes of the wings and body and add the antennae in faint lines. You can erase these later.

STEP 2

Erase unwanted guidelines, refine the details, then add wing patterns.

148

Don't worry if you're not used to drawing animals from life and find it difficult at first – you'll improve with practice! The following butterflies are examples sketched by beginners.

Uneven shapes: if you find it difficult to achieve the correct proportions and symmetry, try using a pencil and rule of thumb, a grid or a ruler to help measure and lay out your work.

Overworking: try not to draw too many outlines and overwork a sketch, unless this is an effect you want to achieve. Draw initial outlines faintly so you can erase them later if they don't look right or you don't want them to show. You're bound to find some shapes more difficult to draw than others but relax, keep going, and you will get better!

Experiment: once you've mastered the shapes, you can experiment with shading and even try sketching with few or no outlines! Notice the different effects when you sketch with and without outlines.

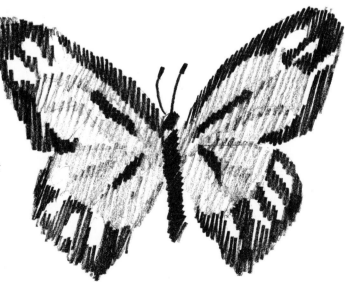

Bee on a flower head

This bee is a little more complicated to draw than the butterfly, but still easily accomplished. You may decide to leave it as an outline sketch or add more detail and tone. Remember, you don't have to draw dark, thick outlines or fill everything in – your drawing will benefit if you leave soft edges and some white space among the features.

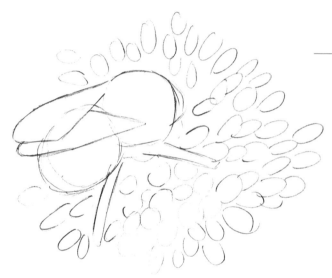

STEP 1

With an HB pencil, sketch two faint circles for the bee head and body, the diamond-shaped wings, and two long rectangles for legs. Add concentric rings of oval flowerhead shapes radiating outwards from the centre.

STEP 2

Once you're satisfied with the rough shapes, lightly define the bee outline more carefully, adding more lines to denote the striped head and body sections. Draw veins on the wings and divide the rear leg into three equal sections; the front leg into two; and add a thin, hooked 'foot' at the end of each leg.

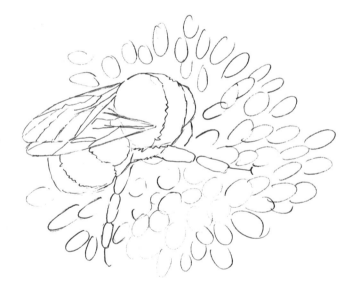

STEP 3

Partially fill in some of the geometric shapes on the wings in medium tones and add a few, thin, darker strokes for the veins.

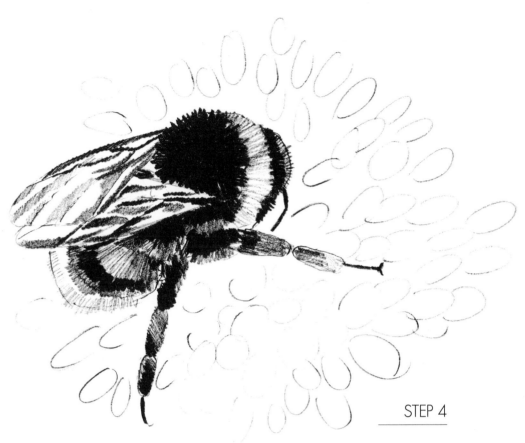

STEP 4

Complete the body and leg sections in stripes of dark, medium and light zigzag strokes, following the body contours. If you need to, rotate the page to draw the 360-degree strokes on the head. Add short strokes for the 'feet' and antennae. If you like, leave the flower head unfinished so the bee appears to be more prominent. Look at your sketch carefully to check you've used a consistent amount of detail and tone across your work; in other words, ensure that the same tones don't change from one place to another.

PROBLEM-SOLVING

If you get stuck or are not sure where to start, just go back to basics and look at what's actually there in front of you. Try a smaller or easier subject, break your drawing into smaller parts, start with simple shapes, look for patterns and work on a little bit at a time, and you will soon build a complete picture. It can also help if you think about the subject and imagine any textures as you draw them.

If your drawing is more complicated, turn your work around and draw upside-down or sideways. It's a great way to see what's really there, not what you think is there.

If you're not sure that your drawing looks right, hold it up to a mirror, take a digital photograph, squint or close one eye to check it – any errors will be more obvious.

Remember there are no new strokes, shapes or shades in any of these subjects!

Birds

It's surprisingly easy to create the impression of a bird with a few simple strokes. Here is a selection of birds for you to sketch; hopefully, you'll recognize a few of them!

The shapes of these birds in flight are quite angular. They are subjects you would perhaps incorporate in the sky of a landscape scene. The different wing shapes and groups of birds all capture the sense of movement very effectively.

Seen from the side, these four birds show very different wing shapes.

This flock of birds can be drawn with triangular shapes (see outlines below).

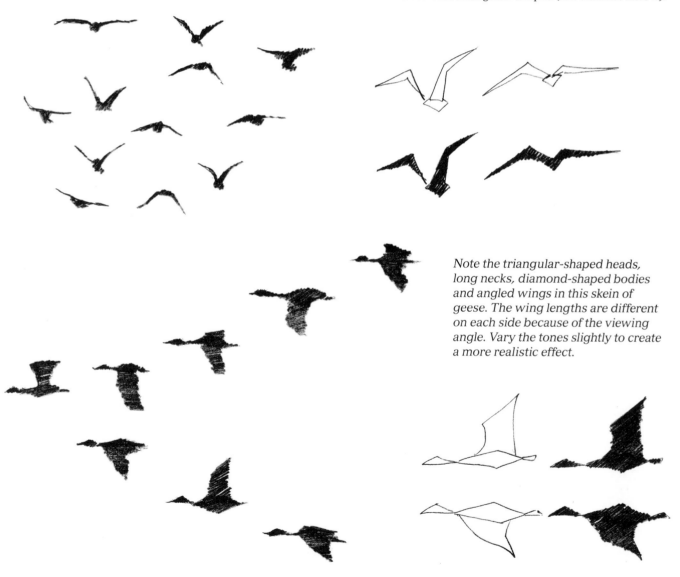

Note the triangular-shaped heads, long necks, diamond-shaped bodies and angled wings in this skein of geese. The wing lengths are different on each side because of the viewing angle. Vary the tones slightly to create a more realistic effect.

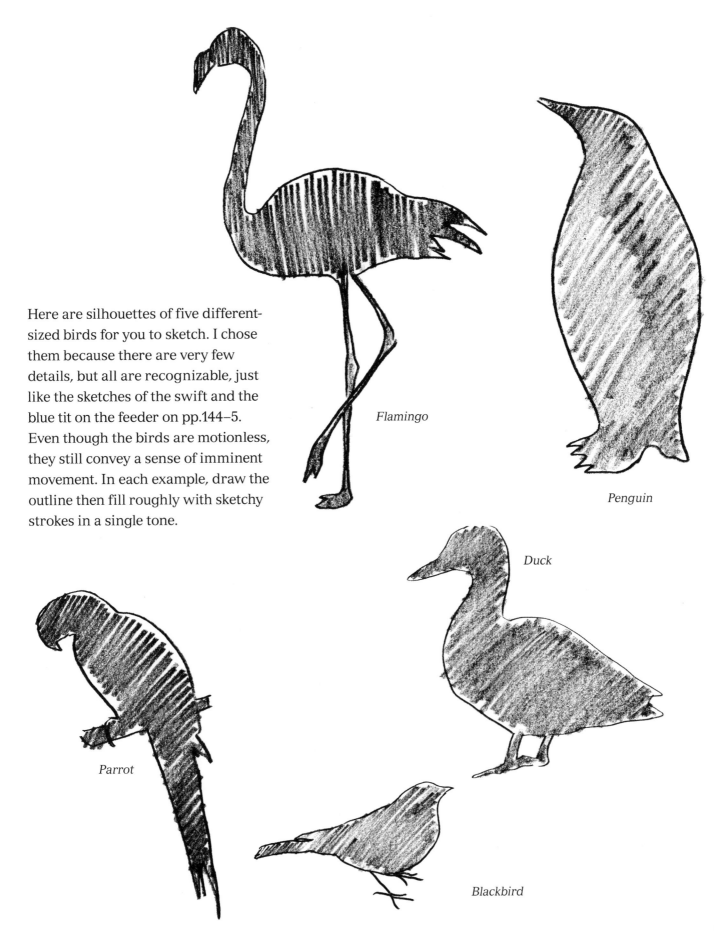

Flamingo

Penguin

Here are silhouettes of five different-sized birds for you to sketch. I chose them because there are very few details, but all are recognizable, just like the sketches of the swift and the blue tit on the feeder on pp.144–5. Even though the birds are motionless, they still convey a sense of imminent movement. In each example, draw the outline then fill roughly with sketchy strokes in a single tone.

Duck

Parrot

Blackbird

OWL IN FLIGHT

This step-by-step example is a bit more detailed and will take longer to draw. It shows how you can achieve a likeness and represent movement with still very few details.

This owl in flight, with legs and talons outstretched, has a high tonal key and low tonal range and is sketched mostly in light and light-medium values. As before, first sketch a rough outline in faint pencil then gradually add and refine the detail. If you want to create a more dramatic picture, add a dark background.

STEP 1

Using an HB pencil, outline the main shapes of the wings, head, body, legs and tail as accurately as you can. The outstretched left wing is roughly twice the length of the body, and the body is approximately twice the length of the head.

STEP 2

Carefully tidy the outlines then add eye, claw and some individual feather details.

STEP 3

When you're happy with the level of detail, lighten or erase any unwanted guidelines so they don't show in the finished piece, then use a blunt point to add blocks of sketchy strokes in medium to dark tones in rows along the wings and tail feathers. Note that the furthest wing is darker overall. Add a circle of short strokes around the eye.

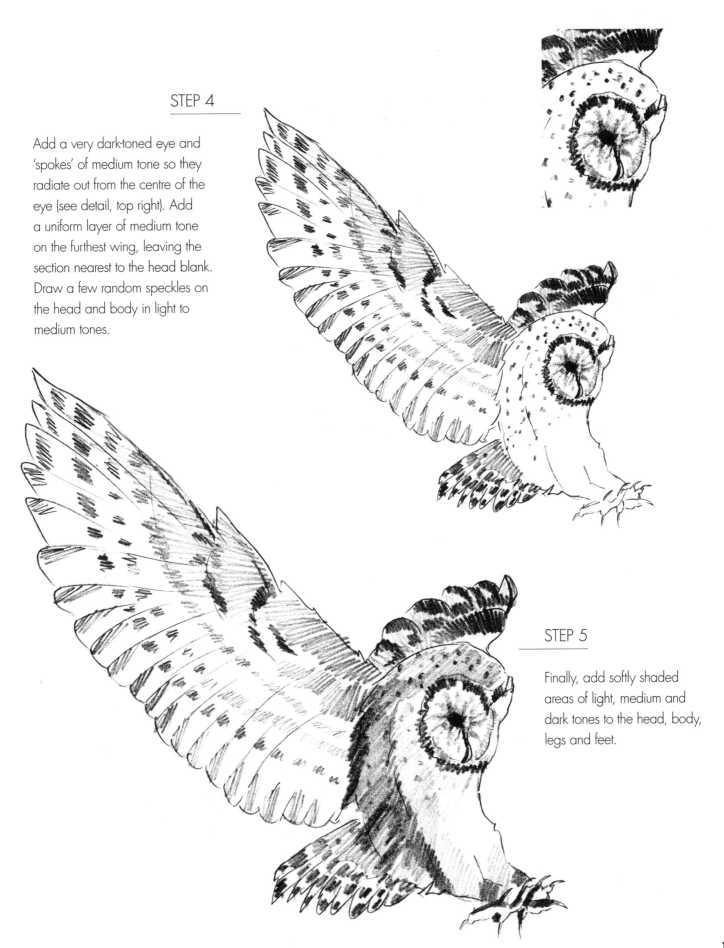

STEP 4

Add a very dark-toned eye and 'spokes' of medium tone so they radiate out from the centre of the eye (see detail, top right). Add a uniform layer of medium tone on the furthest wing, leaving the section nearest to the head blank. Draw a few random speckles on the head and body in light to medium tones.

STEP 5

Finally, add softly shaded areas of light, medium and dark tones to the head, body, legs and feet.

Reptiles

Reptiles are cold-blooded animals and include snakes, lizards, crocodiles, turtles and tortoises. They are easy to draw because of their simple shapes, especially the snake because it has no external body parts such as legs or visible ears. Reptiles are fascinating subjects because their skin is composed of geometrically shaped scales in fractal patterns.

WINDING SNAKE

STEP 1

Using an HB pencil, outline a thin wavy shape that narrows to a wedge-shaped head at one end and a pointed tail at the other.

STEP 2

Add a small dark mark for the eye, then small, slightly curved, criss-cross strokes all along the bottom edge of the snake. To create the shadows, use medium to light graduated tones, working over the criss-cross strokes. Add slightly darker values to the lower loops of the snake's curving body.

A SNAKE'S EYE

Sometimes it's fun to focus on a single element of an animal, such as an eye. The following exercise is a snake eye largely composed of geometric shapes. You should find it easier to complete this sketch if you practised drawing the texture of reptile scales on p.71.

ALLIGATOR

The alligator has a squat, stout body that is thicker in the middle and narrower at both ends; it has a barely discernible neck.

STEP 1

The alligator shape is very angular, so, using an HB pencil, lightly draw the outline as a series of geometric shapes.

STEP 2

Lightly erase the guidelines and smooth out the shapes, adding rounded triangle shapes for the teeth, claws and armour. Add the eye, then sweeping strokes to define the spine, body, and ribs.

Large wild animals

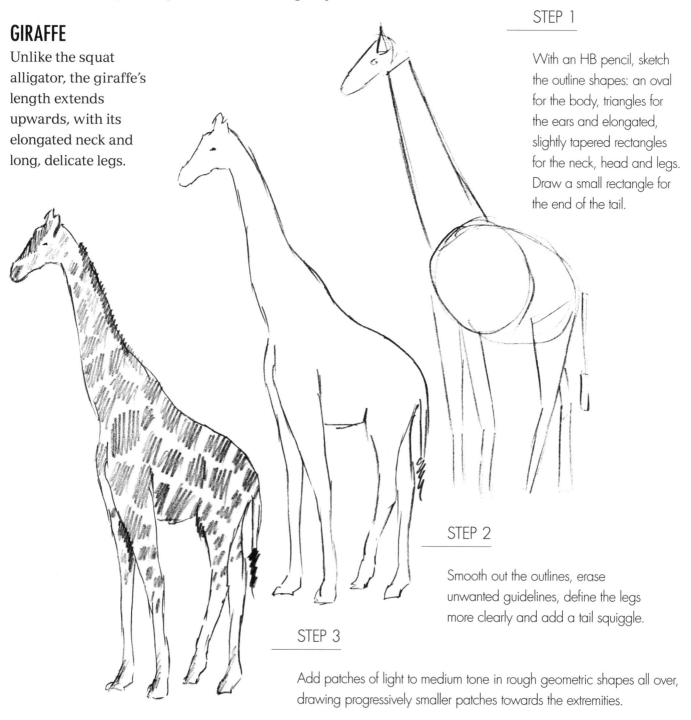

Here I have chosen the two largest land animals, each with a very different shape. The giraffe is the tallest terrestrial animal, with a neck that accounts for nearly half of its height. It looks long, thin and angular compared with the heaviest land animal, the elephant, which has a much more rounded shape. Although these two animals are large, you can still break them down into simple shapes, before adding any skin textures.

GIRAFFE

Unlike the squat alligator, the giraffe's length extends upwards, with its elongated neck and long, delicate legs.

STEP 1

With an HB pencil, sketch the outline shapes: an oval for the body, triangles for the ears and elongated, slightly tapered rectangles for the neck, head and legs. Draw a small rectangle for the end of the tail.

STEP 2

Smooth out the outlines, erase unwanted guidelines, define the legs more clearly and add a tail squiggle.

STEP 3

Add patches of light to medium tone in rough geometric shapes all over, drawing progressively smaller patches towards the extremities.

ELEPHANT

The elephant is the largest land mammal and has a
unique shape, with a large and very bulky body.

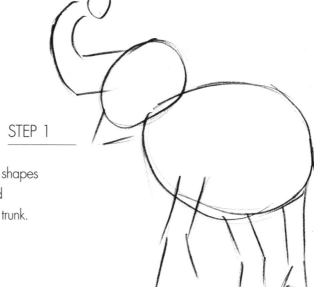

STEP 1

With an HB pencil, sketch rounded shapes
to describe the body and head and
rectangular shapes for the legs and trunk.

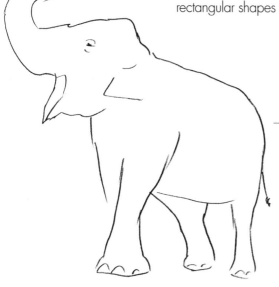

STEP 2

Smooth the outlines,
erase any unwanted
marks and refine the
details. Add the eye,
mouth, toes, and
tail tassel.

STEP 3

To add interest and create a more lifelike, three-dimensional sketch, add
texture details around the eye, following the 'elephant hide' texture example
on p.71. First, in HB pencil, sketch faint guidelines that follow the folds in
the skin, adding a few grid-like strokes in areas of more deeply folded hide.
Thicken the guidelines in dark-toned charcoal strokes, then add graduated
shading and softly blended tones in between the guidelines, leaving some
areas blank.

Horses

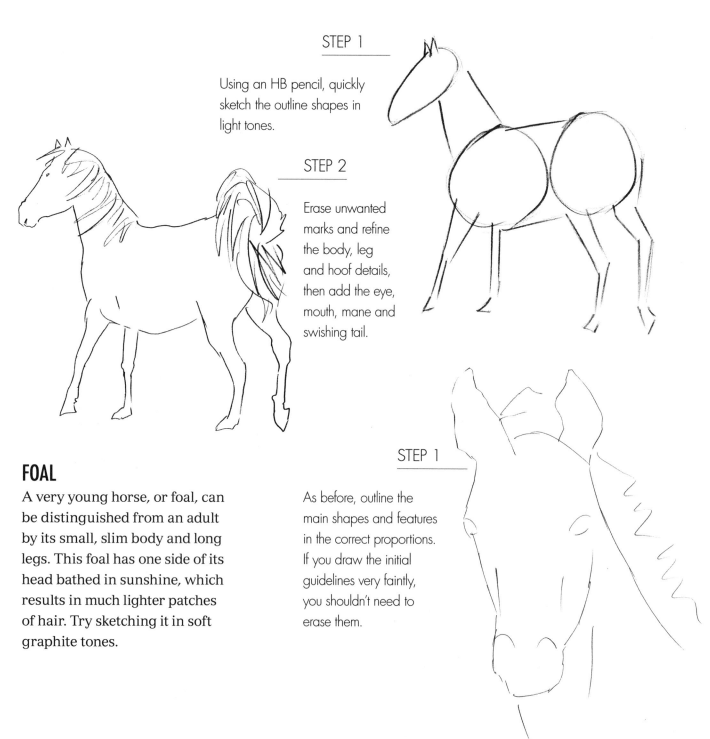

As domesticated animals are so familiar, you'll need to take extra care to draw from observation rather than from possibly misleading memory. This jaunty horse has rounded shapes for its head and body and lots of angular shapes in its legs and hooves. The curved, flowing shapes for the mane and tail help give the impression of movement.

STEP 1

Using an HB pencil, quickly sketch the outline shapes in light tones.

STEP 2

Erase unwanted marks and refine the body, leg and hoof details, then add the eye, mouth, mane and swishing tail.

FOAL

A very young horse, or foal, can be distinguished from an adult by its small, slim body and long legs. This foal has one side of its head bathed in sunshine, which results in much lighter patches of hair. Try sketching it in soft graphite tones.

STEP 1

As before, outline the main shapes and features in the correct proportions. If you draw the initial guidelines very faintly, you shouldn't need to erase them.

STEP 2

Add areas of dark tone to the ears, forehead, eyes, muzzle and mane. Use sketchy, zigzag strokes, as these work well for areas of rough coat.

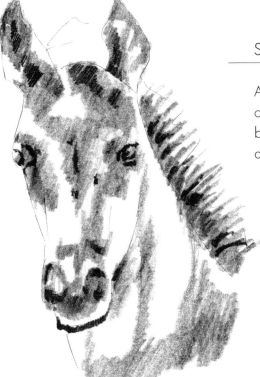

STEP 3

Add the larger patches of medium tone, blending gently with darker tones.

STEP 4

Sketch the areas of lightest tone, blending to leave softer edges, especially on the mane. Add a few eyelashes (see detail, below). Leave the sunlit areas on the left-hand side of the head blank, and erase the outline by the nostril and eyebrow to enhance the effect of light falling on the face.

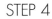

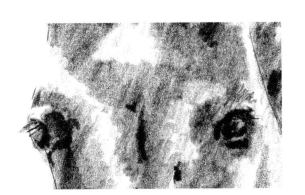

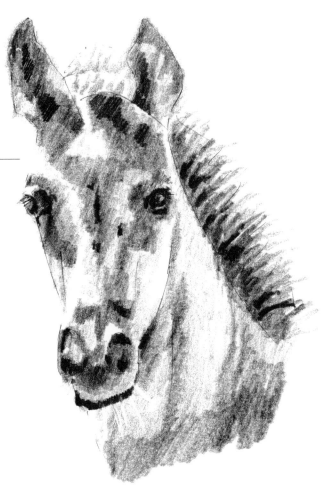

Sheep and lambs

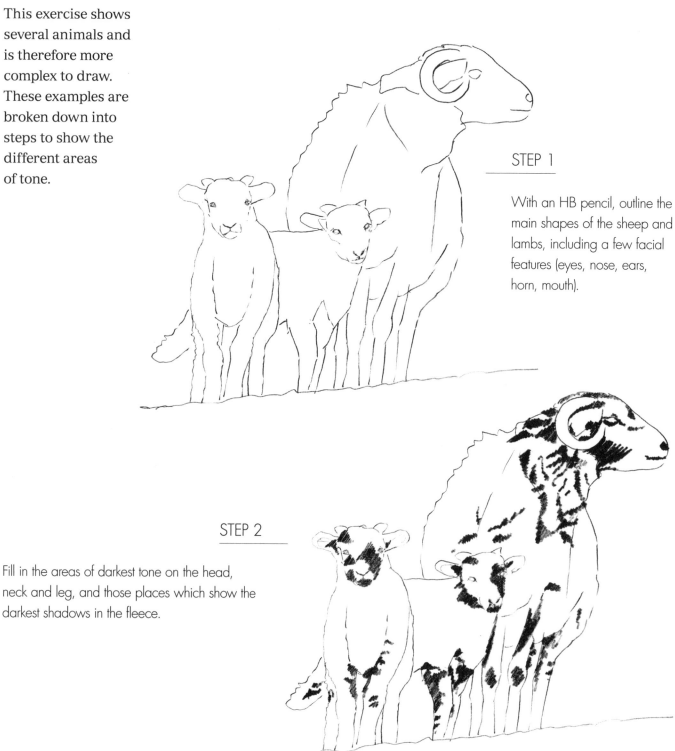

Here is a mountain sheep (a Swaledale) with her two young lambs standing close to her. The mother's fleece is much thicker and more deeply textured than those of her offspring, particularly around the neck.

This exercise shows several animals and is therefore more complex to draw. These examples are broken down into steps to show the different areas of tone.

STEP 1

With an HB pencil, outline the main shapes of the sheep and lambs, including a few facial features (eyes, nose, ears, horn, mouth).

STEP 2

Fill in the areas of darkest tone on the head, neck and leg, and those places which show the darkest shadows in the fleece.

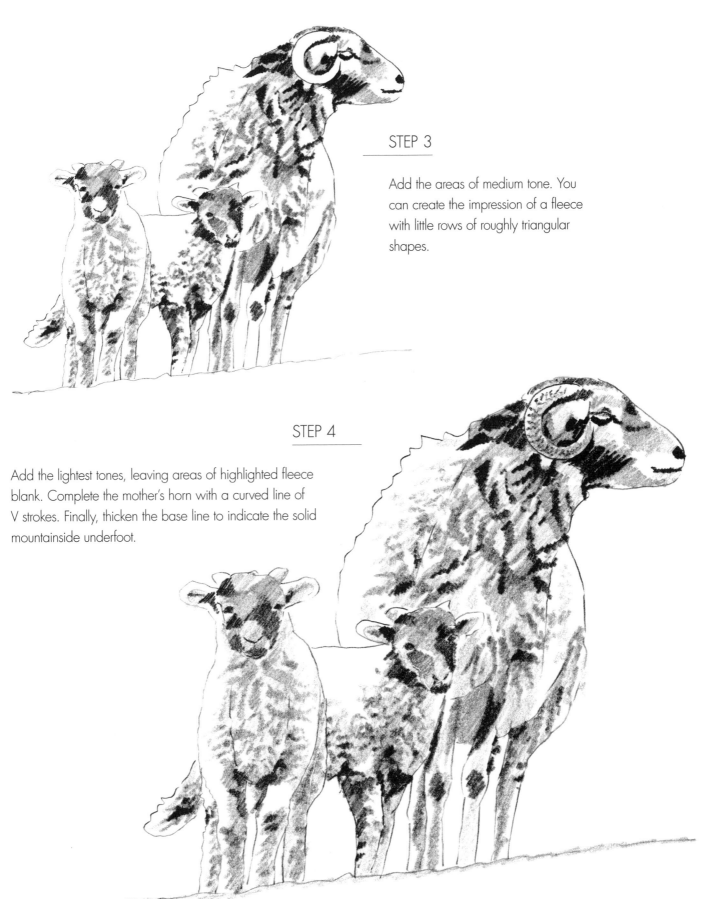

STEP 3

Add the areas of medium tone. You can create the impression of a fleece with little rows of roughly triangular shapes.

STEP 4

Add the lightest tones, leaving areas of highlighted fleece blank. Complete the mother's horn with a curved line of V strokes. Finally, thicken the base line to indicate the solid mountainside underfoot.

Hare

A much smaller mammal than the other ones we have looked at so far, the European, or brown, hare (*Lepus europaeus*) has distinctively large ears and is closely related to the rabbit.

The level of detail in this exercise is quite challenging and it requires a delicate touch to draw the textures. The hare's fur has a low tonal contrast, with very subtle differences between the grey tones. Refer to the 'fur' examples on pp.72–3 if needs be.

STEP 1

Using an HB pencil, lightly sketch the outline shapes and grass and carefully draw the correct proportions, noting that the ears are as tall as the head. Outline the ears, face, fur and legs then the main areas of dark tone (ears, eyes, shadows in the fur), medium and light tones (fur, grass). If necessary, lightly shade the dark-toned areas to help you locate them later when you fill them in. Where the fur patterns are complex, identify uniform tonal areas or use simple lines to show fur direction.

STEP 2

With a graphite stick, fill in the small, irregular-shaped areas of darkest tone around the top of the head, the eyes, nose, and face and along the spine, sketching the single strokes in the direction of the fur. On the ears, leave gaps between the dark strokes (negative spaces) to indicate white fur strands. Leave thin strips of white around the edges of the ears to denote highlights. For the eyes, add thin semi-circular shapes of dark tone around the eye (see detail, above right).

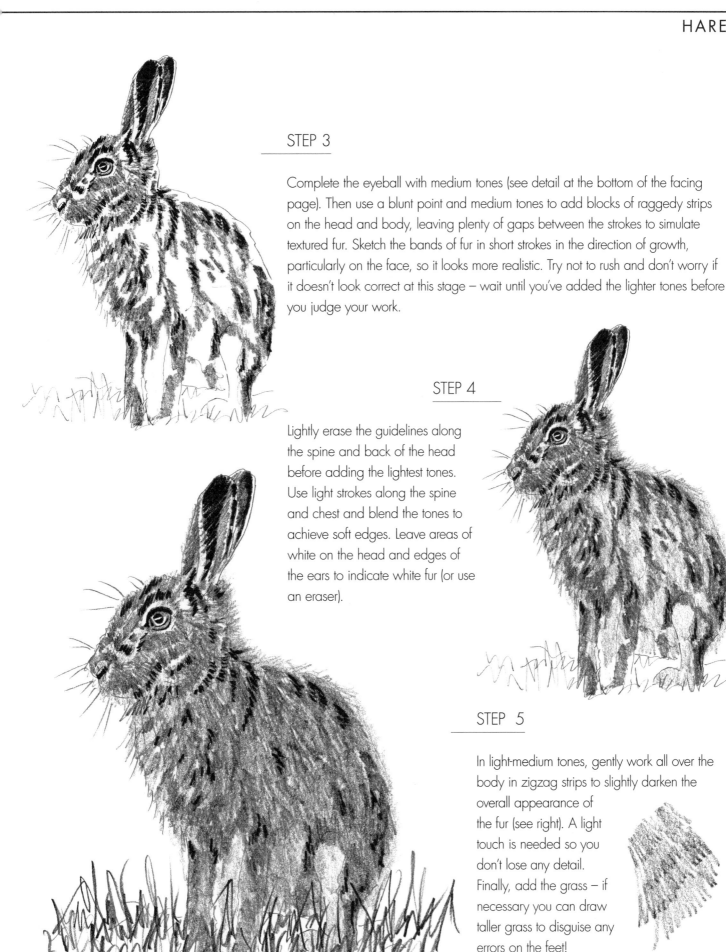

STEP 3

Complete the eyeball with medium tones (see detail at the bottom of the facing page). Then use a blunt point and medium tones to add blocks of raggedy strips on the head and body, leaving plenty of gaps between the strokes to simulate textured fur. Sketch the bands of fur in short strokes in the direction of growth, particularly on the face, so it looks more realistic. Try not to rush and don't worry if it doesn't look correct at this stage – wait until you've added the lighter tones before you judge your work.

STEP 4

Lightly erase the guidelines along the spine and back of the head before adding the lightest tones. Use light strokes along the spine and chest and blend the tones to achieve soft edges. Leave areas of white on the head and edges of the ears to indicate white fur (or use an eraser).

STEP 5

In light-medium tones, gently work all over the body in zigzag strips to slightly darken the overall appearance of the fur (see right). A light touch is needed so you don't lose any detail. Finally, add the grass – if necessary you can draw taller grass to disguise any errors on the feet!

165

Cats

Domestic cats come in a huge variety of types, from moggie to exotic breeds, with different fur lengths, markings and conformations. As with other animals, start with simple outlines and shapes then build and refine the details from there.

When awake, cats are seldom completely still and therefore difficult to draw. You'll probably get your best sketches while they are sleeping or sitting. You may start sketching your pet with tentative strokes, as you try to work out the shapes and proportions, but sometimes it's best just to draw a few bold strokes and not think about it too much. Either method is fine and each conveys a different mood.

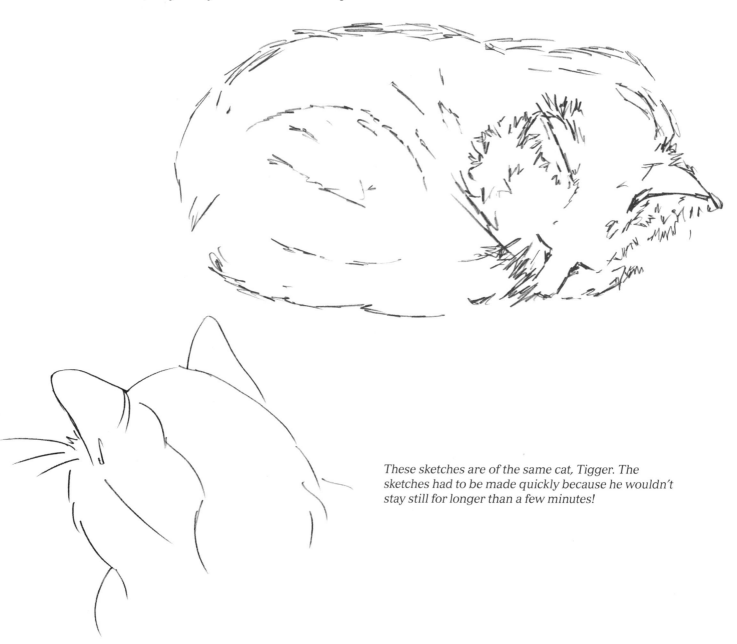

These sketches are of the same cat, Tigger. The sketches had to be made quickly because he wouldn't stay still for longer than a few minutes!

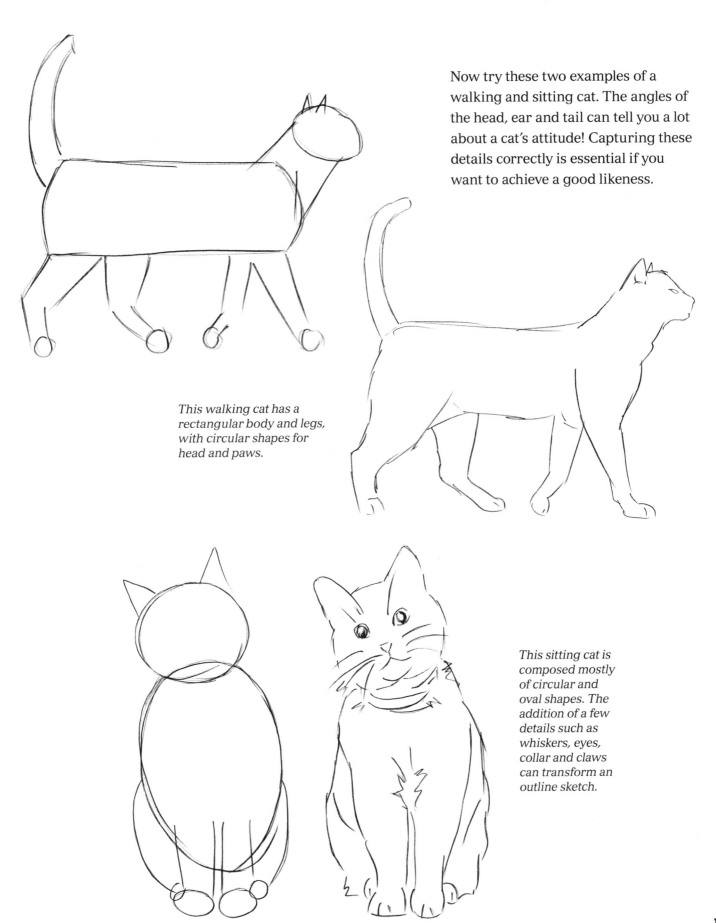

Now try these two examples of a walking and sitting cat. The angles of the head, ear and tail can tell you a lot about a cat's attitude! Capturing these details correctly is essential if you want to achieve a good likeness.

This walking cat has a rectangular body and legs, with circular shapes for head and paws.

This sitting cat is composed mostly of circular and oval shapes. The addition of a few details such as whiskers, eyes, collar and claws can transform an outline sketch.

TIGGER

Some animal features, such as ears and noses, are trickier to draw than others. Here's your chance to try a more detailed cat portrait that includes some intricate structures. Photographs are usually essential if you want to draw in detail, unless you have a good memory or a subject who will happily sit for a long time. I suggest you use a simple square grid to help you place the features accurately.

STEP 1

Using an HB pencil, lightly outline a simple grid and add the main features: the eyes, nose and stripes of fur. Use faint dotted guidelines for less distinct features. If used properly, your grid will ensure the features are in the correct position. Draw as many or as few details as you need to achieve a good likeness. Shading a few of the darker-toned areas will help you navigate around your drawing. The more detail you add at this stage (without cluttering), the better your final drawing will be.

STEP 2

Add the darkest tones in graphite – squint to identify them if you need to. Note that there are lots of geometrically shaped areas, and care is needed to fill in around the whiskers. Follow the direction of fur and don't fill it in as solid blocks – leave gaps between the strokes to give the effect of speckled fur. If you need to, rotate your page to make it easier to draw the strokes at different angles. The eyes are just a collection of shapes carefully placed (see detail, above left). Avoid the temptation to draw a single circle or ellipse – make disjointed shapes instead, which will look more natural. Draw exactly what's there and don't worry if it doesn't look correct at first, since detailed work often doesn't look good until it's three-quarters finished.

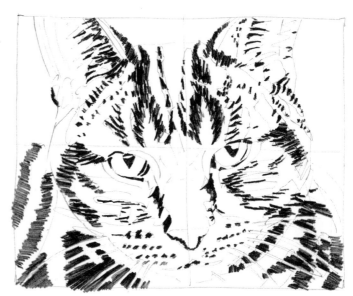

STEP 3

Now add areas of medium tone and blend slightly with the dark tones where the areas overlap. As before, sketch your strokes in the direction of fur, leave gaps between the strokes and leave the whiskers blank. Erase the grid lines carefully.

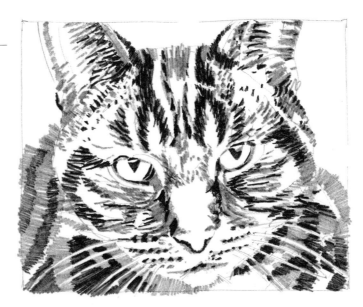

STEP 4

Finally, add the lightest tones and leave a few areas blank, for example, under the eyes, nose and mouth, to show white fur. Carefully add a few delicate touches of tone to the eyes and nose (see details, above left); even a spot of tone can change an expression. Check your work and make any final adjustments.

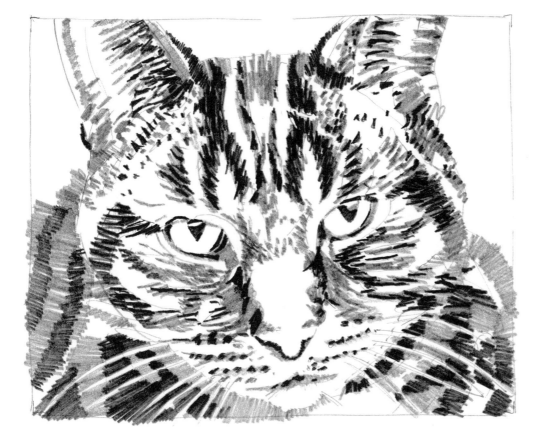

Dogs

Like cats, dogs come in all shapes and sizes, but they are usually more obedient so may pose longer for you to draw or photograph them! They are appealing and popular subjects to draw, especially if they are beloved pets.

Quick sketches are ideal to capture a pose, like these sleeping and jumping dogs. But if you want to draw more detail it's easier to work from a reference photograph.

This dog, Red, is blissfully asleep in a favourite spot. It's a good opportunity to produce a quick sketch. I used a number of pale, short strokes to outline him, and rule of thumb to estimate proportions. I added a few dark strokes to emphasize the facial features.

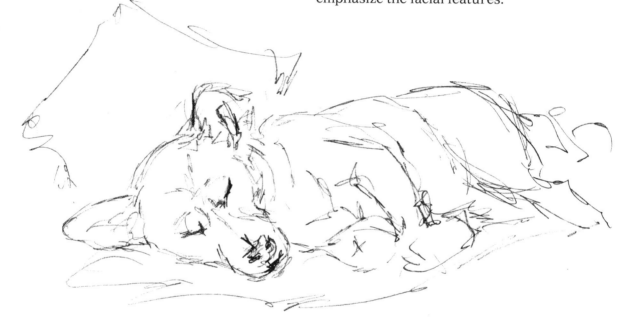

Quick scribbles are a great way to capture dogs in action, like this one leaping. It's not particularly accurate but the scribbles do convey a sense of speed and action.

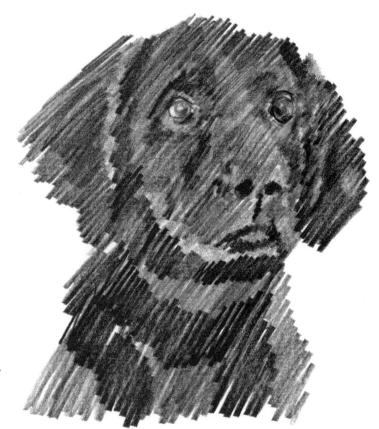

BO, LABRADOR PUPPY

If you want to sketch a black dog like this labrador puppy, Bo, graphite is a good medium to capture the sheen of the coat. A black coat can look almost pale grey if the dog is sitting in bright sunlight, and it can be hard to judge the tones. Don't be afraid to use dark values when drawing dark dogs and remember that your first marks and features will still show through if you need to darken the tones later.

TARA, YOUNG WORKING LABRADOR

A few simple strokes and features can also portray a dog, so have a go at sketching this young female labrador called Tara.

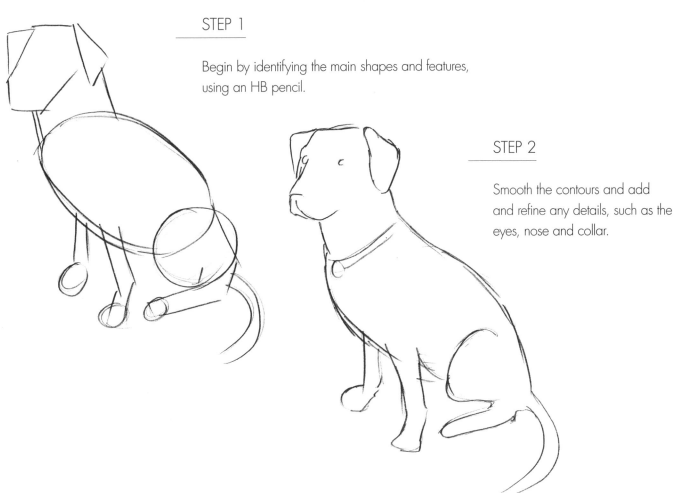

STEP 1

Begin by identifying the main shapes and features, using an HB pencil.

STEP 2

Smooth the contours and add and refine any details, such as the eyes, nose and collar.

DOGS IN DETAIL

As you discovered in the texture samples, some parts of animals like fur, noses and mouths can appear to be particularly difficult to draw because of the negative spaces, overlapping shapes and soft tones. However, with a combination of careful observation and not attempting too much at once, these features can be easily mastered and your drawings transformed.

This is a drawing of Ellie May, a border collie/bearded collie cross, with a close-up image of her nose.

Nose and mouth (HB pencil)

Dog noses and mouths often appear tricky to draw: noses because of the complex, rounded shapes, intricate skin folds and unusual mix of textures (dark smooth nostril, shiny moist skin, bumpy skin on top of the nose); and mouths because they're often indistinct and hidden under fur (negative shapes).

This exercise is a simplified version of a dog's nose and mouth in preparation for the next exercise – a dog portrait.

STEP 1

With an HB pencil, outline the main tonal areas: very dark, dark, medium and light.

STEP 2

Fill in the areas of darkest tone in the nostrils, around the edge of the nose and the negative shapes in the mouth. Leave the white areas blank. At this stage, as with many drawings, it looks nothing like what it represents, but persevere regardless!

STEP 3

In dark-medium tones, use swirls to fill in the elongated, slightly curved blob shapes between the nostrils on either side of the nostril centre line, and the curved blobs under each nostril.

STEP 4

In the same tone, add rough circles to the area above the nostrils, graduating to light-medium tones towards the edges. Fill in the gaps between the circle shapes in the same tone.

STEP 5

Use slightly lighter medium tones to add strokes of fur to the areas around the edge of the nose and to fill in the shapes around the nostrils and under the mouth.

STEP 6

Next, partially erase the guidelines and overhanging strands of fur around the mouth to remove the dark strokes. Use light values to fill the areas around the mouth and fur with swirls, blending the edges until they look softer. In the same way, add and blend light tones to the fur around the nose.

STEP 7

Still using blended light tones, fill in the small circle shapes on the top of the nose in swirls, leaving the middle circle shapes blank (these are highlights). Add shadows in uniform long strokes in medium tones to the left-hand side and under the nose.

STEP 8

Now blend all areas of adjacent tones to create much softer edges, taking care where the very dark and light tones meet — it's trickier to blend these. Finally, check your work and make any adjustments, such as darkening the area immediately under the nose, up the nose centre line and above the nostrils.

SPRINGER SPANIEL

Now you've tried drawing more detailed features, you can apply these in the next exercise – a portrait of a springer spaniel called Fin, done in HB pencil. To speed up the drawing process, I suggest you draw a grid on your page to help you outline all the features in their correct proportions. Allow yourself more time to draw this picture but don't attempt too much detail – a very detailed drawing will take at least 30 hours!

If you use a grid to draw from one of your own photographs, I suggest a 2cm (3/4in) grid printed onto a Perspex sheet. This is preferable to drawing directly on to a photograph, unless of course the image is on your computer for you to print out as many times as you like. You can choose to enlarge the drawing if you wish (see p.37).

Don't worry about using a grid or other form of measurement – it's not restrictive or cheating in any way and many famous artists have used drawing aids like this.

In this exercise, you'll draw the features and tones square by square rather than a single tone at a time, so each square is a picture in itself.

This is the image of Fin to draw, with a grid already placed over the top.

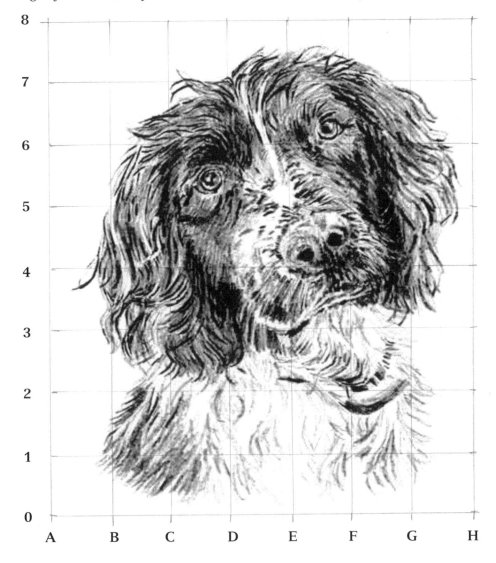

STEP 1

After you have drawn your grid lightly on your page, begin by outlining the main features square by square. You just need sufficient detail to guide you, so try not to draw too much at this stage.

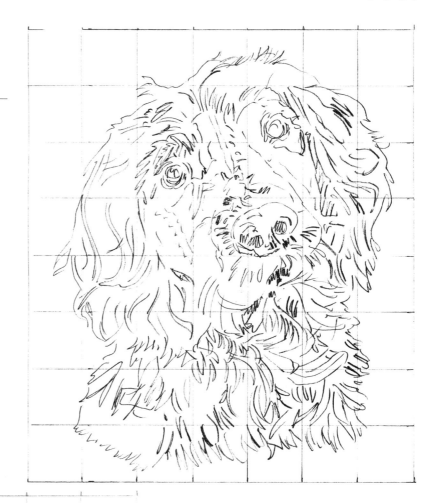

STEP 2

Start to fill in the details a square at a time, limiting the number of tones to about four (not including white). Start with the darker tones – it's easier to see them if you close one eye or squint. Remember to leave gaps between the strokes to create more realistic fur. Leave the bits of white fur blank. You can always darken them later, if necessary.

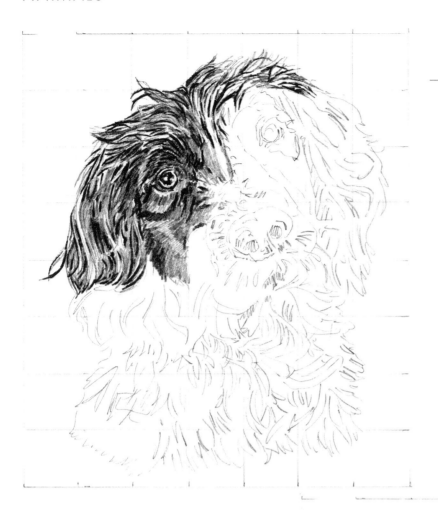

STEP 3

Gradually work your way through the squares. If you're right-handed, work from left to right to avoid smudging; the opposite applies if you are left-handed. You can also rest your hand on a piece of scrap paper. Carefully draw the tones for the eye (see detail, below). The areas around the eye are more important for creating the overall expression than the eyeball itself.

STEP 4

Much lighter tones are needed on the nose and chest. Try to ensure that you use the same range of tones across the whole picture and that your picture doesn't get progressively lighter or darker as you work.

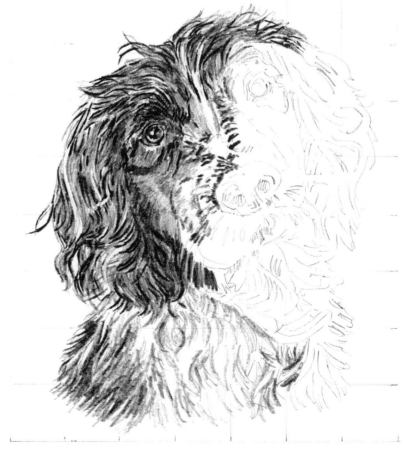

STEP 5

Now complete the right eye and muzzle, again taking care with the expression lines (see detail, below).

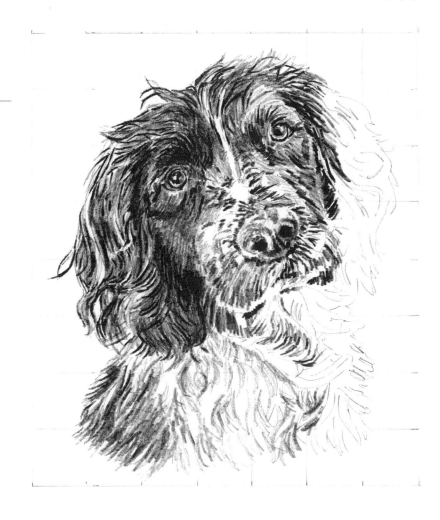

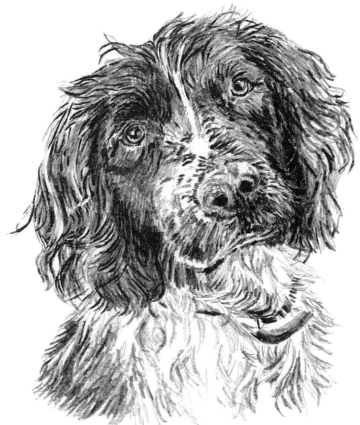

STEP 6

Continue completing the details, square by square. Refer to 'leather' (p.68) and 'fur' (pp.72–3) if you need to refresh your memory about drawing these textures. Carefully erase any visible guidelines. Remember to take a break if you need to.

STEP 7

Once you're satisfied you've completed all the squares in sufficient detail, check the tones are uniform across your picture (hold it up to a mirror for a fresh look). Then gently shade over all the squares in a very light tone, except for the white fur on Fin's muzzle and chest. If you like, use a sliver of eraser to create a few white hairs on the nose.

STEP 8

Finally, check if you need to make any corrections, then soften the fur by blending adjacent tones. Erase any unwanted marks or smudges around the outside of your drawing.

Now congratulate yourself on drawing a pet portrait!

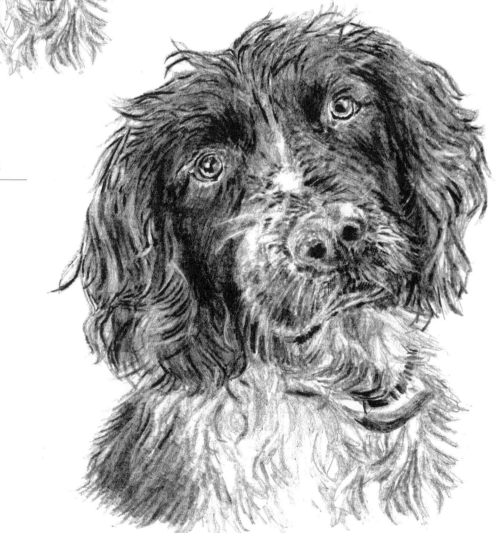

Fun with thumbnails

By now, you should be developing your own style of drawing and discovering different materials and techniques that you enjoy. Here you can have some fun with these thumbnail sketches. See how many other ways you can find to draw this dog called Millie!

 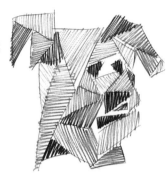 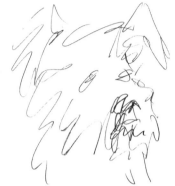

Original photo; outline sketch *Cubist; Impressionist*

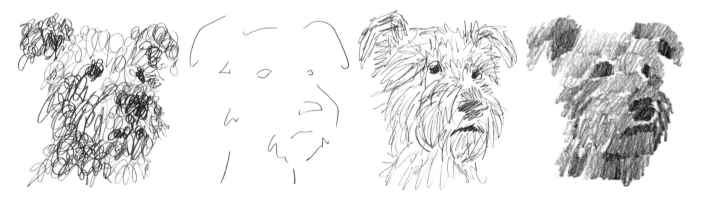

Scribble; minimalist *Quick sketch; quick tonal sketch*

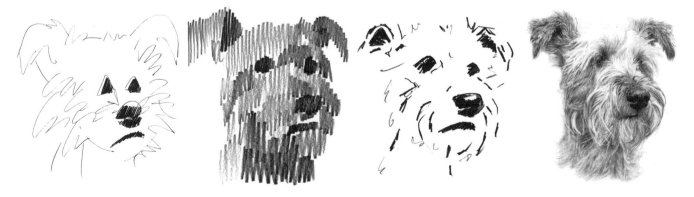

Cartoon; vertical strokes *Dark tonal sketch; detailed drawing*

Chapter 6
Portraits

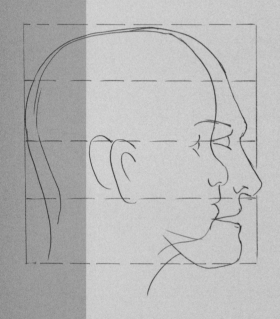

This final chapter looks at drawing portraits of people, which some artists consider to be the most difficult subject of all. These drawings don't contain any shapes or tones you haven't already mastered, but you need to be careful to render the various elements in the correct place so that your portraits have the likeness you intend.

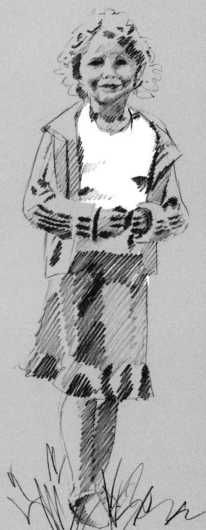

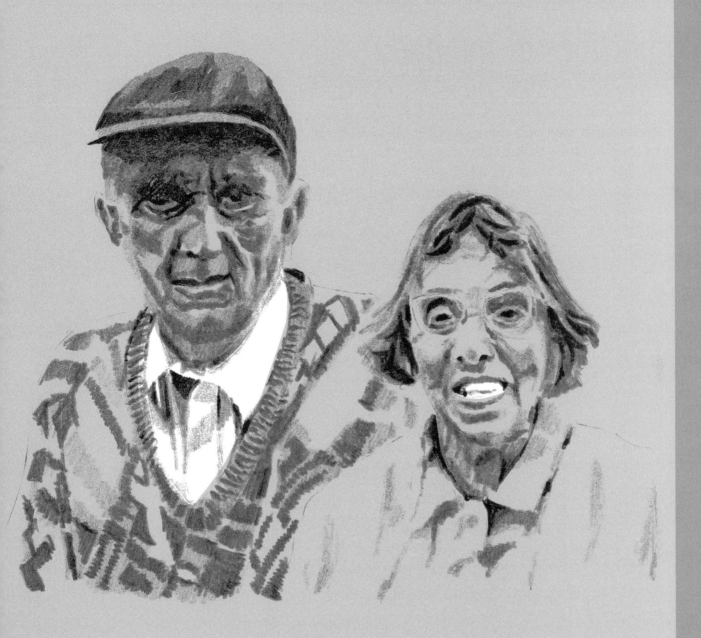

We'll begin by looking at some basic proportions of the head, face and body before moving on to step-by-step portraits of people of different ages in varying poses. When drawing portraits, the skill is in observing your subject and working out which details and features are important to create a recognizable representation on your page. There is no single style of drawing a portrait and we all interpret subjects in different ways.

You've practised sketching other subjects and animals from life and, in the process, worked out how to draw various elements, their proportions and placement. Now you just need to use the same techniques with portraits. Careful observation of your subjects in different poses and from different viewpoints plus lots of practise will help you get to grips with portraiture – there's no special magic to it!

Proportions of the body

Sometimes portrait sketching comes naturally, but on other occasions it's difficult to know where to start, or to understand why a portrait doesn't look quite right. Often it's simply knowing how to place all the features correctly, and fortunately there are some simple guidelines for this.

Distance from the top

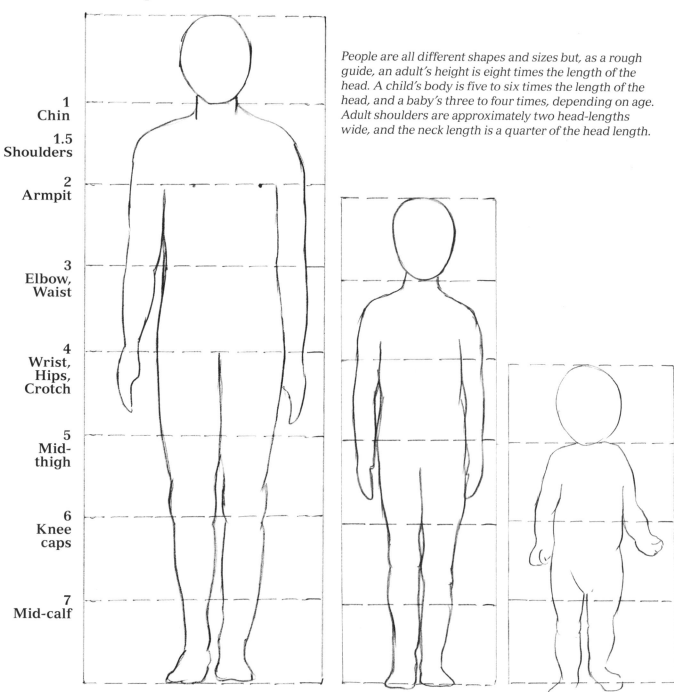

1
Chin

1.5
Shoulders

2
Armpit

3
Elbow,
Waist

4
Wrist,
Hips,
Crotch

5
Mid-
thigh

6
Knee
caps

7
Mid-calf

People are all different shapes and sizes but, as a rough guide, an adult's height is eight times the length of the head. A child's body is five to six times the length of the head, and a baby's three to four times, depending on age. Adult shoulders are approximately two head-lengths wide, and the neck length is a quarter of the head length.

Proportions of the head

Heads are egg-shaped, as you've probably noticed. A common mistake is to place the hairline much too high at the front. In an adult, the eyes are on the halfway point of the whole head. Compared with an adult, a child's head is larger in relation to the body, and the head and eyes are more rounded. In adults, female features tend to be more rounded and male features more angular.

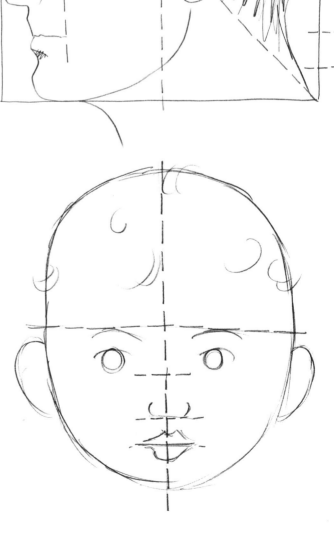

Seen in profile, the adult head fits into a square. The eyes and ears are halfway down the head, the eyes and mouth are aligned, and the hair occupies half the area.

The profile view shows the differences between the head and facial features of an adult, child and baby. Notice the baby's more rounded head shape, with the eyebrows (rather than the eyes) on the centre horizontal line. A baby has a proportionately smaller face in relation to the head.

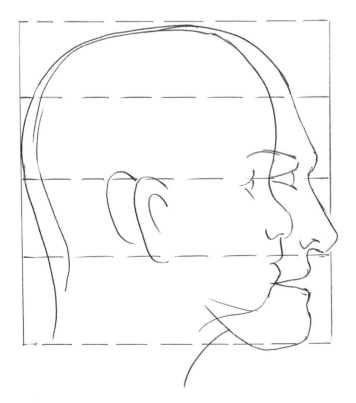

SIMPLE METHOD FOR DRAWING A HEAD

To get you started, here is a quick and simple method for drawing faces. Although faces are rarely symmetrical, it's easier to start by drawing them this way then, as you progress, you can adapt your approach according to the portrait you're sketching. In these examples, the head is divided into equal sections.

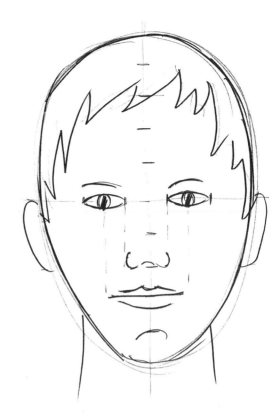

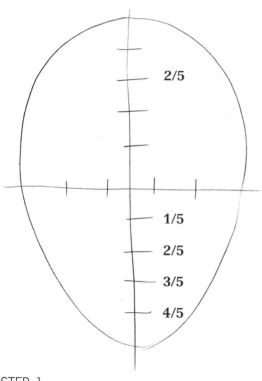

STEP 1

Draw a slightly elongated egg-shaped head and divide into quarters.

STEP 2

Divide the vertical line into five equal sections at the top and bottom, then divide the horizontal line into five sections across its entire width (this is five eye-widths).

STEP 1

Draw two eyes on the centre horizontal line between the marks as shown. Add circles for pupils and partially fill the pupils with a dash of dark tone, then add the eyebrows.

STEP 2

To locate the nose, follow a line down vertically from the inner edge of each eye to the two-fifths mark below the centre line and draw the width of the nostrils.

STEP 3

Now draw the horizontal centre mouth line on the three-fifths mark, with the edges of the mouth aligning under each pupil.

STEP 4

Mark the chin on the four-fifths line.

STEP 5

Add the ears, between the eyeline and bottom of the nose (two-fifths line).

STEP 6

Draw the neck lines, which align under the outer edges of the eyes.

STEP 7

Finally, add the hairline, which starts two-fifths of the way down from the crown of the head.

Your first portrait

The first thing to do is to choose your subject and, depending on the time available, decide the pose, size, medium and style of your portrait. If you don't have anybody willing to pose, you can always draw yourself. Sit or stand in front of a mirror and draw your reflection, beginning with something like a quick head and shoulders sketch. Remember that your observational skills have improved with practice, so just jump in and have a go! You'll soon discover the areas you find easiest and those you still need to work on.

Draw what you see before you, using quick strokes to note any shapes and proportions. Keep it simple – you can always add details later. Alternatively, you could sketch from a photograph and use a grid, or trace the outline details, until you feel more confident about sketching from life.

Your first portrait might be a quick sketch like this one.

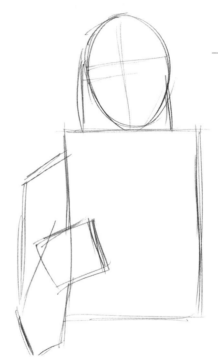

STEP 1

Using an HB pencil, lightly outline the basic round and angular shapes (shown darker here so you can see them) and note any angles such as the way the arm bends. Use the rule of thumb to help you lay out your sketch, and the guide on p.184 to place the facial features.

STEP 2

Refine the outlines, erase guidelines if needed, then add the hair, hand and facial details.

Limit yourself to 20 minutes or so for each sketch at first, and experiment as much as you can with different angles and poses. Don't worry if you make mistakes, since this is how you learn – simply use an eraser and redraw, have a break, or try a different pose (or all of these!)

Do explore and draw a mix of subjects – sketch your own hands and feet if you have no model. Some subjects present interesting perspectives so more care is needed when outlining the shapes. Practise by sketching from different angles.

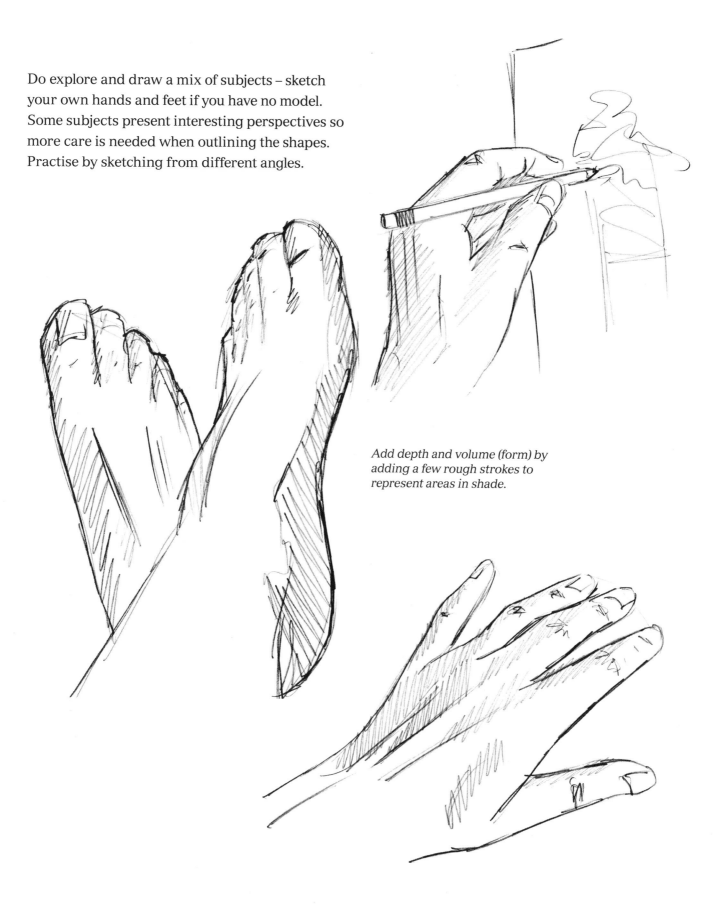

Add depth and volume (form) by adding a few rough strokes to represent areas in shade.

Sketching a complete figure

When you feel more confident, have a go at sketching a whole person. In this exercise, the model is sitting on a chair, turned partially away to give a three-quarter view. You can see it's possible to capture a likeness without including too much detail – a few strokes are sufficient to suggest such things as shoelaces or buttons.

Note that the overall proportions of a person can change depending on the pose and perspective, so check the angles and features carefully as you sketch.

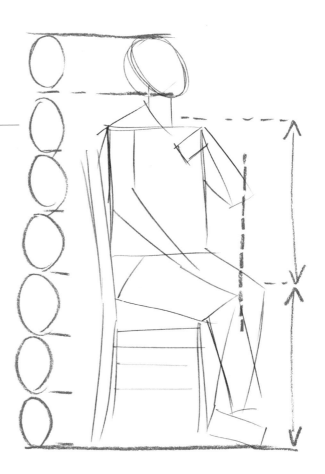

STEP 1

Examine the subject and focus on the overall shapes and their positions. Using an HB pencil, lightly sketch the basic shapes of the model and, in this case, the chair upon which she is sitting. Look for features to help you gauge measurements, for example, the head fits into this body six times; the distance from knee to sole of the foot is the same as the distance from shoulder to knee; and the right elbow and left knee are aligned.

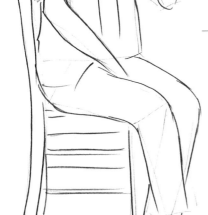

STEP 2

Lightly erase the guidelines, then begin to refine the shapes of the person and chair. Pay particular attention to the head, face, arms and clothing.

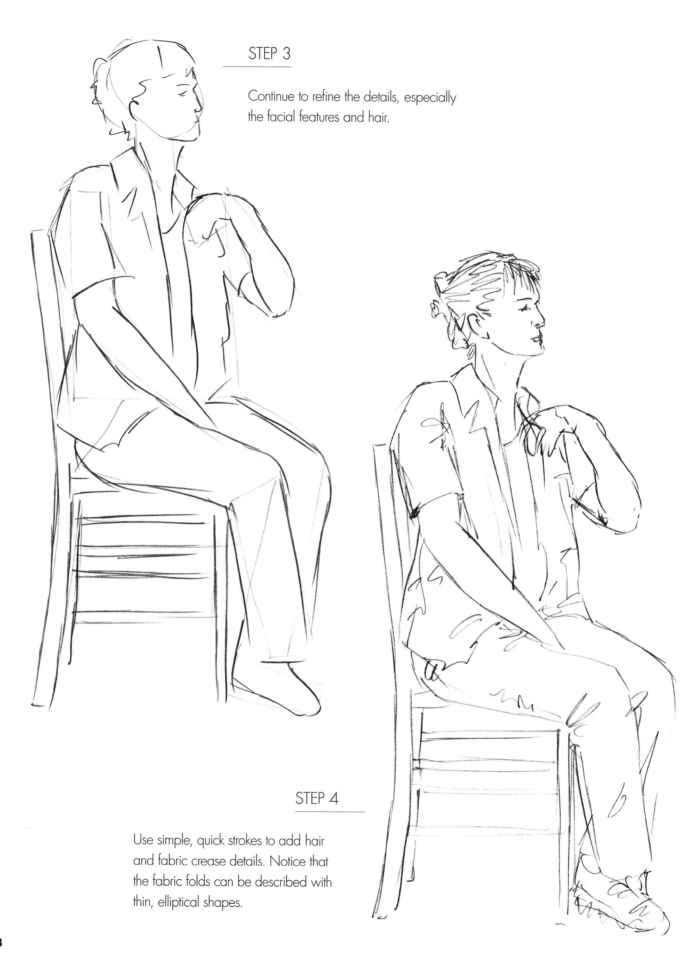

STEP 3

Continue to refine the details, especially the facial features and hair.

STEP 4

Use simple, quick strokes to add hair and fabric crease details. Notice that the fabric folds can be described with thin, elliptical shapes.

Different poses

Now try some different poses, mindful of the effects of different viewing angles.

A reclining figure can make an interesting pose, and it's comfortable for the model. Be aware of tricky angles, like the bent arm and leg in this portrait. They can present odd shapes to the viewer, so always double-check the proportions when outlining your work to pick up any errors. Careful measuring pays dividends.

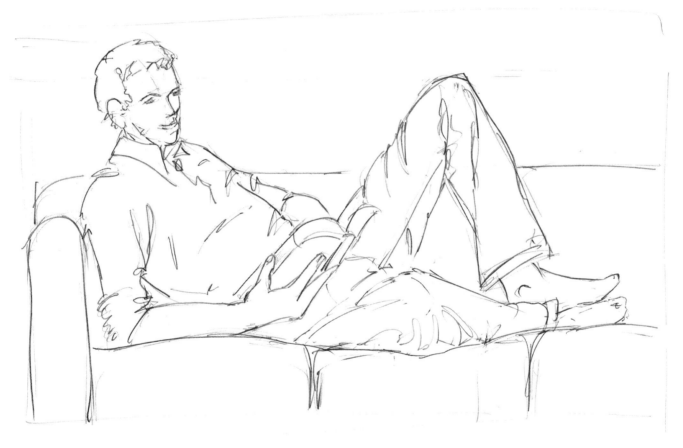

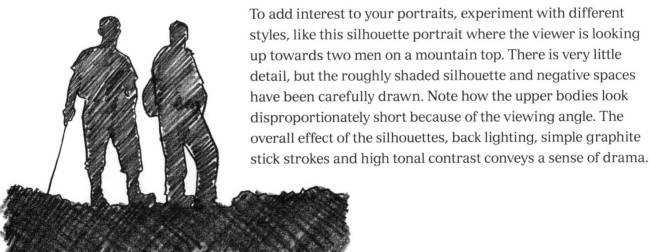

To add interest to your portraits, experiment with different styles, like this silhouette portrait where the viewer is looking up towards two men on a mountain top. There is very little detail, but the roughly shaded silhouette and negative spaces have been carefully drawn. Note how the upper bodies look disproportionately short because of the viewing angle. The overall effect of the silhouettes, back lighting, simple graphite stick strokes and high tonal contrast conveys a sense of drama.

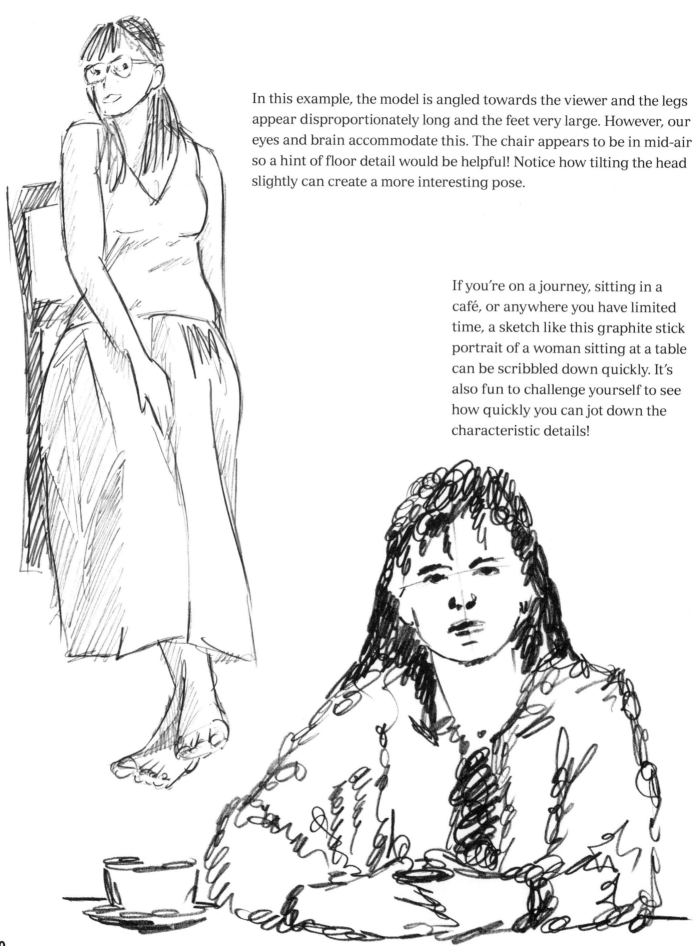

In this example, the model is angled towards the viewer and the legs appear disproportionately long and the feet very large. However, our eyes and brain accommodate this. The chair appears to be in mid-air so a hint of floor detail would be helpful! Notice how tilting the head slightly can create a more interesting pose.

If you're on a journey, sitting in a café, or anywhere you have limited time, a sketch like this graphite stick portrait of a woman sitting at a table can be scribbled down quickly. It's also fun to challenge yourself to see how quickly you can jot down the characteristic details!

People in action

When it comes to people in action, you'll have just enough time to sketch a quick impression. The more you practise this, the better you'll become at capturing essential details in your own style. If you want to produce a more detailed drawing later, it's best to take reference photographs as well. These examples illustrate different ways to capture the essence of a subject in action with minimal detail.

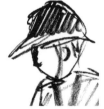

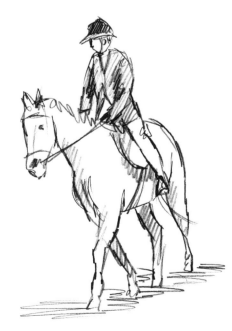

This sketch with diagonal tonal strokes in graphite stick conveys the movement of a horse and rider in serious concentration in a competition ring. The rider's face is an outlined nose and ear, partially concealed under a hat (see detail, above).

Quick, almost horizontal, sketchy HB pencil strokes give the impression of an athlete racing over a hurdle in a blur, while a few simple fluid curves depict a young child playing football. The child's head may be just a semi-circle and the right arm a single charcoal pencil stroke, but there's enough detail to capture a carefree moment. The disproportionately large head, short legs and large football inform us that this is a child. Neither portrait has a face, but none is needed.

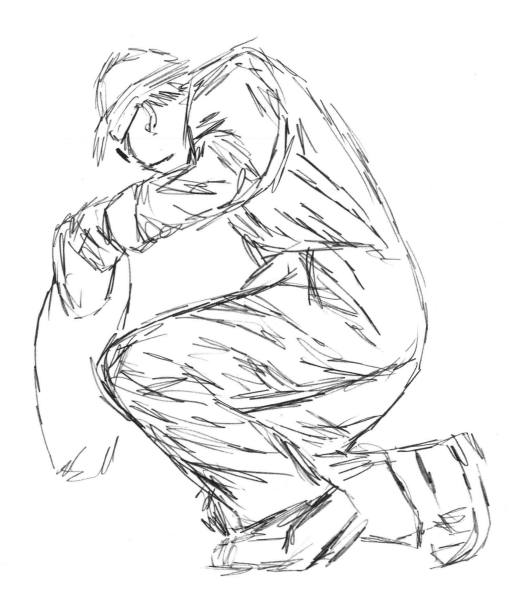

Although these HB pencil strokes appear hesitant and imprecise they nonetheless portray a kneeling man in overalls, busy at work. Diagonal strokes help to imply motion as well as effectively showing the folds and stretched fabric of the clothing.

Energy of a different kind is illustrated in this pen and ink sketch of a young man on a performance motorbike. The main shapes are simple outlines and the facial features a few strokes, but they are carefully placed and the viewer can quickly discern a happy portrait. A few strokes describe the face and hand (see detail, below).

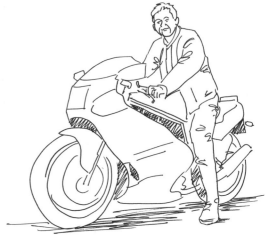

Portrait of a young girl

This next exercise shows you how to use simple blocks of dark, medium and light tones in rough, diagonal HB strokes to sketch a portrait of a young girl on a summer day.

STEP 1

Sketch the main shapes in outline and roughly mark the proportions of the head and facial features.

STEP 2

Lightly erase any unwanted guidelines, ensuring you can still see the outlines (or trace them onto a new page for this step). Add outlines of the main facial features, the hand shapes, fingers and fabric edges and folds.

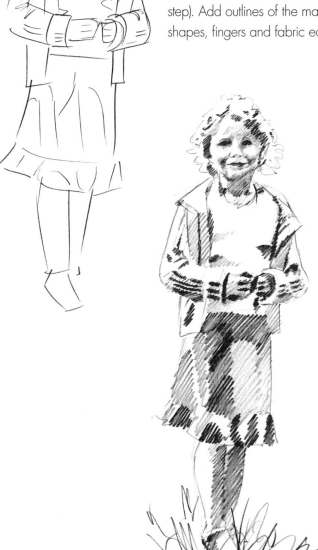

STEP 3

Add areas of dark, medium and light tone in diagonal sketchy strokes (see detail, above). Apply darker tones to the hairline and medium tones to the forehead. Use dark tones for the eye shapes, then medium-dark to medium-light tones for the surrounding sockets and bridge of the nose. Sketch curved areas of medium-light tone on either side of the nose and add two little blobs of dark tone for the nostrils. Use dark tone for the upper lip, medium for the shadow underneath, and fill the triangular dimples on either side of the mouth in medium and dark tones. Leave the cheeks blank and use medium and dark tones to define the chin and neck areas. Add blocks of all three tones to define the clothing and shoes and, finally, add a few rough strokes to denote grass.

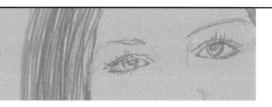

Baby portrait

Now try this step-by-step portrait of a baby viewed from above, which also shows how to capture a subject with minimal detail. The simple strokes and hint of tones in charcoal portray the lighting very well and create a captivating portrait.

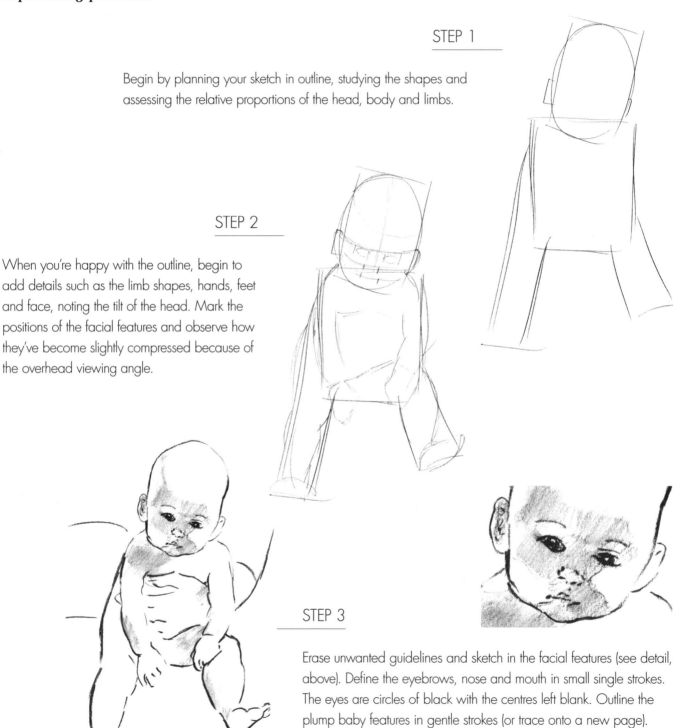

STEP 1

Begin by planning your sketch in outline, studying the shapes and assessing the relative proportions of the head, body and limbs.

STEP 2

When you're happy with the outline, begin to add details such as the limb shapes, hands, feet and face, noting the tilt of the head. Mark the positions of the facial features and observe how they've become slightly compressed because of the overhead viewing angle.

STEP 3

Erase unwanted guidelines and sketch in the facial features (see detail, above). Define the eyebrows, nose and mouth in small single strokes. The eyes are circles of black with the centres left blank. Outline the plump baby features in gentle strokes (or trace onto a new page). Add soft, blended areas of tone to face and torso to imply shadows.

An adult woman

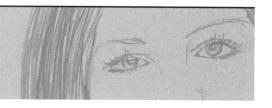

This next exercise is a close-up of an adult female face and requires you to draw much more detailed facial features to create her expression. You can either simply draw an outline sketch or add the tonal details of subtle skin textures and long flowing hair to create a more realistic portrait. The proportions of the face are first laid out using the guide on p.184. I drew this in HB but used a 4H pencil for the finer tonal details of the skin.

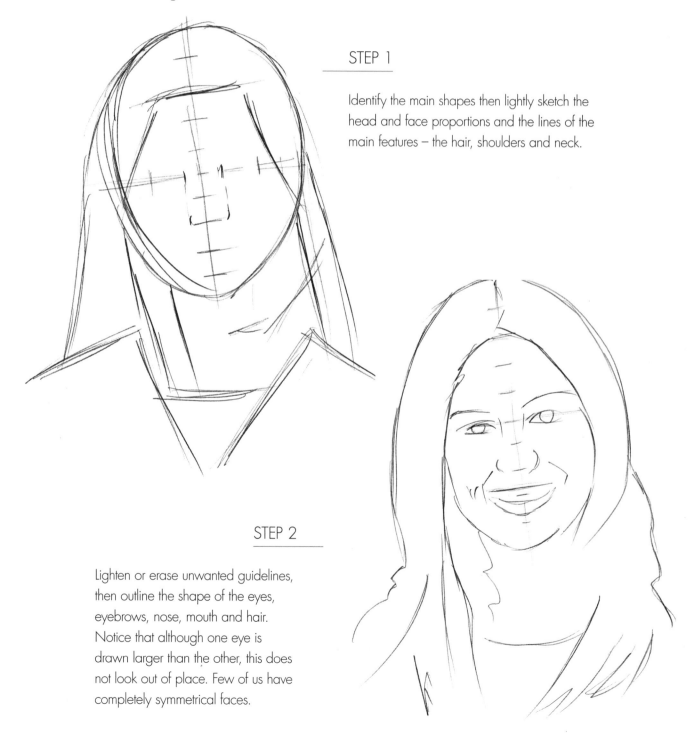

STEP 1

Identify the main shapes then lightly sketch the head and face proportions and the lines of the main features – the hair, shoulders and neck.

STEP 2

Lighten or erase unwanted guidelines, then outline the shape of the eyes, eyebrows, nose, mouth and hair. Notice that although one eye is drawn larger than the other, this does not look out of place. Few of us have completely symmetrical faces.

STEP 3

Refine the details of the eyes, eyebrows, lashes, nose and mouth and add a very slight hint of teeth. Do not draw around the teeth, but just lightly sketch the lower and upper edges. The eyelashes will look more realistic if drawn unevenly spaced and of different lengths.

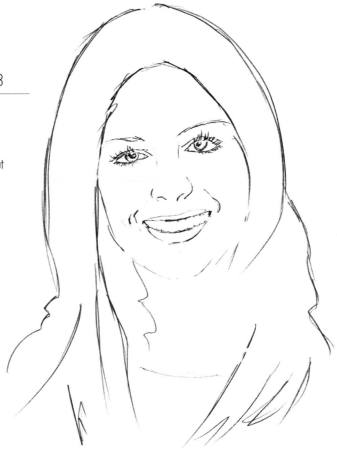

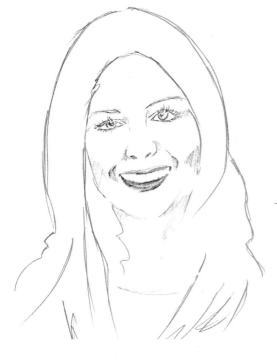

STEP 4

At this stage, you can choose to leave the portrait as an outline sketch or you can go on to add tonal details to the face and hair. To add shadows, draw areas of tone on the face sparingly and with a light touch, using a 4H pencil. They are often regular, geometric shapes with softly blended edges in graduated shades. Only deeper crease lines, such as laughter lines, are darker and more clearly defined.

To begin, sketch two triangle shapes in light tones above the inner corners of the eyes, then add a layer of the same tone in sketchy strokes across the eyebrows. Add an area of small, oval-shaped tone to the face at the outer edge of each eye. Then sketch small triangles of tone next to each nostril, and larger triangles next to the hairline on the cheeks.

Add two smaller rounded triangle shapes in the creases at either side of the mouth. In light-medium tone, add two elongated blobs along the lower part of the upper lip, then slightly darken the lines around the lower lip with an HB pencil and overlay with strokes in 4H. Add a squashed triangle shape of light tone on the right-hand side of the chin; slightly darken the nostrils using tiny diamond and circle shapes; sketch a triangle shape on the left-hand side of the neck under the chin, and finish with an elongated diamond shape on the right-hand side of the neck.

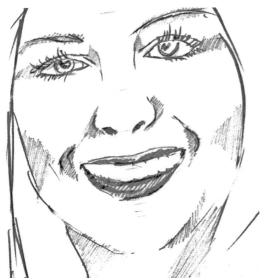

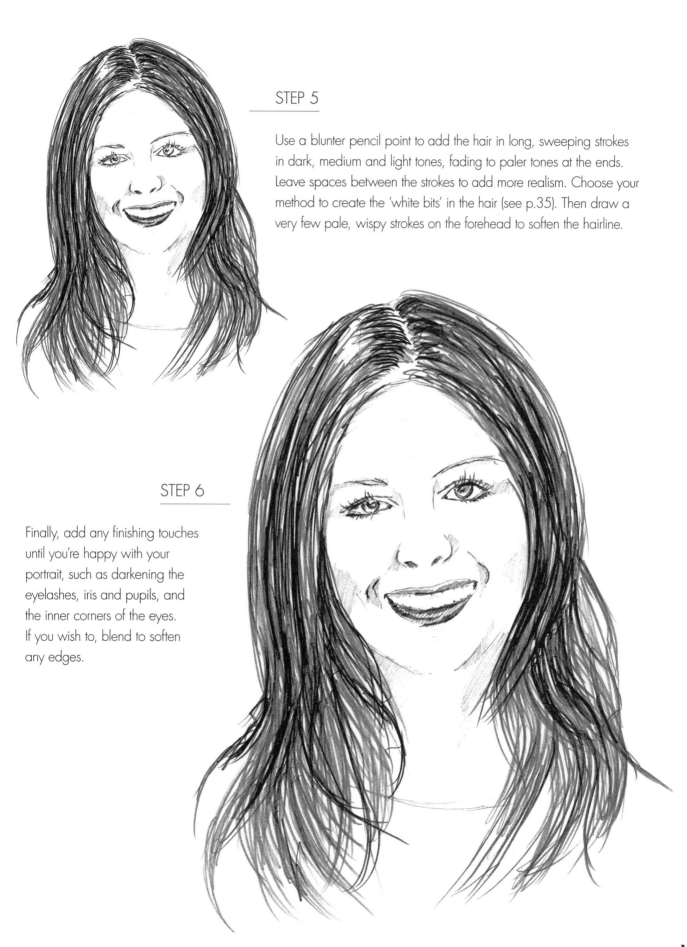

STEP 5

Use a blunter pencil point to add the hair in long, sweeping strokes in dark, medium and light tones, fading to paler tones at the ends. Leave spaces between the strokes to add more realism. Choose your method to create the 'white bits' in the hair (see p.35). Then draw a very few pale, wispy strokes on the forehead to soften the hairline.

STEP 6

Finally, add any finishing touches until you're happy with your portrait, such as darkening the eyelashes, iris and pupils, and the inner corners of the eyes. If you wish to, blend to soften any edges.

Side view

A side view can be much quicker to sketch than a full face, especially if the angle is straightforward; there are fewer features to record and it's possible to capture a person's personality in a few simple strokes. However, it does take skill to place the features accurately.

Notice how the use of much darker tones on the facial outline adds emphasis and draws your eye to this part of the sketch. The paler tones in the rest of the sketch add context but it's not necessary to add any more details here. The eyes are absent from this profile but the eyelashes indicate their placing. You'll notice that the eyes and their shapes will vary depending on the angle from which you view them.

STEP 1

With an HB pencil, lightly sketch the overall shapes, referring to the head and face proportions diagram on p.183 if you need to. When you're sketching from life, ensure the features are positioned correctly at this stage before you put in further work.

STEP 2

Next, erase unwanted strokes (or trace onto a new sheet), then refine the outline of the features in slightly darker tones and define the cheekbone, ear, a hint of eyebrow and a few eyelashes. Add a few sketchy strokes above the cheek to suggest shadow. Finally, add rough, dark-toned strokes for the fringe and fewer, much paler strokes for the rest of the hair. One or two light, sweeping lines are sufficient to suggest the hair is gathered simply at the back of the head.

Extreme angles

The face looks very different at extreme viewing angles and features can appear to be in very different relative positions, as these examples show.

In this upward-looking face, the prominent rounded jaw and chin fill half the head area and the facial features (eyes, nose and mouth) appear squashed together in the top third of the head. The forehead is very narrow, the nose tip appears above the eyes and the ears appear below the chin – the one on the right is almost touching the shoulder. The curved line at the throat defines the neck nicely.

The features appear compressed into the bottom of the head shape in this downward-looking face. The hair occupies half the space, the forehead a quarter, and the ear appears above all the facial features. The eyes are barely visible and the eyebrows and cheeks are much more prominent.

This face viewed from below (perhaps as a child would see it) appears to show the facial features compressed sideways into a narrow column on the left-hand side of the head. The facial features occupy more than half the height of the head, and the hair, ear, cheek and jaw occupy most of the space.

A young man

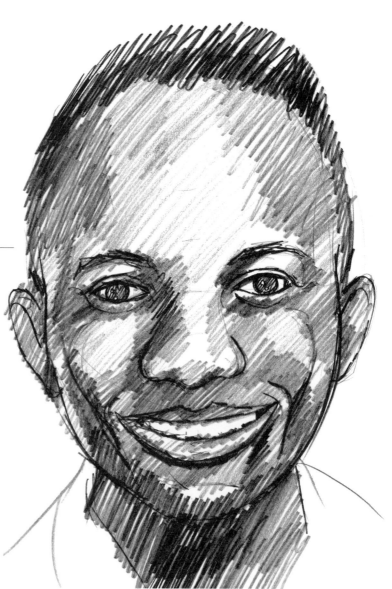

Next, try this graphite portrait of a young man, using simple outlines and sketchy strokes but with large areas of stronger tones to indicate his dark skin.

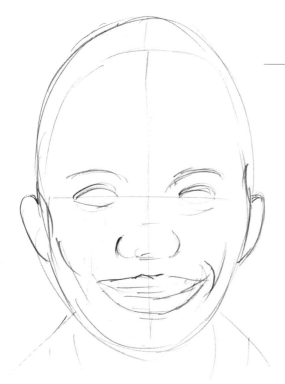

STEP 1

Outline the shape of the head and the position of the facial features (as before, divide the head into quarters and then fifths to help you locate the eyes, nose, mouth, ears and neck).

STEP 2

Define the facial features more clearly by outlining them in medium-dark tones using simple strokes. Then use blocks of dark, medium and light tone to describe the hair, skin tones and shadows. Leave the teeth and whites of the eyes blank.

An older man

Now have a go at sketching a portrait of an older man. It is produced here with a few sketchy strokes and blocks of tone in graphite stick, with a very dark background. There are few facial details, but the contrasting background emphasizes the features and brings the portrait to life.

STEP 1

Outline the shape of the head and neck, then position the eyes, nose, mouth, chin and ears as before. Add a few strokes to suggest a collar plus scribbles for the hair. Then sketch a few lines across the forehead, around the eyes and on the cheeks to help show this is the face of an older man. Fill in the whites of the eyes with light tones. Use dark and medium tones to sketch blocks of tone around the eyes, nose and mouth.

STEP 2

Sketch in the dark background using rough cross-hatch strokes in very dark tones. Draw them in different directions, taking care when shading around the face.

Notice that, compared to a younger face with smoother skin, older faces have more lines and wrinkles, the skin surface is less firm and the surface structures change with age as the skin loses its firmness and elasticity.

Tonal portrait of a teenage boy

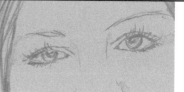

This next step-by-step exercise in graphite pencil depicts a teenage boy and is a more detailed and challenging sketch, as it uses tones rather than lines.

STEP 1

Use light strokes to plan out the overall shapes of your drawing.

STEP 2

Lightly outline the main features and main areas of tone (shown darker here so you can see the outlines more clearly).

STEP 3

Gently erase the guidelines if you don't want them to show in the final work. Next, add the blocks of dark and medium tones, many of which are elongated and geometric. If you wish, you can leave the portrait like this, appearing to show the subject illuminated by bright sunlight.

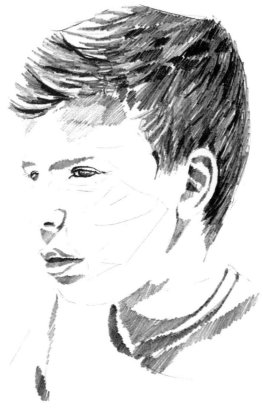

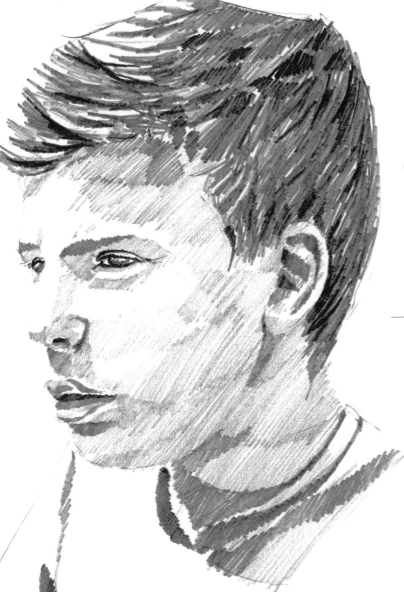

STEP 4

Add the blocks of light tones, overlapping them on the cheek to create slightly darker tones at the overlap. Add slight furrows at the brow to indicate concentration. Leave some areas white, such as facial highlights and parts of the clothing. Also, leave the outline white on the left side of the portrait – there's no need to draw a line around the edge. Notice that younger skin has few lines and creases.

By now, you will have realized that you can create portraits in different styles with very few details. Creating a likeness just requires observation, accurate placement of features and an eye for variations of tone.

An older couple

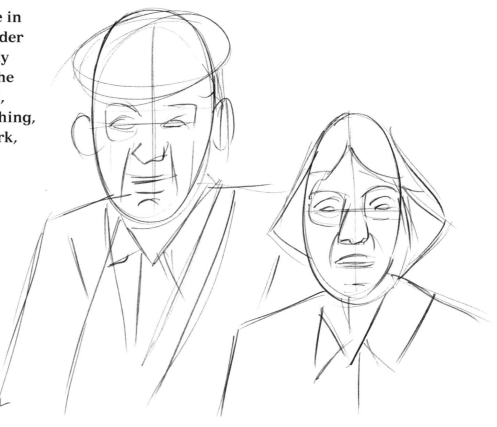

In contrast to the portrait of the teenage boy, this exercise in graphite pencil shows two older people whose faces are deeply lined and full of character. The portraits contain more detail, particularly in the man's clothing, which can be rendered in dark, medium and light tones.

STEP 1

Start by lightly outlining the main shapes of the people, and features such as eyes, nose, mouth and clothing (this image is shown much darker so the outlines are visible). The more care you take to achieve the correct proportions at this stage, the better the final result.

STEP 2

Lighten or erase any unwanted guidelines so they won't show in the finished piece, but leave sufficient detail so you can see to sketch the next stage.

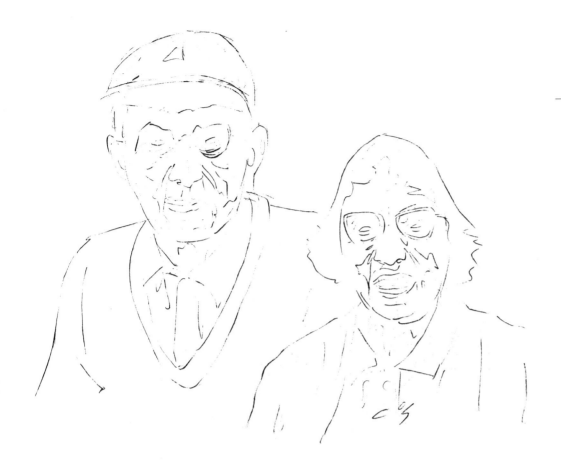

STEP 3

Outline the major areas of dark, medium and light tones. You may find it easier to outline the darkest and lightest tones first; you can choose to omit some areas if you feel confident enough to fill these in without guidelines.

STEP 4

Add the areas of dark tones, which are mostly the areas of deepest shadow. You'll find it easier if you look for the shapes rather than try to draw the features. The darkest tones are around the eyes, mouth, neckline, hair and the man's cap.

STEP 5

Add the areas of medium tone, the dominant tone in this portrait. Soften the edges and blend into the dark tones where they are adjacent. The pattern on the man's top is largely medium tones, and its ribbed neckline is a series of short parallel strokes.

STEP 6

Finally, add the lightest tones to the faces, cap and clothes, blending into adjacent tones. The light tones add definition to the facial features and show wrinkles and areas of paler shadow where the clothes fall into folds. Leave your work for a while then review it with a fresh eye and make any necessary adjustments.

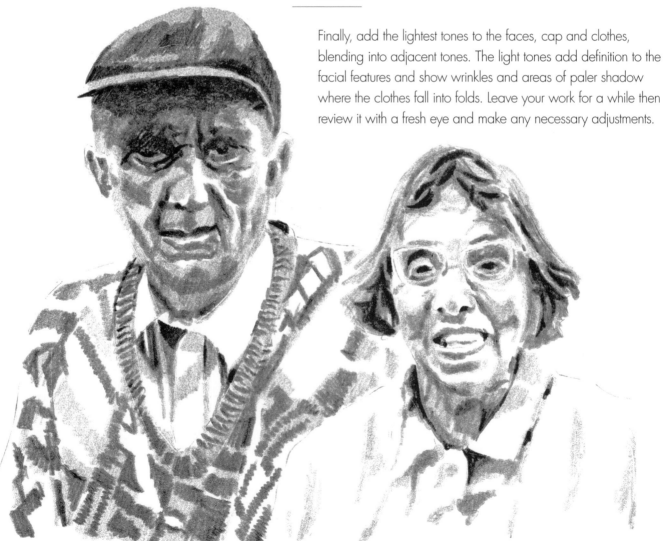

Summary

I hope you have enjoyed your journey, which has taken you from exploring simple strokes, shapes, shades and textures to creating beautiful objects, landscapes, animals and portraits. Learning to draw often requires you to look differently at the world around you, and acquiring these observational skills is invaluable when you translate what you see onto paper.

The best thing you can do is to keep practising and finding ever more challenging and fun ways of developing your skills, so that it becomes easier to make the marks you want on your page. If you do stop drawing for a while, don't worry that you'll lose your skills – you might get a bit rusty, but you'll soon pick them up again! The initial exercises in this book make an excellent refresher practice course.

As you continue to experiment with different techniques and styles, you'll understand how you like to draw and what works best for you. Buy the best materials you can afford for your more finished work and remember that drawing is meant to be enjoyable! Be patient with yourself – learning to do anything well takes time and your mistakes are not a waste of that time, for they teach you valuable lessons.

Often, we're not the best judge of our own work. If you do get stuck, then have a break or leave your drawing altogether and look at it with fresh eyes the next day. You can be more objective if you hold your work up to a mirror or take a photograph and view it on a computer screen. If there is a local art group you can join, you can also seek constructive feedback there.

Whatever you do, keep going – and don't throw your work away! I've lost count of the number of times I've almost given up on a drawing halfway through because it didn't 'look right'. Later I've realized it was better than I originally thought and been relieved to have kept it.

Continue to inspire yourself by looking at the work of other artists and always carry a pencil and paper with you – you are surrounded by a world just waiting for you to capture it on paper!

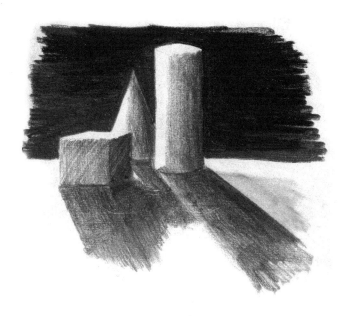

Index